Put any picture you want on any state book cover. Makes a great gift. Go to www.america24-7.com/customcover

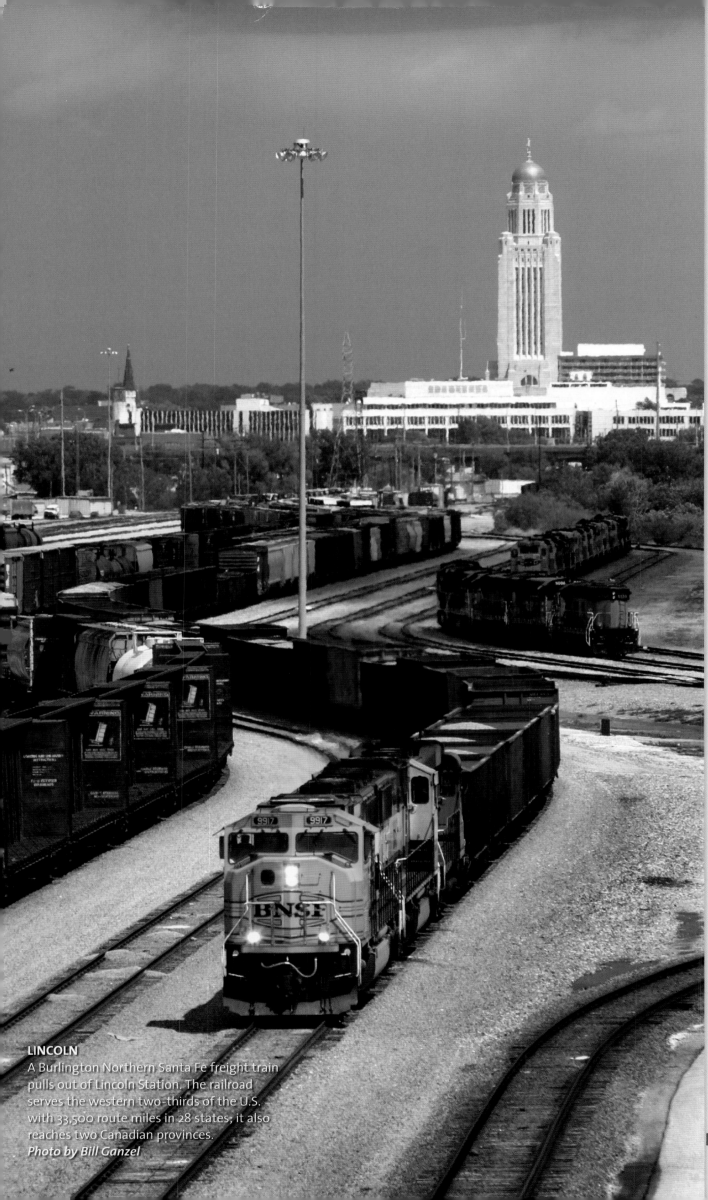

LINCOLN
A Burlington Northern Santa Fe freight train
pulls out of Lincoln Station. The railroad
serves the western two-thirds of the U.S.
with 33,500 route miles in 28 states; it also
reaches two Canadian provinces.
Photo by Bill Ganzel

Nebraska 24/7 is the sequel to *The New York Times* bestseller *America 24/7* shot by tens of thousands of digital photographers across America over the course of a single week. We would like to thank the following sponsors, the wonderful people of Nebraska, and the talented photojournalists who made this book possible.

Adobe

OLYMPUS

LEXAR
Media

snapfish

jetBlue
AIRWAYS

WEBWARE

Google

DIGITAL
POND

ebay

LONDON, NEW YORK, MUNICH, MELBOURNE, and DELHI

Created by Rick Smolan and David Elliot Cohen

24/7 Media, LLC
PO Box 1189
Sausalito, CA 94966-1189
www.america24-7.com

First Edition, 2004
04 05 06 07 08 10 9 8 7 6 5 4 3 2 1

Published in the United States by
DK Publishing, Inc.
375 Hudson Street
New York, NY 10014

DK Publishing, Inc. offers special discounts for bulk purchases for sales promo-
tions or premiums. Specific, large-quantity needs can be met with special
editions, personalized covers, excerpts of existing guides, and corporate
imprints. For more information, contact:

Special Markets Department
DK Publishing, Inc.
375 Hudson Street
New York, NY 10014
Fax: 212-689-5254

Cataloging-in-Publication data is available
from the Library of Congress
ISBN 0-7566-0067-7

Printed in the UK by Butler & Tanner Limited

First printing, October 2004

LANCASTER COUNTY
On a Saturday afternoon, a farmer plows his
field northeast of Lincoln. Twenty-two percent
of Nebraska's workforce is employed in farm-
related jobs.
Photo by Ken Blackbird

NEBRASKA 24/7

24 Hours. 7 Days.
Extraordinary Images of
One Week in Nebraska.

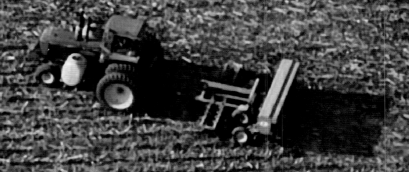

Created by Rick Smolan and David Elliot Cohen

DK Publishing

About the America 24/7 Project

A hundred years hence, historians may pose questions such as: What was America like at the beginning of the third millennium? How did life change after 9/11 and the ensuing war on terrorism? How was America affected by its corporate scandals and the high-tech boom and bust? Could Americans still express themselves freely?

To address these questions, we created *America 24/7*, the largest collaborative photography event in history. We invited Americans to tell their stories with digital pictures. We asked them to shoot a visual memoir of their lives, families, and communities.

During one week in May 2003, more than 25,000 professionals and amateurs shot more than a million pictures. These images, sent to us via the Internet, compose a panoramic yet highly intimate view of Americans in celebration and sadness; in action and contemplation; at work, home, and school. The best of these photographs, more than 6,000, are collected in 51 volumes that make up the *America 24/7* series: the landmark national volume *America 24/7*, published to critical acclaim in 2003, and the 50 state books published in 2004.

Our decision to make *America 24/7* an all-digital project was prompted by the fact that in 2003 digital camera sales overtook film camera sales. This techno-logical evolution allowed us to extend the project to a huge pool of photographers. We were thrilled by the response to our challenge and moved by the insight offered into American life. Sometimes, the amateurs outshot the pros—even the Pulitzer Prize winners.

The exuberant democracy of images visible throughout these books is a revela-tion. The message that emerges is that now, more than ever, America is a supersized idea. A dreamspace, where individuals and families from around the world are free to govern themselves, worship, read, and speak as they wish. Within its wide margins, the polyglot American nation manages to encompass an inexplicably complex yet workable whole. The pictures in this book are dedicated to that idea.

—Rick Smolan and David Elliot Cohen

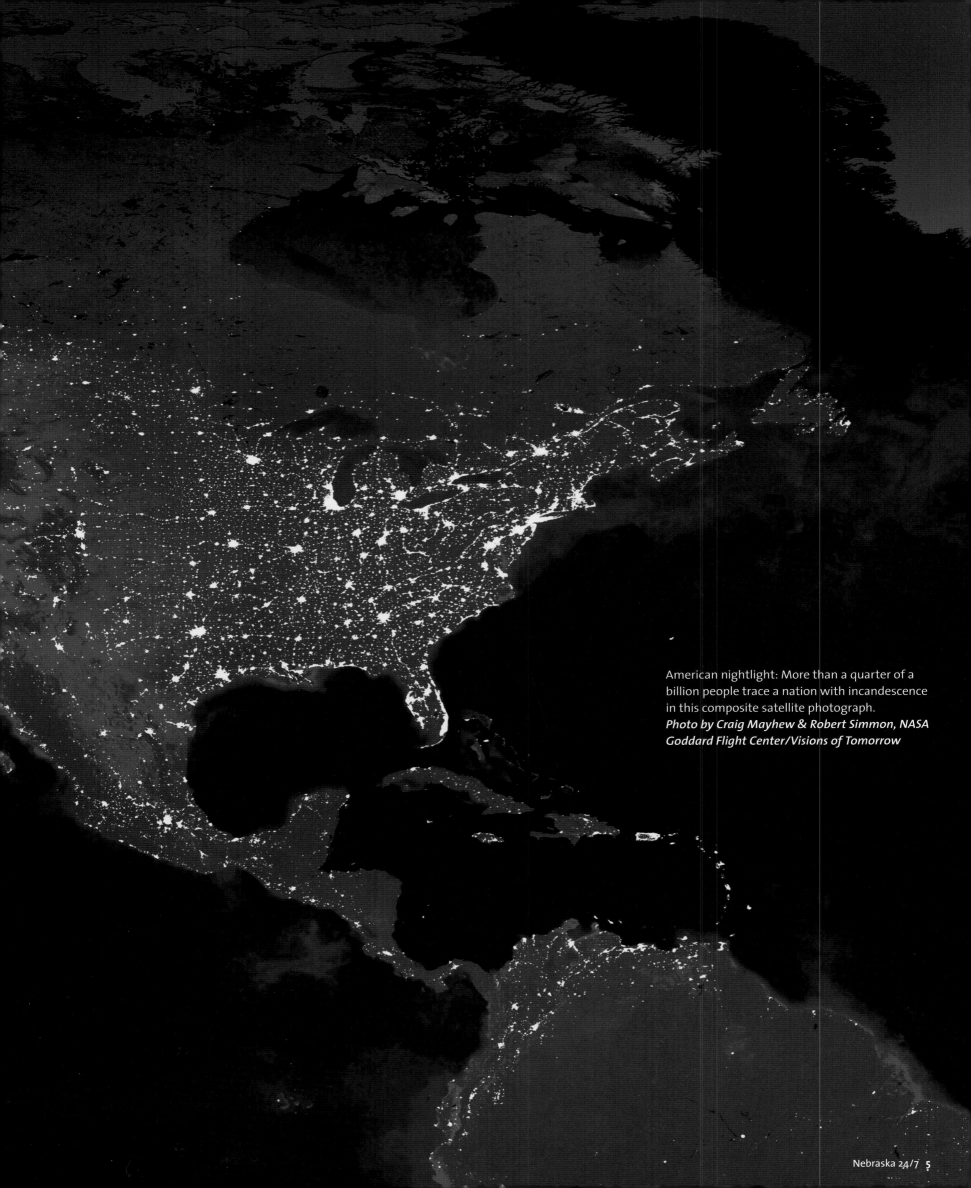

American nightlight: More than a quarter of a billion people trace a nation with incandescence in this composite satellite photograph.
Photo by Craig Mayhew & Robert Simmon, NASA Goddard Flight Center/Visions of Tomorrow

Along the Platte

By Cindy Lange-Kubick

Every August we hurtle west on Hwy. 2, an asphalt ribbon unspooling through Nebraska's heart. We race coal trains across rolling sand dunes, slowing down for one-blink towns, lost cattle in the road, thunderheads on the horizon. We are going away from the heat. Heading for someplace—anyplace—we won't drip sweat going to the mailbox. But we always come back when it cools. Nebraska calls us back.

Likewise, the cranes return every spring, appearing as the snow melts, hundreds of thousands of big-winged birds with Pippi Longstocking legs, roosting along the Platte River, dancing on its sandbars. But more and more farmers go away and stay away. Five thousand Nebraska farms disappeared in the past five years. But the corn still grows thick, and city kids come out to pluck its tassels each July. We grow beef here, too. Slaughter it. Pack it. Eat it. Small towns thrive on those packing plants, even as they adapt to *las panaderias* on Main Street.

In the fall we harvest milo—and play football. There are no Husker linebackers on these pages. *Nebraska 24/7*'s photos were shot in May, too late for spring drills, too early for the first kick-off. Still, we think Big Red is special, the Godiva chocolate of college football. It dazzles us, binds us together, for better or worse. When Tom Osborne retired as head coach we sent him to Congress—*another* Nebraska Republican in Washington.

We're conservative here, on the whole. Sensible, too. Like the one-finger, steering-wheel wave: friendly without being reckless.

Nebraska stretches 459 miles end to end, but all of us couldn't fill

Manhattan's apartment buildings. We like it that way. Willa Cather called Red Cloud home; home for Johnny Carson was Norfolk. Malcolm X was born in Omaha, Dick Cheney in Lincoln.

Nebraska is a tall-grass prairie with trees planted by immigrants—the only place I know where state employees get Arbor Day off. Cather wrote about those trees in *My Antonia*: "I love them as if they were people." The same way we love our big sky and Big Red and all those checkerboard squares of earth passed down generation to generation, *as if they were people.*

Nebraska is a dichotomy, divided by geography. Golden and green, flat and rolling, city and country. Seed caps and mortarboards, cowboy boots and business suits, rodeos and Rolexes.

To the east is Omaha—billionaire Warren Buffet, food giant ConAgra, the College World Series. And Lincoln, the capitol, where the nation's only one-house legislative body—the Unicameral—is trying to figure out if we should be the last state to use electrocution as its sole means of execution.

Out west is the breadbasket—cattle ranches, family farms and shrinking towns, all fighting to keep their hometown schools. The poorest counties in all of America are here. Meanwhile, Ted Turner buys up the Sandhills, dreaming of the buffalo's return.

We dream too. It's easy: Take any highway out of town...sky unfolding all around...one-finger waves from red pick-up trucks...thunderheads on the horizon...and the welcome promise of rain.

CINDY LANGE-KUBICK *is an award-winning columnist and reporter for her hometown paper, the* Lincoln Journal Star.

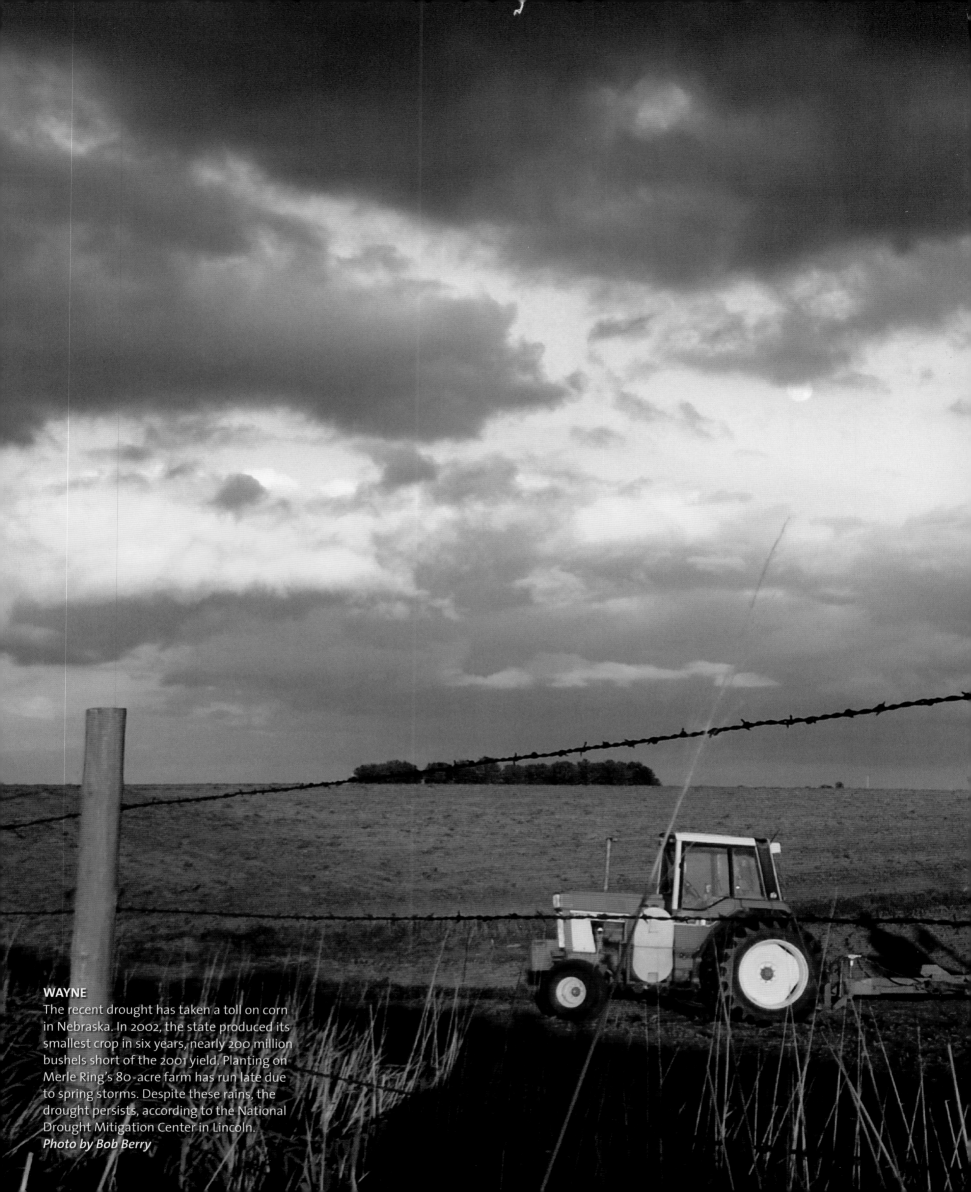

WAYNE
The recent drought has taken a toll on corn in Nebraska. In 2002, the state produced its smallest crop in six years, nearly 200 million bushels short of the 2001 yield. Planting on Merle Ring's 80-acre farm has run late due to spring storms. Despite these rains, the drought persists, according to the National Drought Mitigation Center in Lincoln.
Photo by Bob Berry

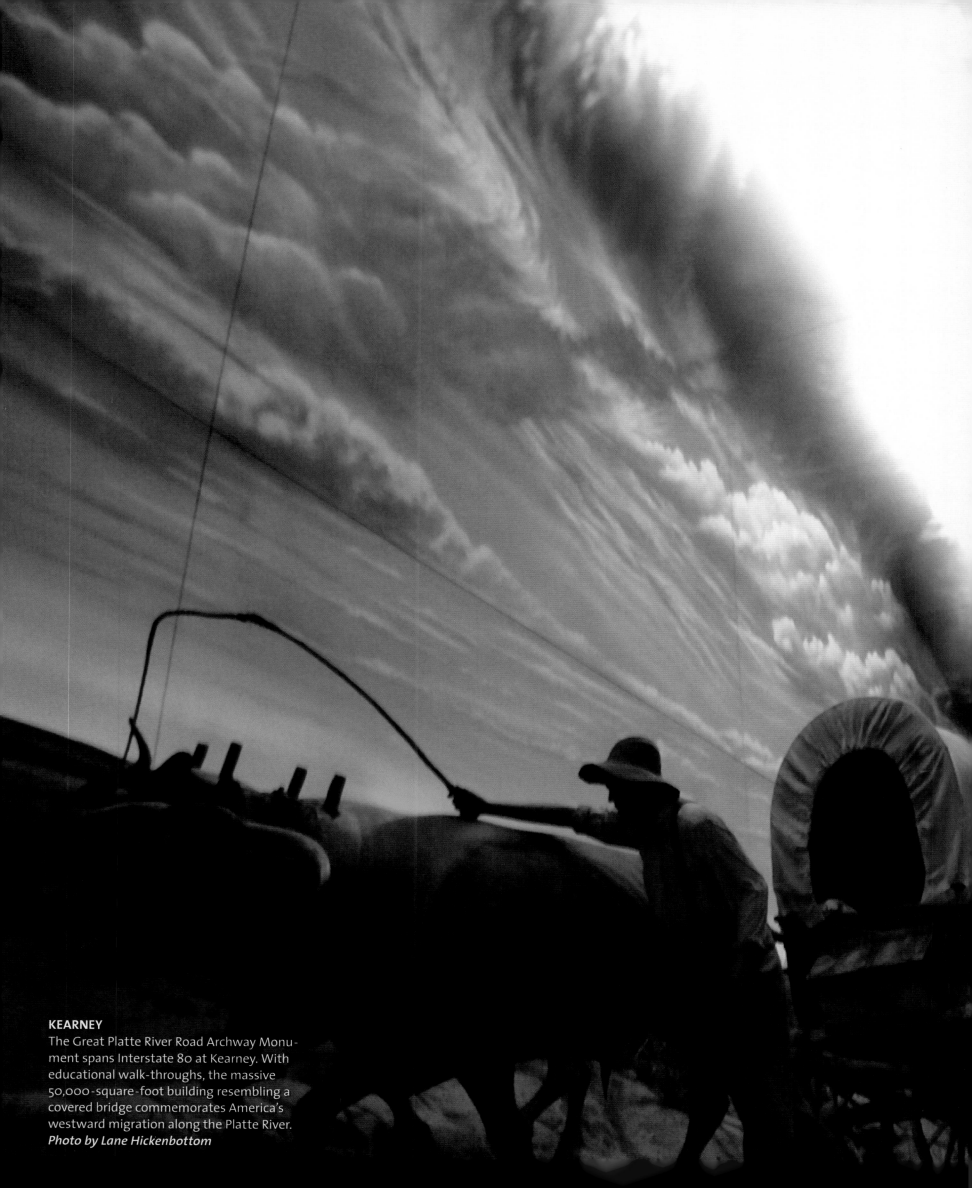

KEARNEY
The Great Platte River Road Archway Monument spans Interstate 80 at Kearney. With educational walk-throughs, the massive 50,000-square-foot building resembling a covered bridge commemorates America's westward migration along the Platte River.
Photo by Lane Hickenbottom

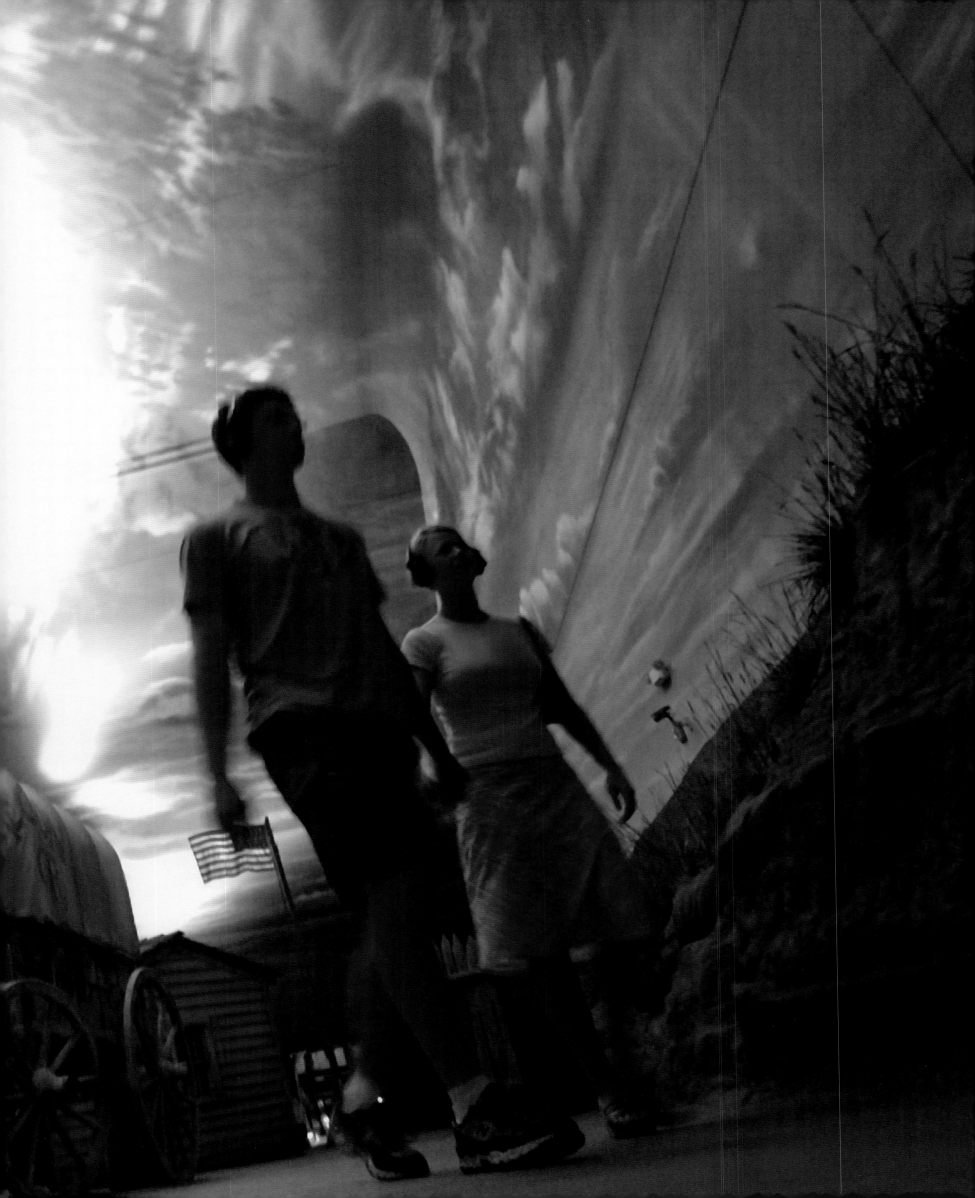

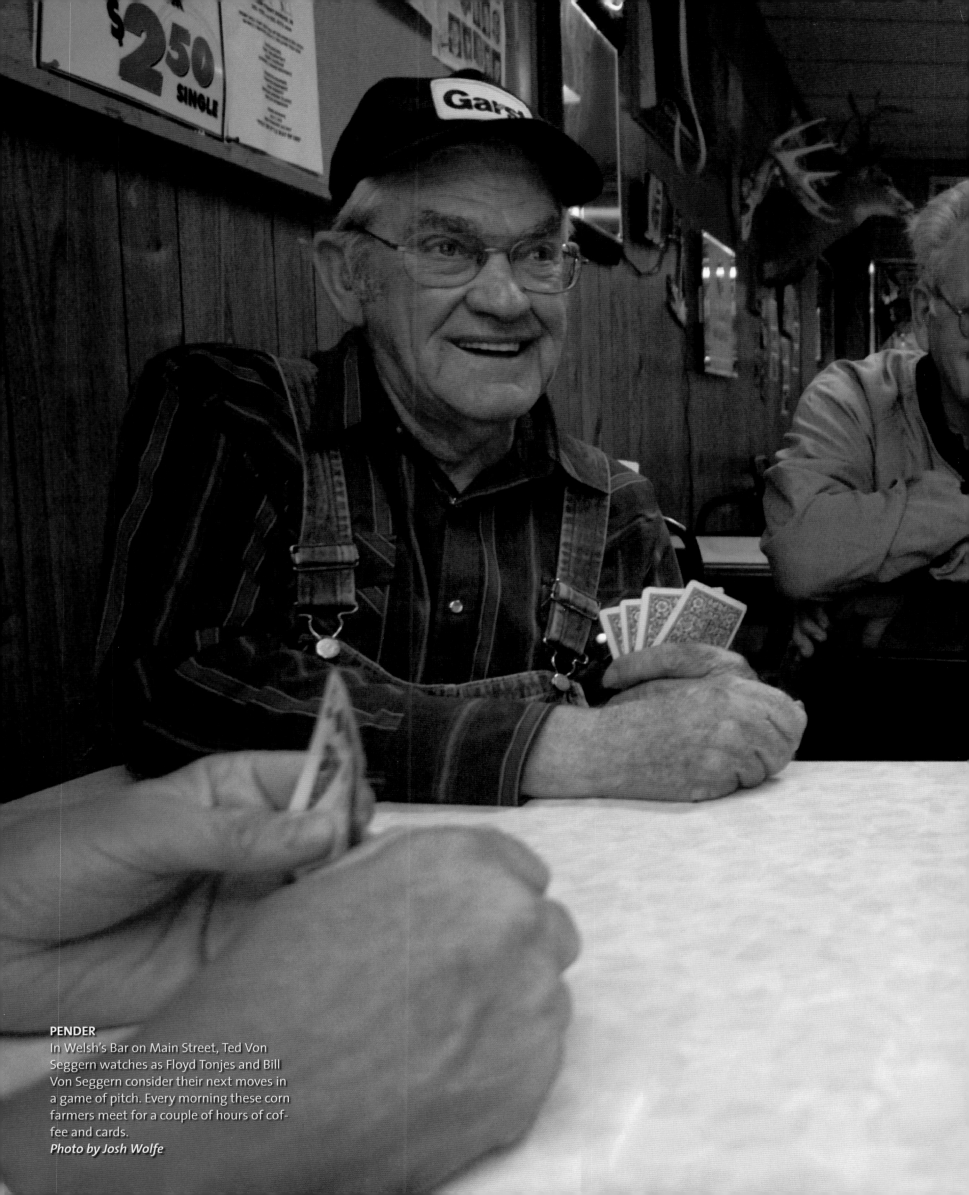

PENDER
In Welsh's Bar on Main Street, Ted Von Seggern watches as Floyd Tonjes and Bill Von Seggern consider their next moves in a game of pitch. Every morning these corn farmers meet for a couple of hours of coffee and cards.
Photo by Josh Wolfe

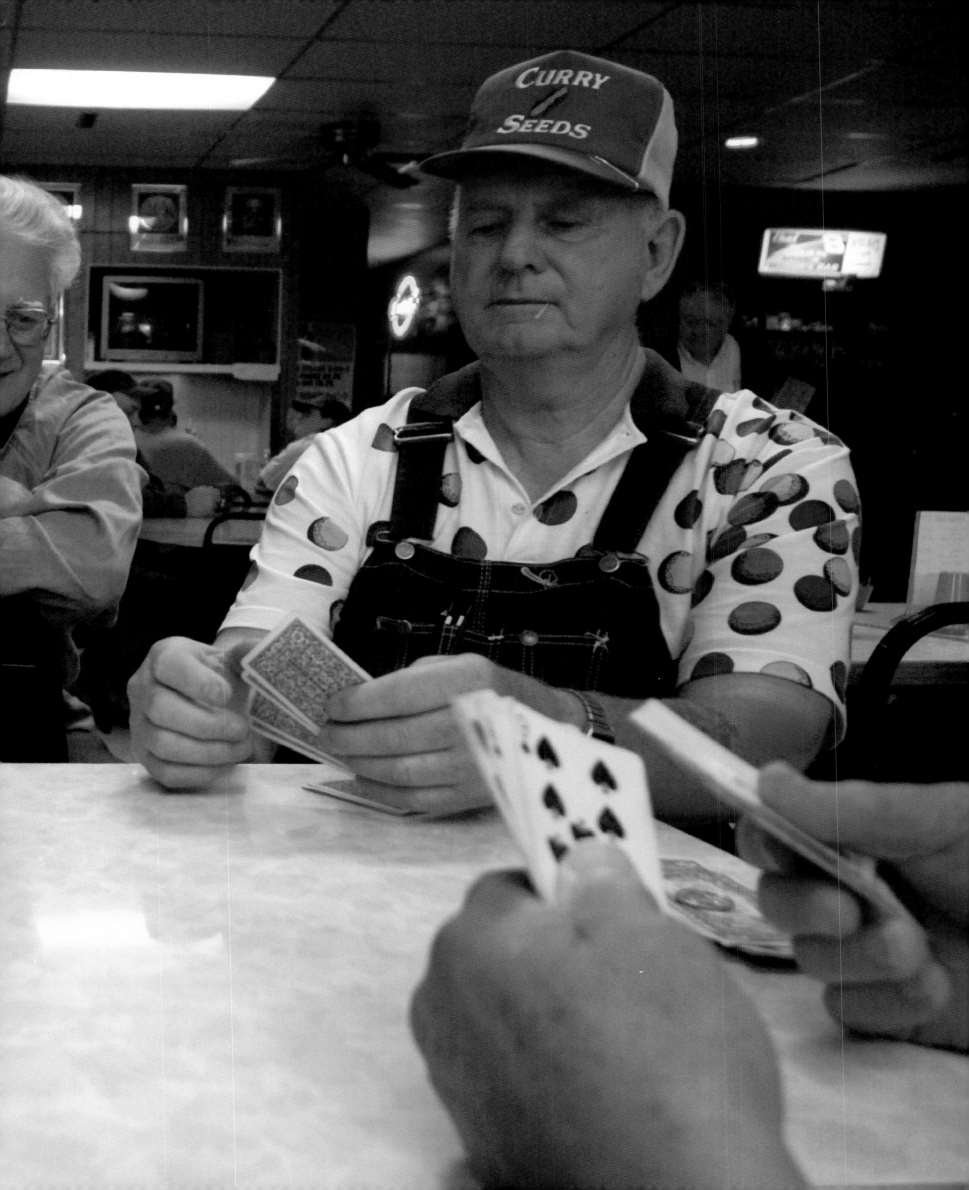

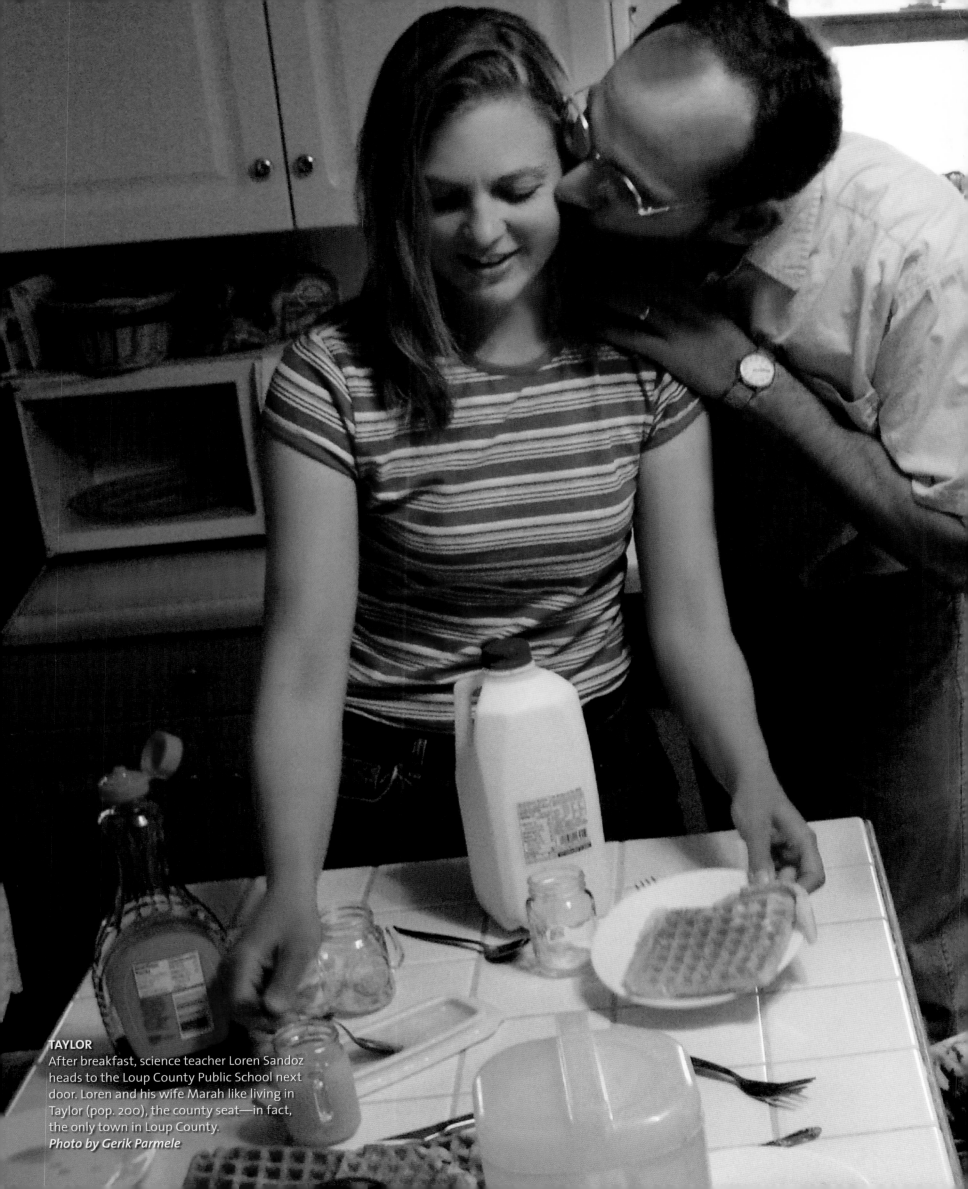

TAYLOR
After breakfast, science teacher Loren Sandoz heads to the Loup County Public School next door. Loren and his wife Marah like living in Taylor (pop. 200), the county seat—in fact, the only town in Loup County.
Photo by Gerik Parmele

Hearth & Home

LINCOLN

Irina Frolov and her son Misha snooze as husband Mikhail, a physicist on a short-term project at the University of Nebraska, leaves for work. The family dreams of buying an apartment in their native Russia. Irina does not speak English and has not adjusted to life in America. Mikhail says, "Every week she asks me, 'When are we going back?'"
Photo by George Burba

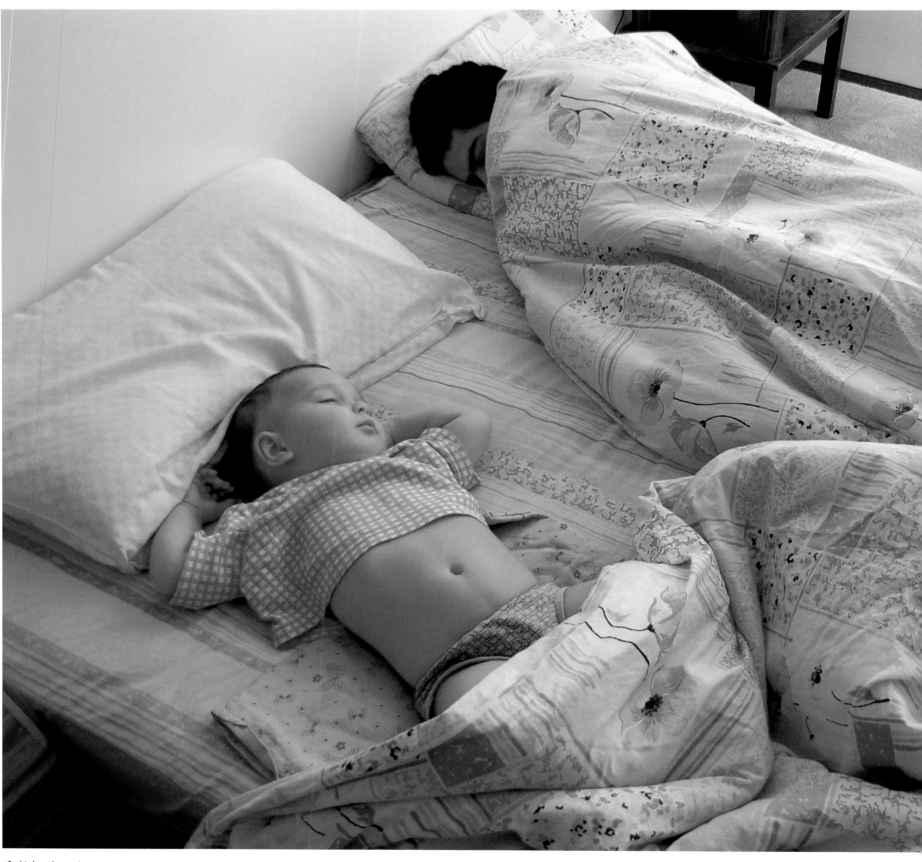

GRAND ISLAND

Elise Johnson-Schriner watches a Sesame Street video while mom, Jennifer Johnson, fixes a bottle. "She usually wakes up at 9 after a good 10 hours," Johnson, a single mom, says gratefully. Johnson works nights so she can be with Elise during her waking hours; she enlists family and friends to stand guard while her baby sleeps.

Photo by Scott Kingsley

OMAHA

Think pink: After a bath, Evan and Ellie Prendes's skin and quilt are downright color-coordinated. "Why do they always get along great right before bedtime, no fighting?" asks mom Amy. "You hate to break that up."

Photo by Khara Marae Lintel

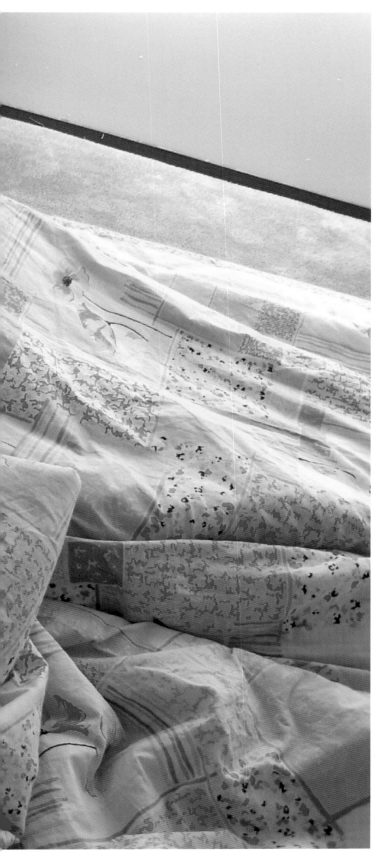

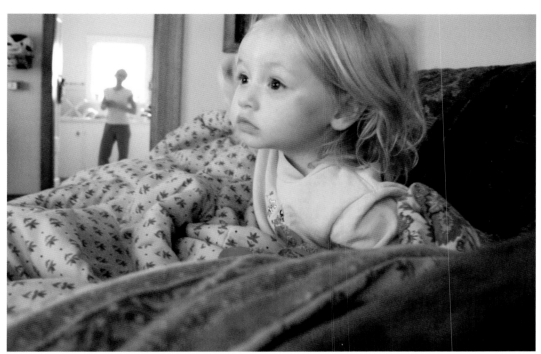

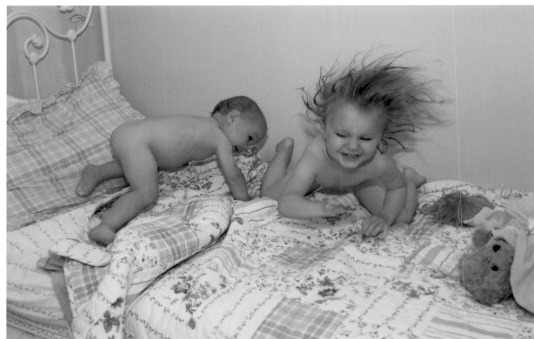

Richard and Robert Wright, 40-year-old fraternal twins, both married nurses. Their sons Aaron and Robert were born three weeks apart. On top of that, Richard's daughter Emily is three months older than Robert's boy Nelson. As Richard puts it, "It seems my brother and I think alike."
Photo by Richard Wright

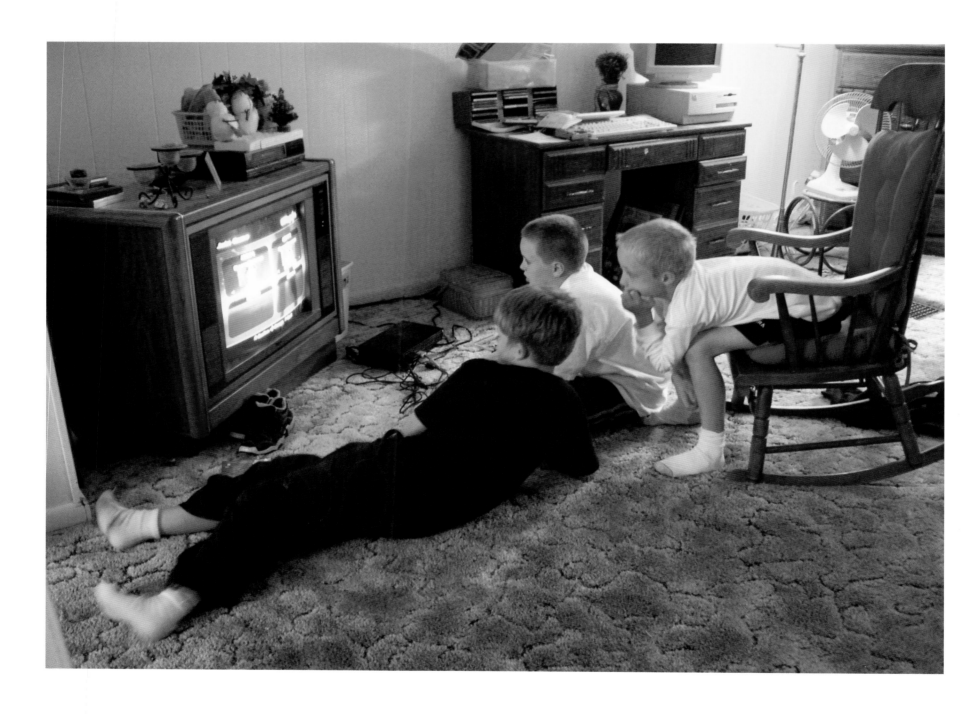

ARNOLD

Bob and Mona Crow eat breakfast every morning as the sun rises. "We're still gettin' along, after 50 years," says Bob. They have a 3,000-acre ranch on which they raise a special breed of calf—a cross between a Black Angus cow and a Charolais bull. "I'm known for the calves. They yield good in butcherin'," Crow says.

Photo by Lane Hickenbottom

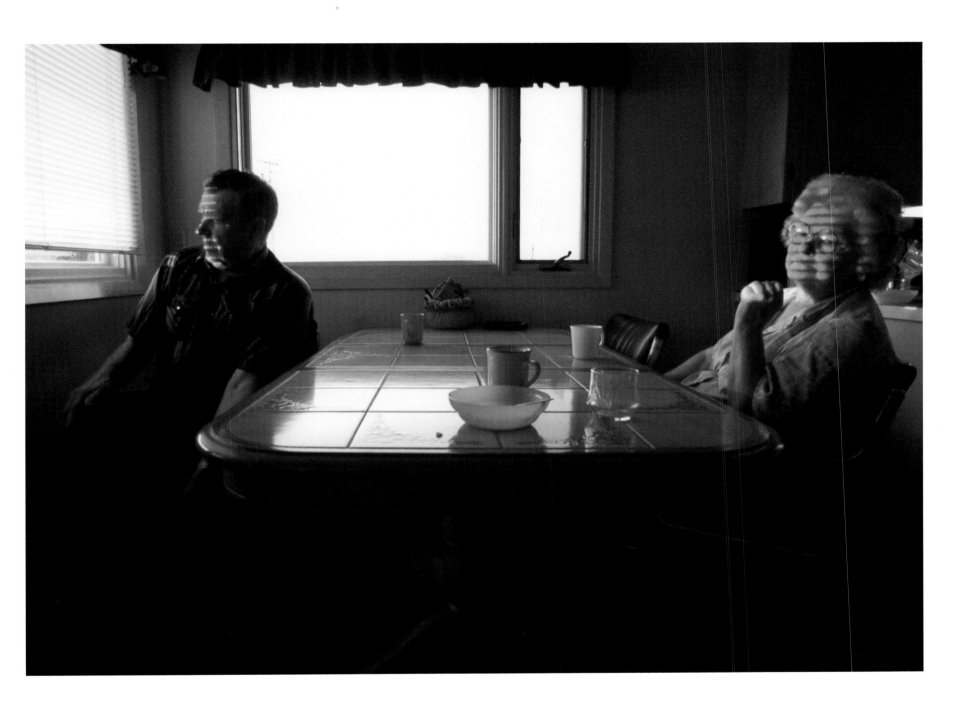

TAYLOR

The Sandoz family lives in the poorest county in the country—Loup County, with a per capita income of $6,000—so they can have a good life. They get by on Loren's teacher's salary, and Marah stays home with their five kids. She baby-sits to make ends meet. Spending time together is what they value.
Photos by Gerik Parmele

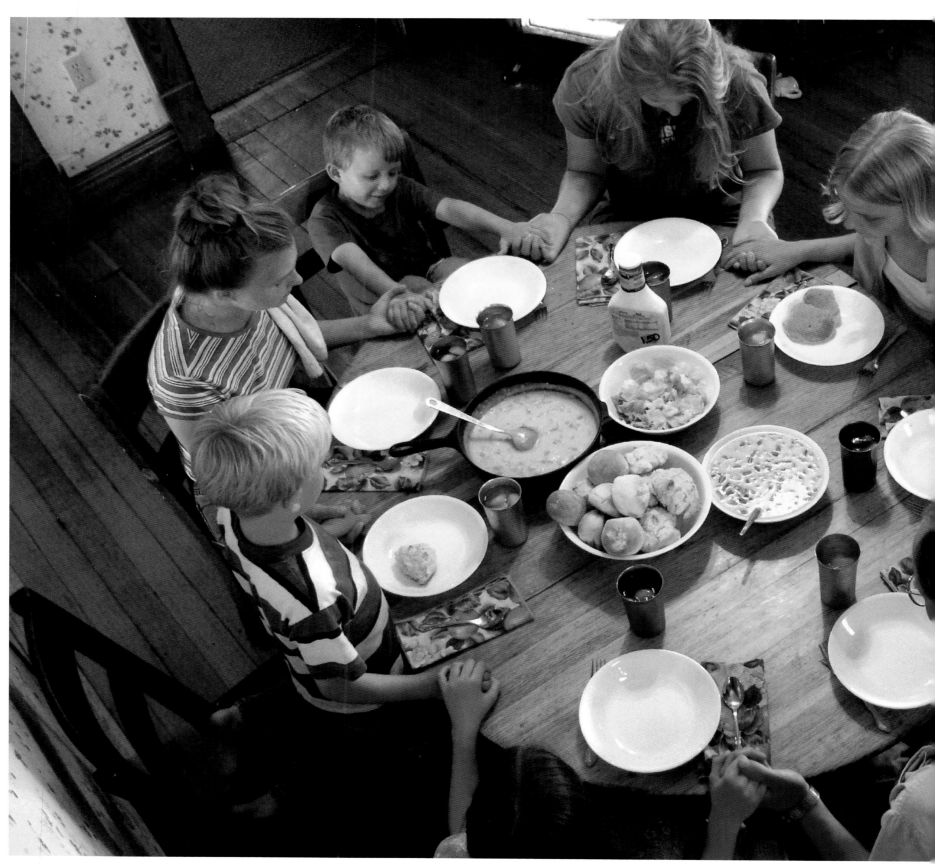

TAYLOR

Whitney Steckel doesn't bother with the door to the playhouse at the Sandoz place. Marah Sandoz takes Whitney for the three days a week that her mom works as a 911 dispatcher.

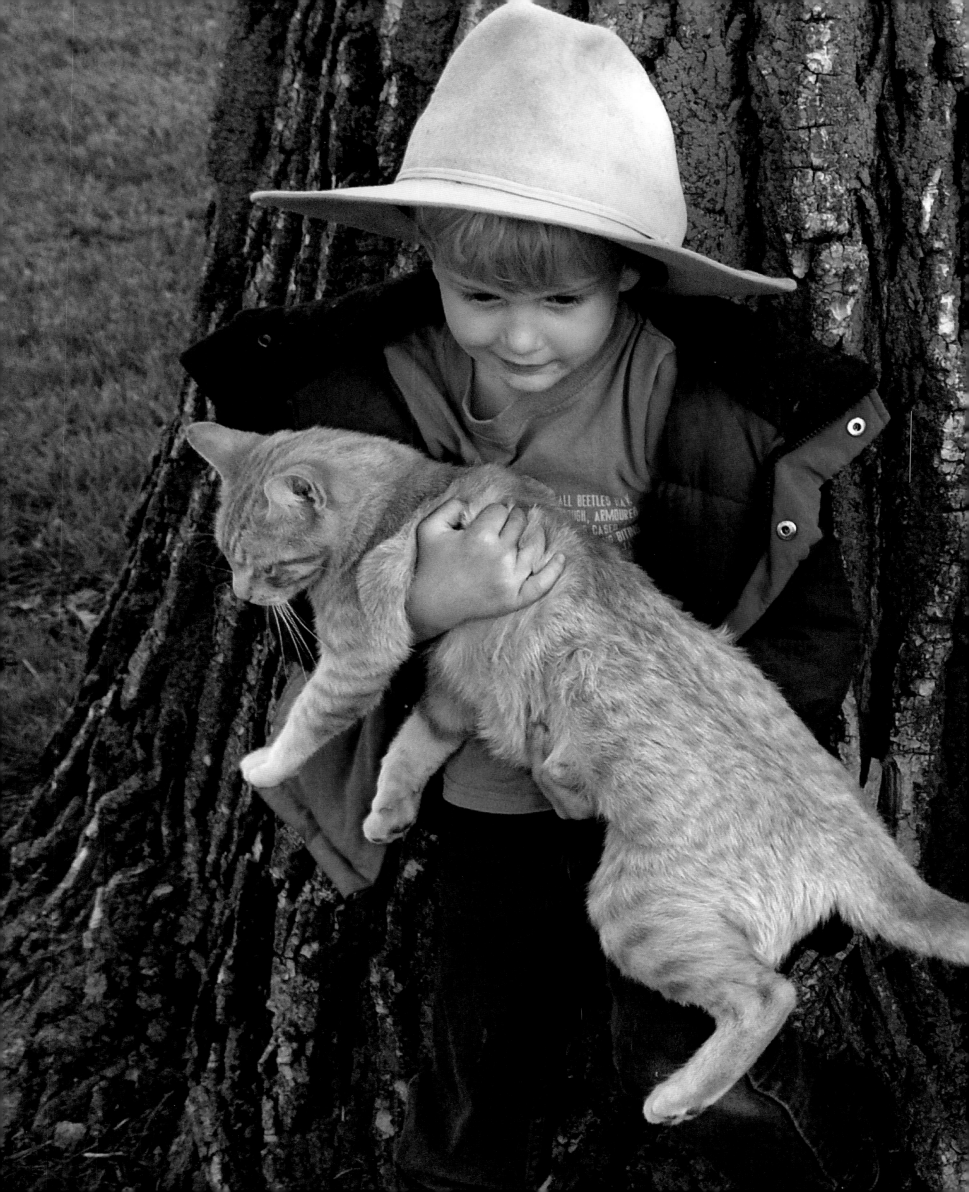

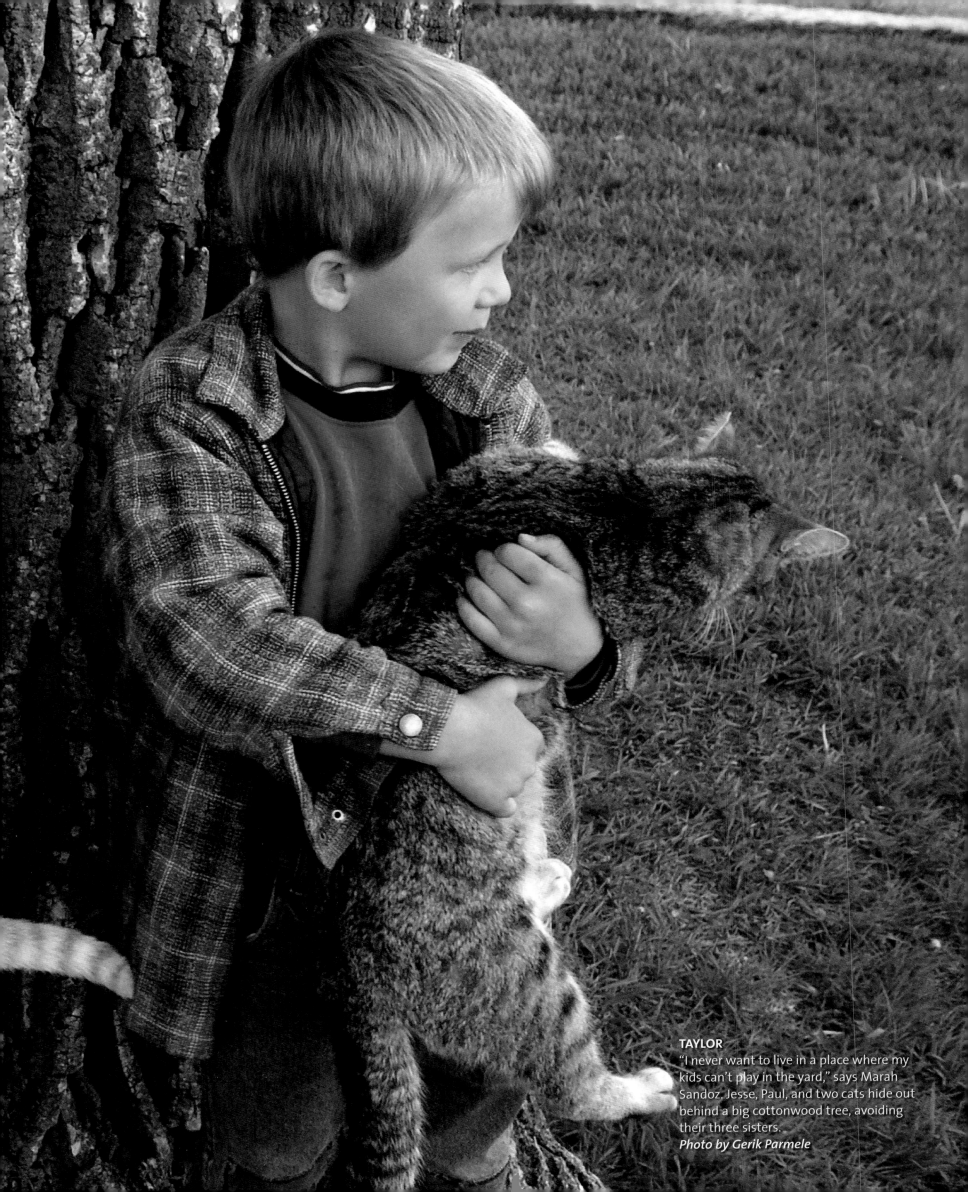

TAYLOR
"I never want to live in a place where my kids can't play in the yard," says Marah Sandoz, Jesse, Paul, and two cats hide out behind a big cottonwood tree, avoiding their three sisters.
Photo by Gerik Parmele

TAYLOR
Jesse Sandoz heads for school on his own. A day-dreamer, Jesse is interested in science like his dad. He loves tools and taking things apart. "He likes to invent things," says his mom.
Photos by Gerik Parmele

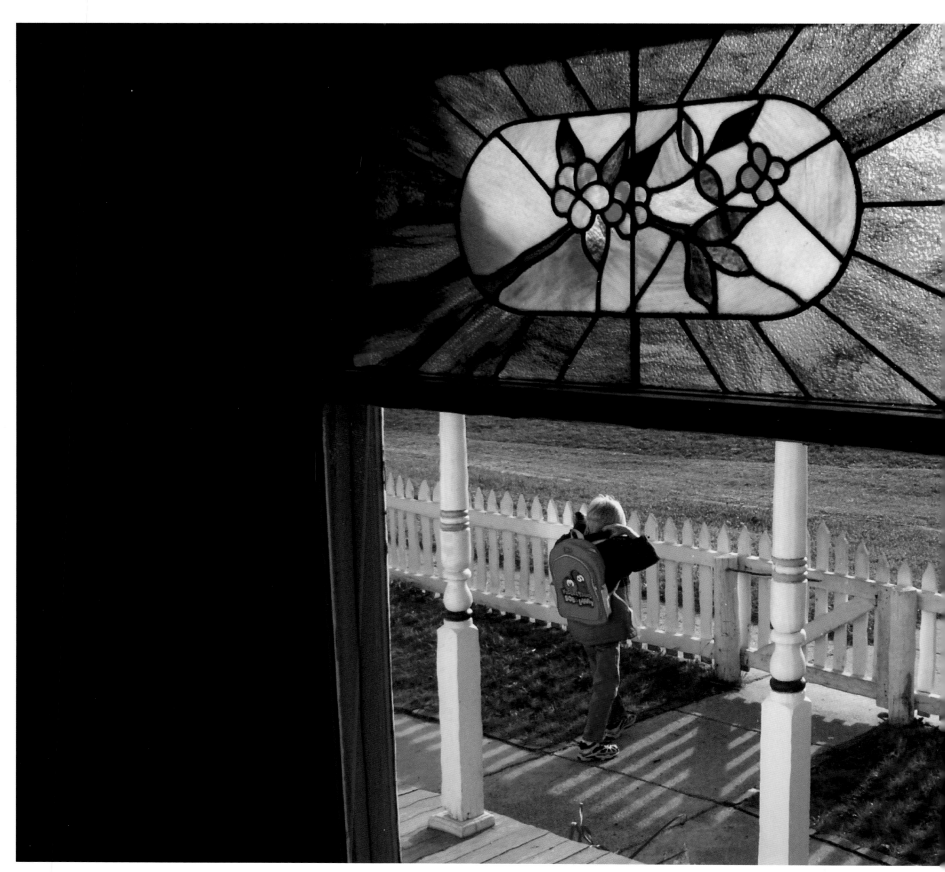

TAYLOR

Living on a farm, Whitney Steckel knows there is work to be done. She wants to be a trick rodeo rider when she grows up.

TAYLOR

Whitney's mom hears no whining when it's time for her to go to the baby-sitter. In fact, Whitney complains on the days she's not scheduled to go.

LINCOLN

In her friend's backyard, Sarah Towne primps for the Northeast High School prom well before her date is due to arrive. It's important that she gets started before evening—sunlight is best for getting her makeup just right.

Photos by Josh Wolfe

LINCOLN

A group of Northeast High School juniors and seniors capture the moment before heading to the prom. The seven couples chipped in to rent one of the largest limos in Lincoln—a 20-passenger Hummer H2.

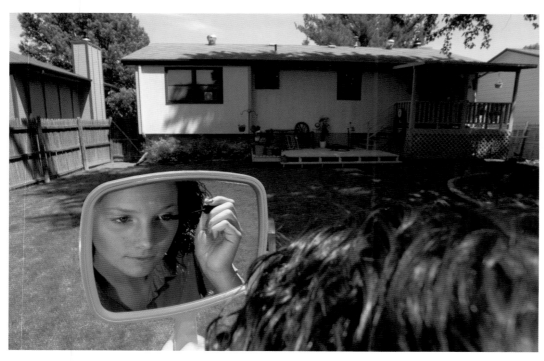

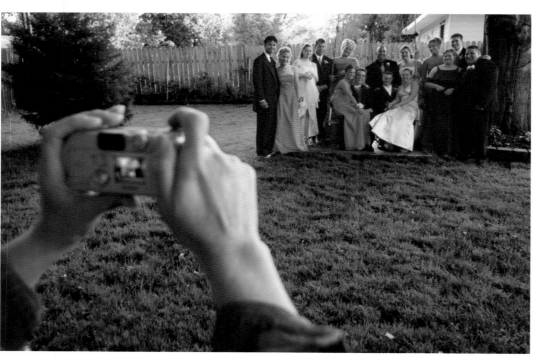

LINCOLN
Ladies in waiting: It's 10:35 p.m. and you can cut the tension with a manicured fingernail, just before the announcement of the prom's king, queen, and royal court.

LINCOLN
Dan Cummings and Sarah Towne smooch on the way to a post-prom party. The soirée goes from midnight to 4 in the morning and will include a hypnotist, music, and games. Sponsored by the high school's parents, the party co-opts less savory events.
Photos by Josh Wolfe

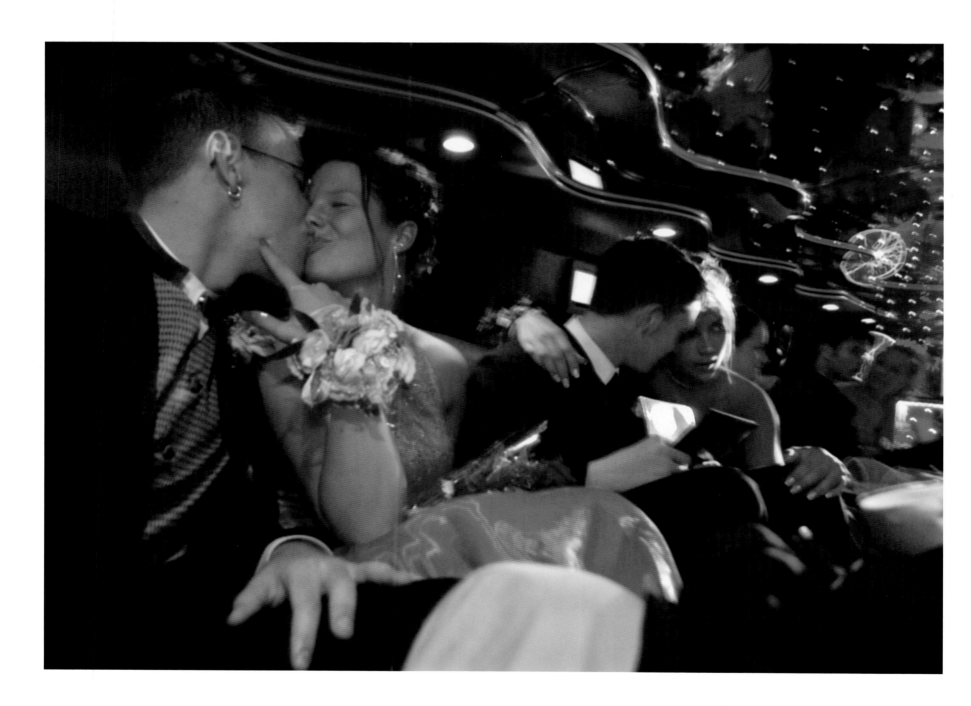

LINCOLN

Turn that music down! Northeast High School student Kali Wathen asks the limo driver for a little quiet. She's taking a very important call. Jody Frazer and Thomas Miller, who are in the middle of watching *The Matrix* on the vehicle's DVD player, are no help.

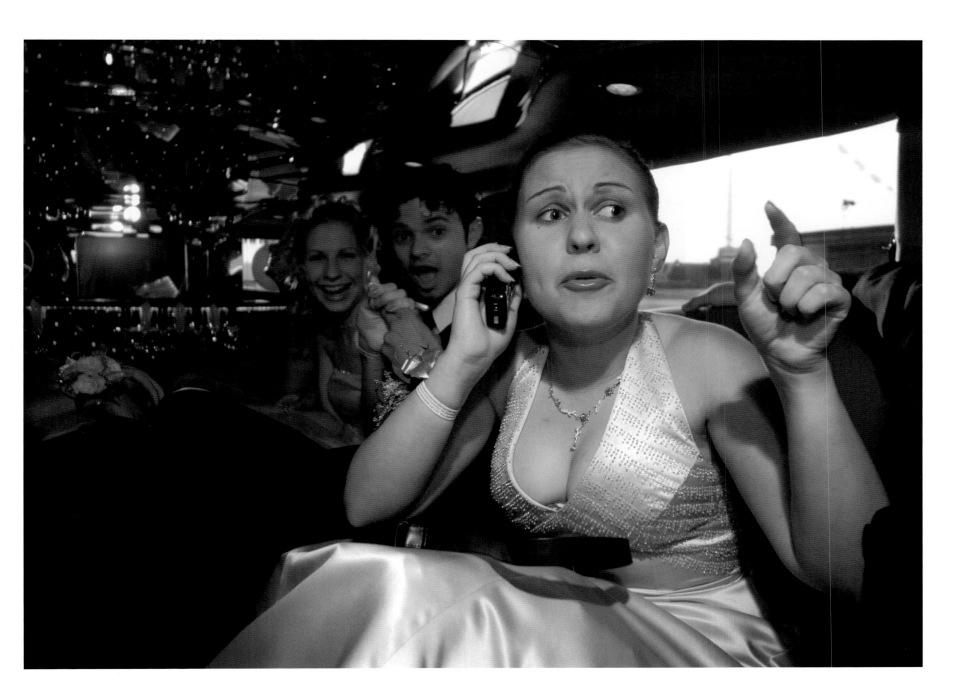

MONOWI

Elsie Eiler waves good-bye to son Jack, who's headed back home to Ponca. The empty grain elevator is a reminder of better times. Monowi, which means prairie flower, was founded in 1902, along the Chicago & Northwestern Railroad track in northern Nebraska. Population peaked at 123 in 1930. Elsie and husband Rudy are now the only residents left.
Photos by Laura Inns

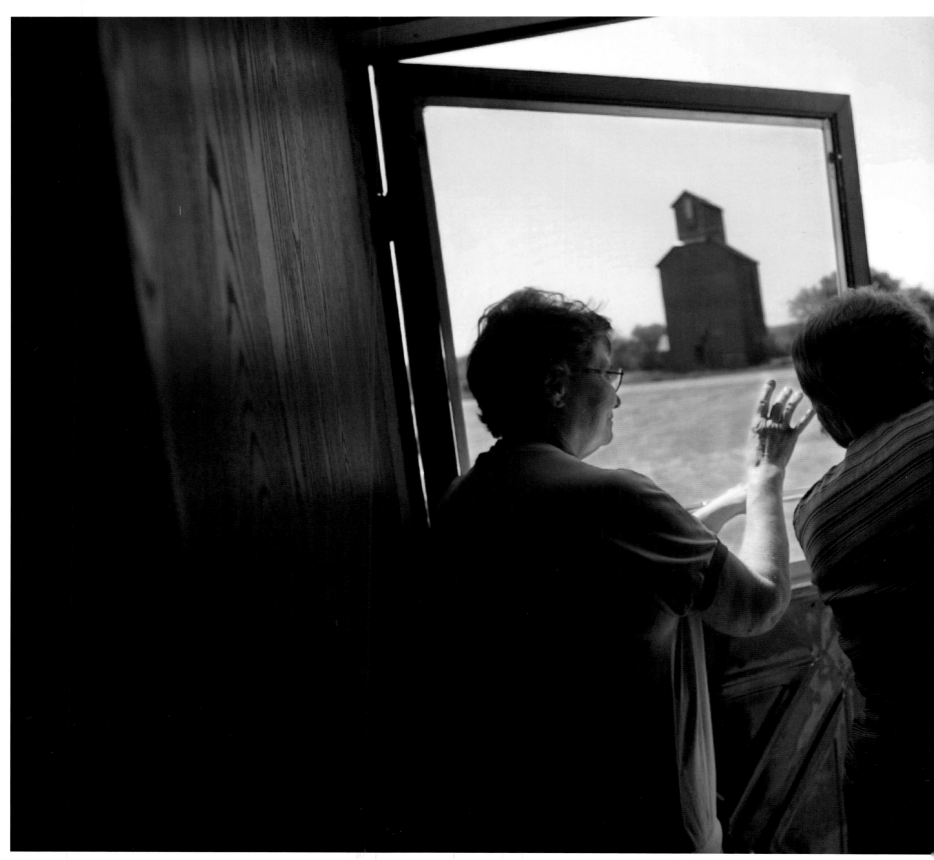

MONOWI

In Nebraska's smallest incorporated town, Rudy is the unofficial mayor and wife Elsie is clerk-treasurer. "I get to handle state money and he signs the checks," she says. They also run the town's only business, Monowi Tavern, which they bought in 1971 when the town boasted 22 residents.

MONOWI

The tavern is a gathering place for local farmers. Rudy handles the bar while Elsie waitresses and grills her famous steaks. The 1912 prairie fires, combined with the end of railroad service, began Monowi's slow decline. "It's a matter of economics," says Elsie, a former school teacher. "There isn't anything to keep young people here."

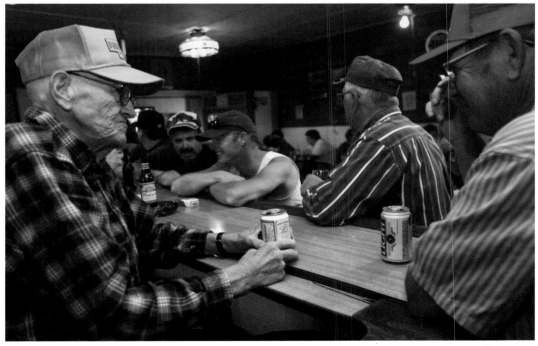

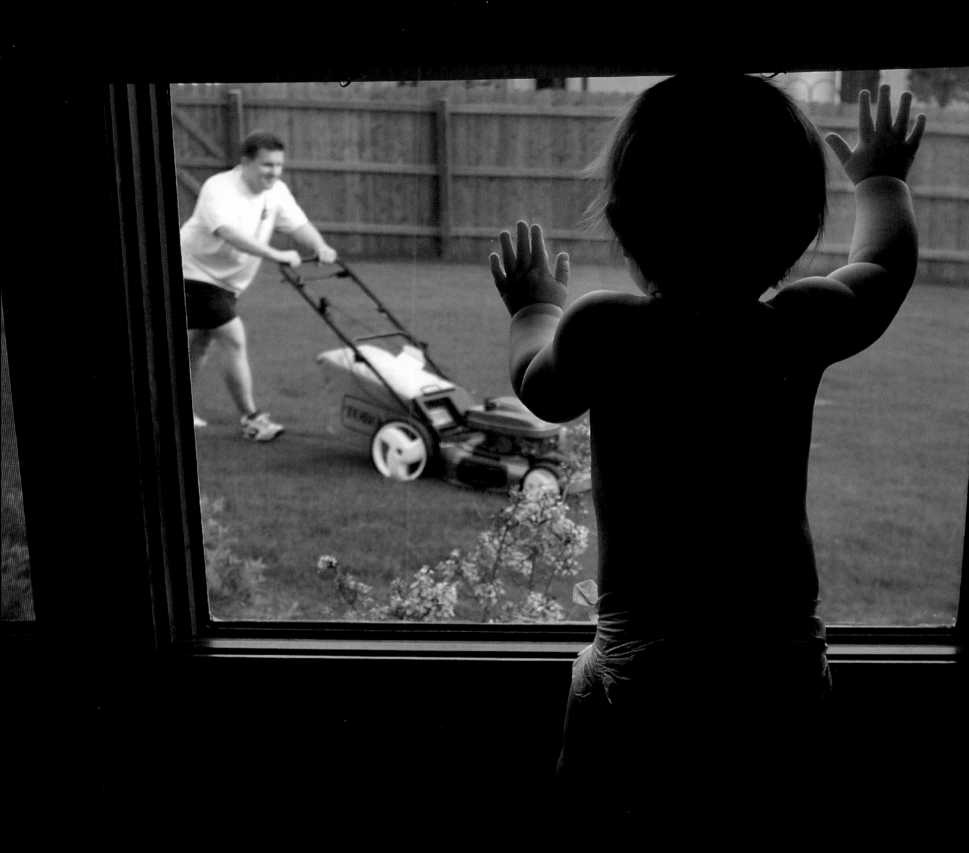

PAPILLION

Growing up in Sarpy County, the fastest-growing in Nebraska, Jena Cruse won't have to go far for college or to find work. The bedroom community of Papillion is a 20-minute drive from downtown Omaha.
Photo by Kiley Cruse

LINCOLN

An intense 20-minute downpour makes a spring day shiny—in the midst of Nebraska's costly three-year drought. While the farmers want the rain, they don't want too much in May, when they're planting crops.
Photo by Richard Wright

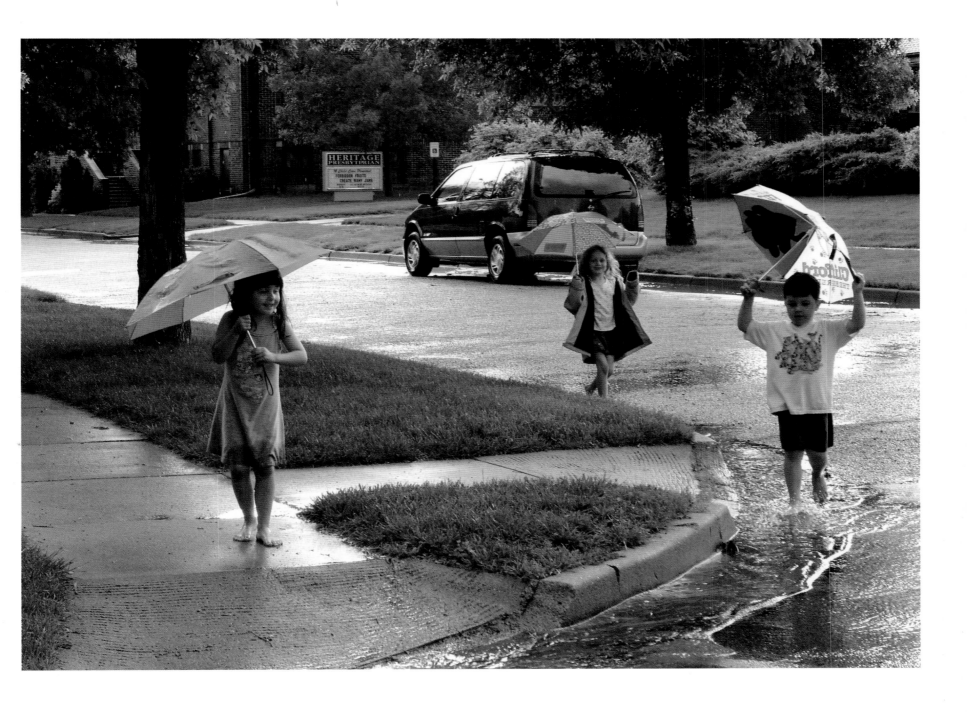

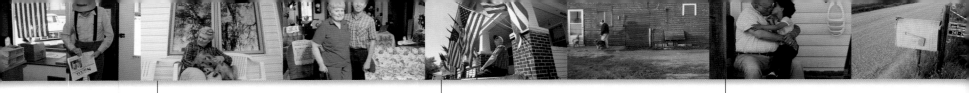

ST. LIBORY

Rosemarie Grabowski takes a breather after a day of working on the 181-acre farm in Howard County she owns with her husband Larry. "Not all couples can work together—it takes a sense of humor," she says.
Photo by Scott Kingsley

GENEVA

"I'm a flag waver and I don't care who knows it," says Al Wise, a retired Nebraska State Trooper and former Geneva Chief of Police. Since 9/11, his 13 flags have been displayed day and night—and replaced three times due to wear and tear.
Photo by George Tuck,
University of Nebraska-Lincoln

OMAHA

Joe Scarpino is the lucky recipient of a kiss from granddaughter Madison Dennis. Madison and her mom live with Scarpino, a retired truck driver, near Columbus Park.
Photo by Kent Sievers

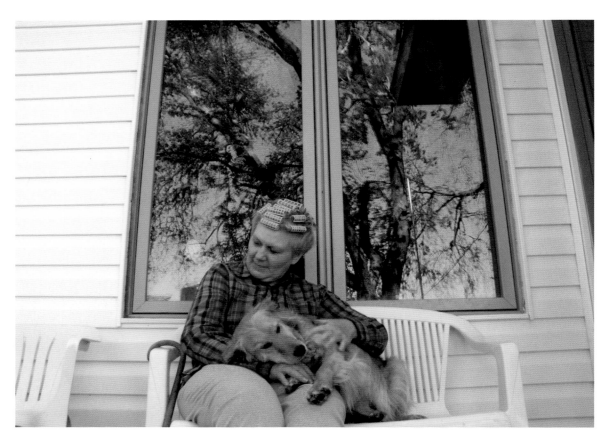

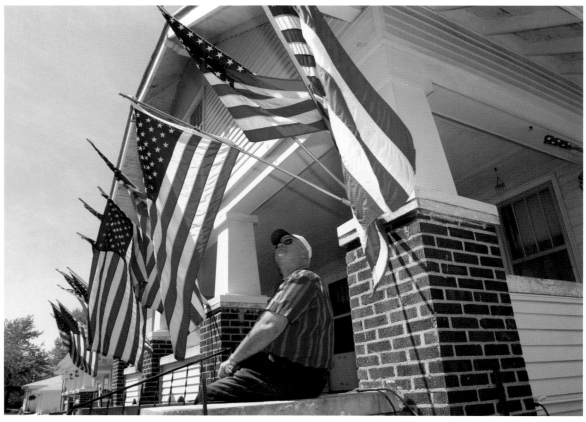

BELLEVUE

Caught in the act: Naomy Elton's red tongue is a dead giveaway that she's been eating candy. Her mom Lupe, a native of Mexico, runs her own business, La Michoacana, selling *paletas* (Mexican frozen juice bars) at her storefront factory and from a fleet of handcarts.

Photo by Laura Inns

ALLIANCE

Ande Girard's great-grandfather opened the first hardware store in Alliance in 1886 and then put up the town's first water tower. Now Girard caters to the region's basic needs by building and maintaining water-pumping windmills. Though he has five children (Bernie, 5, is the youngest), Girard doesn't think any of them will take over the business. "This is hard, physical work," he explains.

Photo by Matt Miller

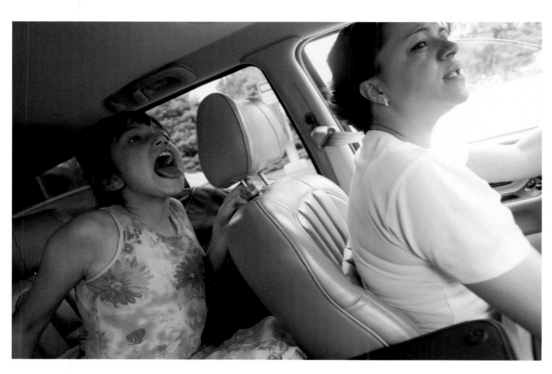

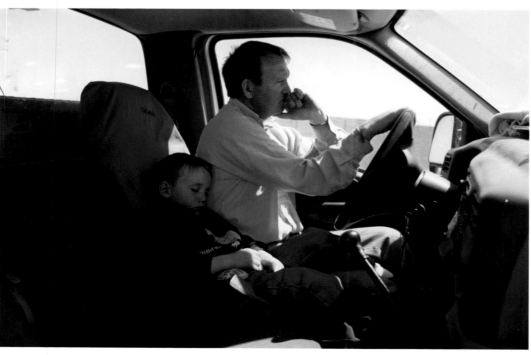

TAYLOR

Kelly Dockweiler and her husband mow lawns during the summer to pick up a little extra cash. Son Clancy rides along at the Calvary United Methodist Church, where the family are members. "We don't charge here. It's our offering," says Kelly.

Photo by Gerik Parmele

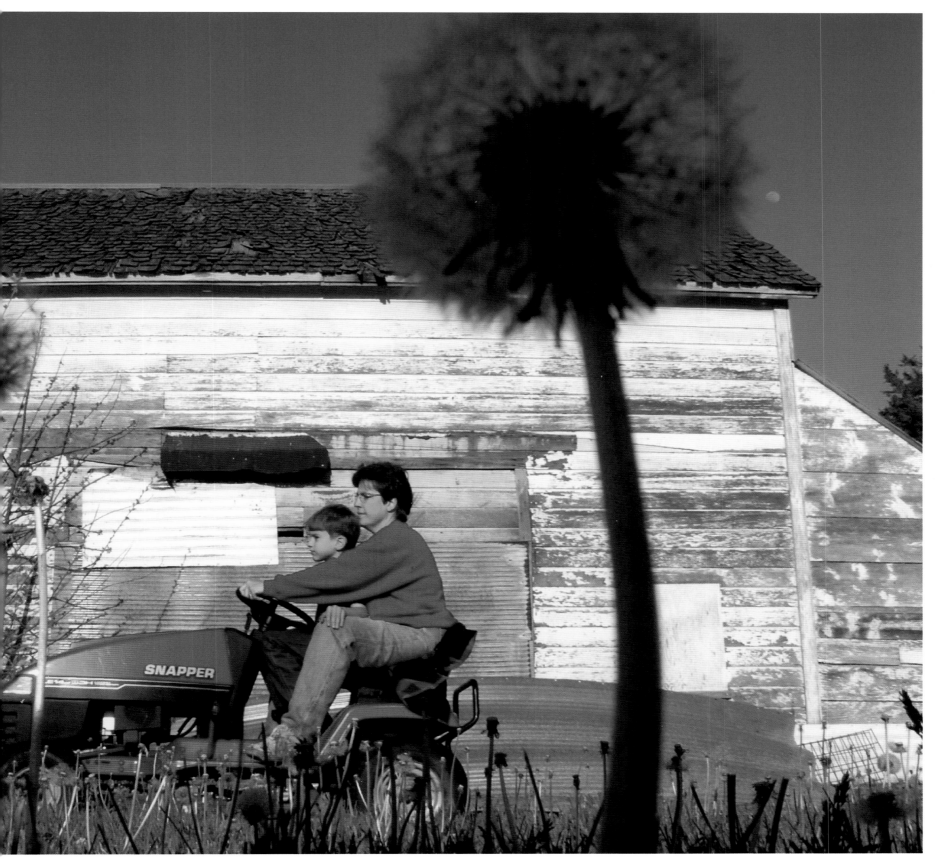

The year 2003 marked a turning point in the history of photography: It was the first year that digital cameras outsold film cameras. To celebrate this unprecedented sea change, the *America 24/7* project invited amateur photographers—along with students and professionals—to shoot and, via the Internet, submit digital images. Think of it as audience participation. Their visions of community are interspersed with the professional frames throughout this book. On the following four pages, however, we present a gallery produced exclusively by amateur photographers.

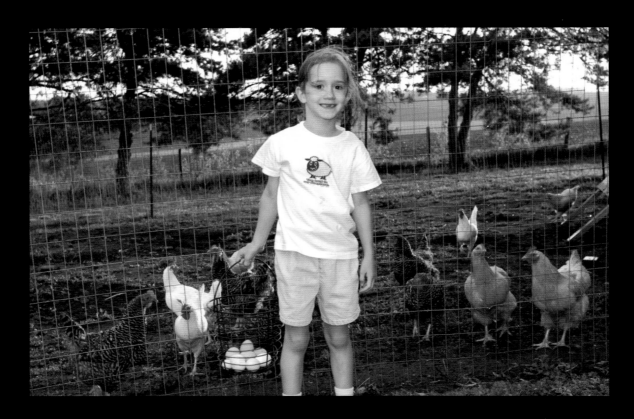

SARPY COUNTY On her family's farm, Laura Hicks collects fresh eggs from Barred Rock, Leghorn, and Buff Orpington hens. There are approximately 54,000 family farms in Nebraska. *Photo by Charlie Hicks*

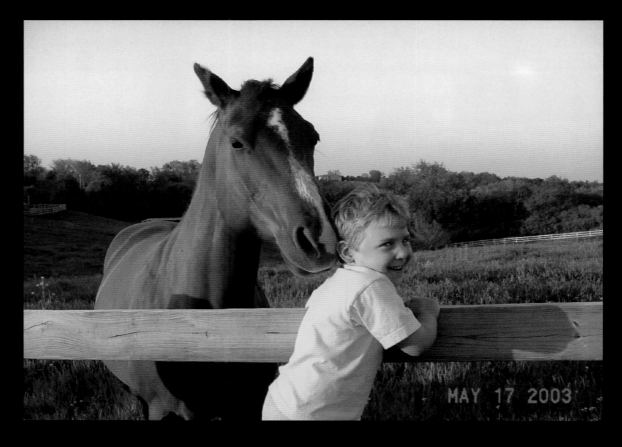

FT. CALHOUN Nacho, a Western pleasure horse, nuzzles up to Dalton Van Stratten. Ambling around Nacho's 6-acre pasture together is what they like best. *Photo by Lisa Van Stratten*

HAMPTON Emma Long's visits to her Uncle Barry's farm are a far cry from life in Colorado Springs. He grows soybeans and corn and raises horses and cows. ***Photo by Matt Long***

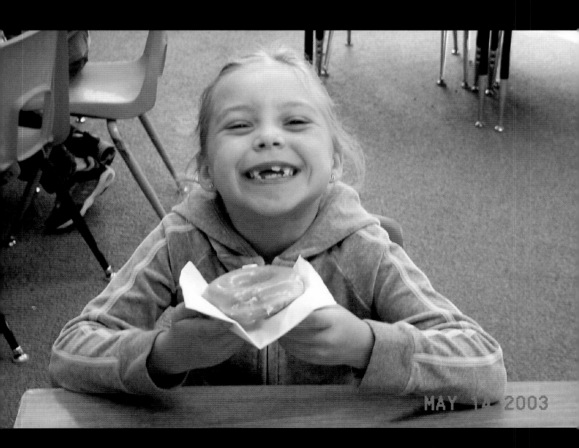

MAY 14 2003

BLAIR At South School, Dallas Van Stratten chooses to celebrate her eighth birthday with Krispy Kreme dough-

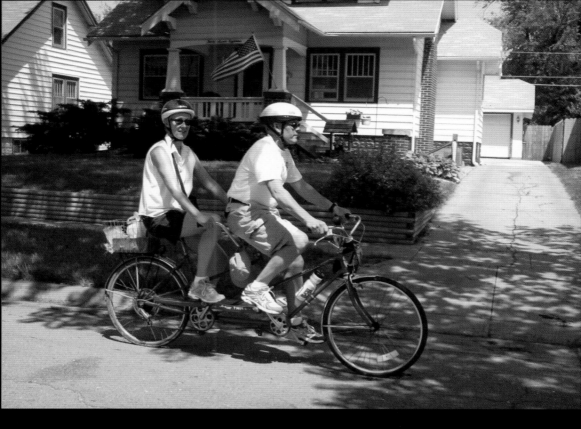

LINCOLN Coming home from the Haymarket's Farmers Market, tandem cyclists Frances Beaurivage (left) and Gail Getscher peddle through their Antelope Park neighborhood. *Photo by Tawnya Douglas*

OMAHA For more than 40 years, men have played paddleball in Kountze Park. In good weather, they'll keep at it all afternoon. *Photo by Allen Hudson*

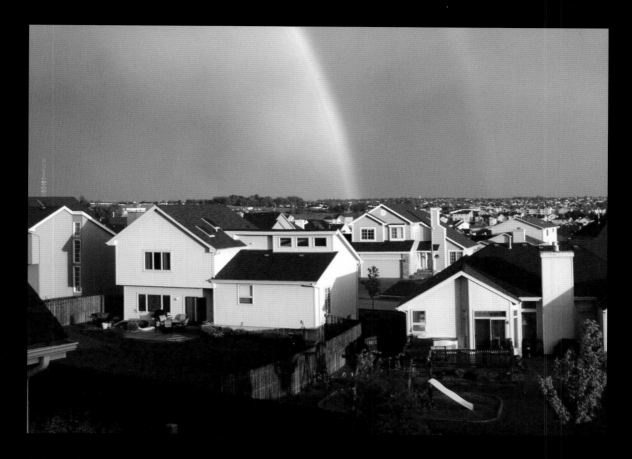

OMAHA During a break from spring thunderstorms, a double rainbow materializes in a rain shower over southwest Omaha. *Photo by Randy Zuke*

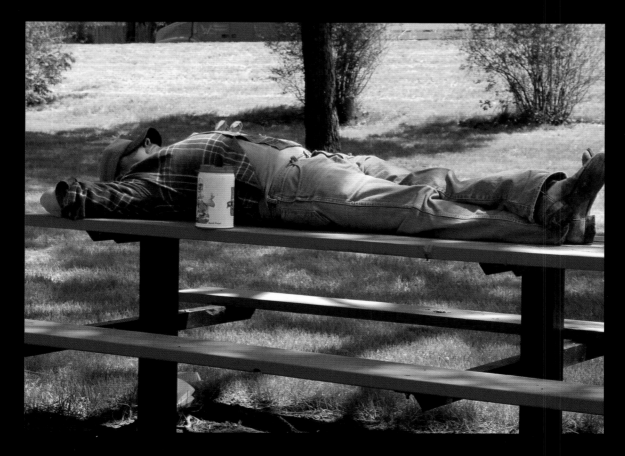

LINCOLN Construction engineering inspector Richard D. McBride takes a lunchtime siesta in Van Dorn Park.
Photo by Tawnya Douglas

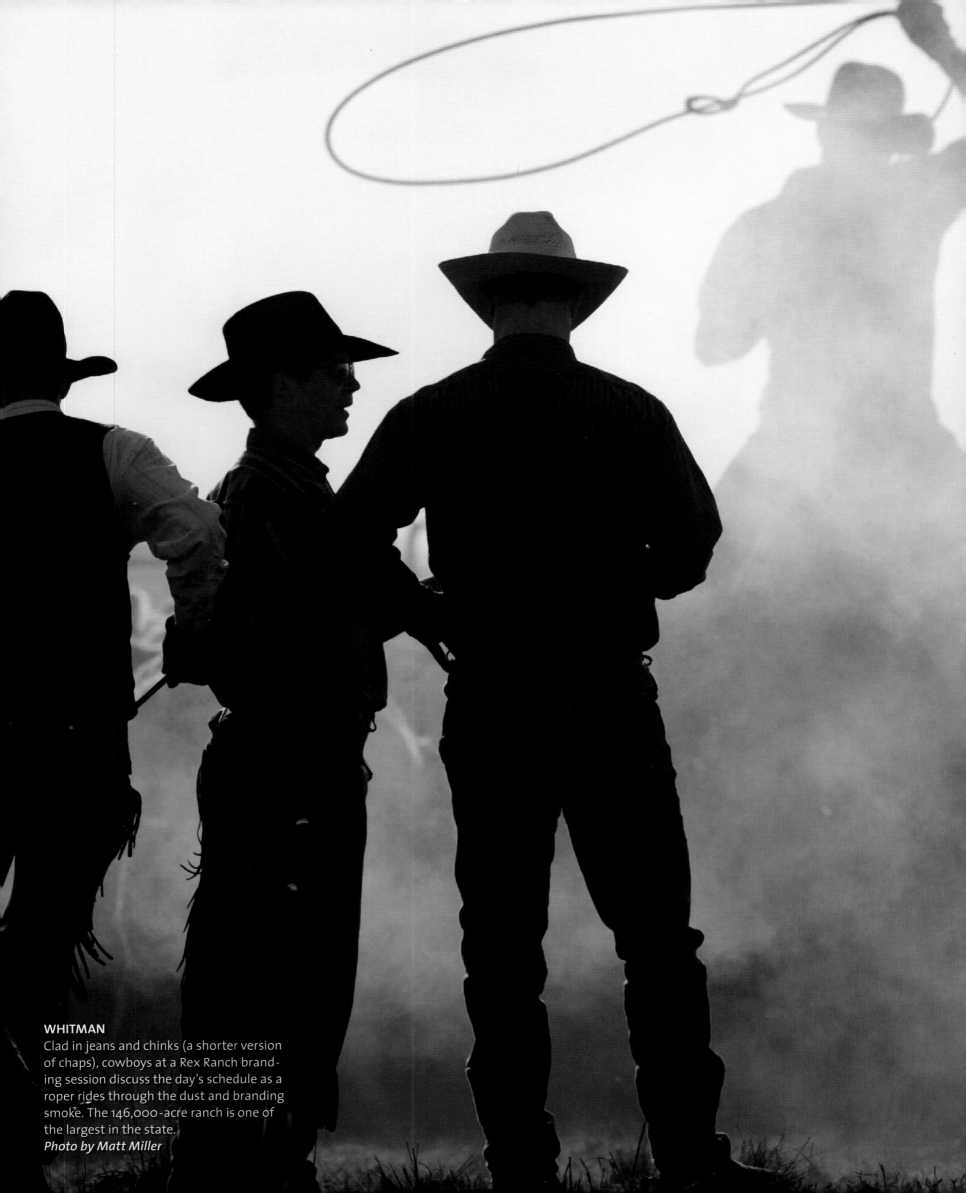

WHITMAN
Clad in jeans and chinks (a shorter version of chaps), cowboys at a Rex Ranch branding session discuss the day's schedule as a roper rides through the dust and branding smoke. The 146,000-acre ranch is one of the largest in the state.
Photo by Matt Miller

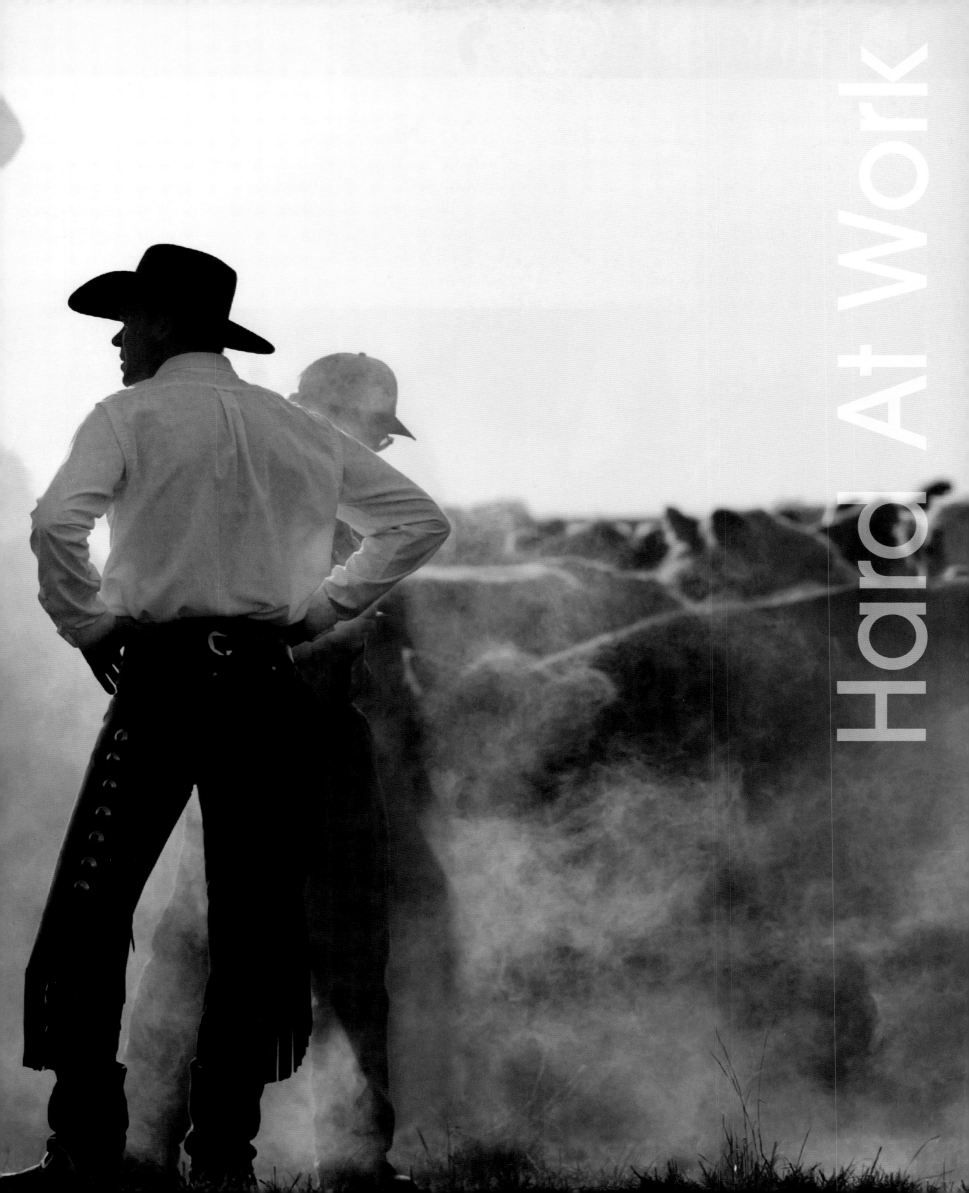

Hard At Work

GORDON

Brander's butt: Two cowboys wrestle down each calf after the roper snags it during branding at the Ostrander Ranch roundup. The one who grabs the hind leg ends up on the ground every time. "Their bottoms get dirtier than the rear end of a calf," says Jecca Ostrander.

Photo by Don Doll, S.J., Creighton University

GORDON

Rachel Twogood and her niece Hannah Carlson lose their grip on a large calf at the Jones Ranch, down the road from the Ostranders'.
Photo by Don Doll, S.J., Creighton University

WHITMAN

Intern David Ellis holds a cow for branding. A finance and animal sciences major at Utah State University, Ellis hopes to land a job in agricultural management. At Rex Ranch, he learned the Bud Williams approach to handling livestock. "You move the cows more slowly and don't yell at them," he explains. "They end up less stressed and healthier."
Photo by Matt Miller

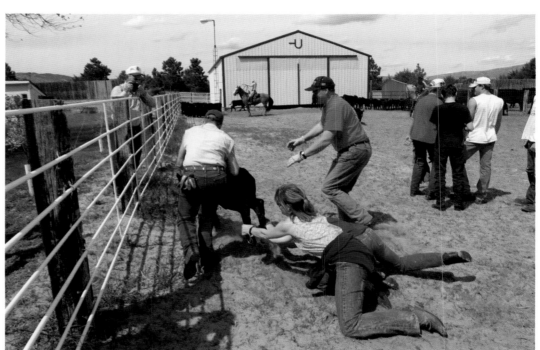

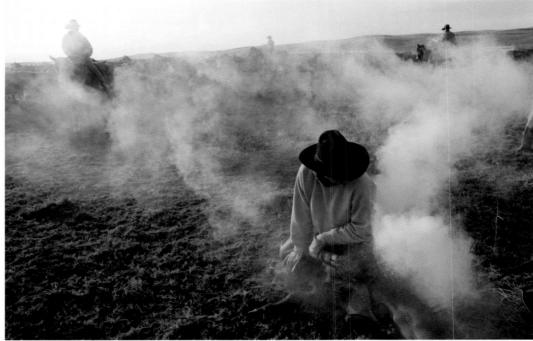

WHITMAN

Branding starts before dawn and ends with a big midday meal. This group of 45 Rush Creek Ranch employees and friends took care of 700 head of cattle in a morning. The ranch is one of several in Grant County. As the Highway 2 sign states at the county line, "You are now entering the best cow country in the world."
Photo by Matt Miller

GORDON

Crash pad: After a night's partying to celebrate one of the Ostrander boys' high school graduation and a full morning's roundup at the ranch, these cowboys will have to tackle a new herd later in the afternoon.
Photo by Don Doll, S.J., Creighton University

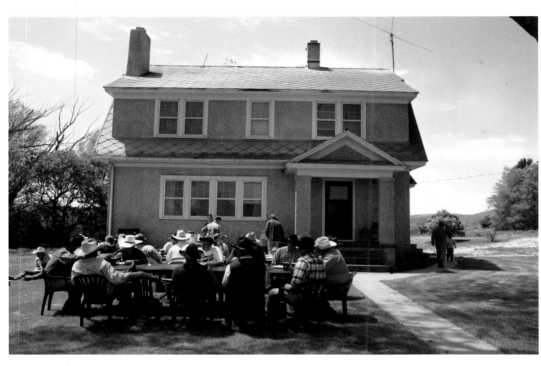

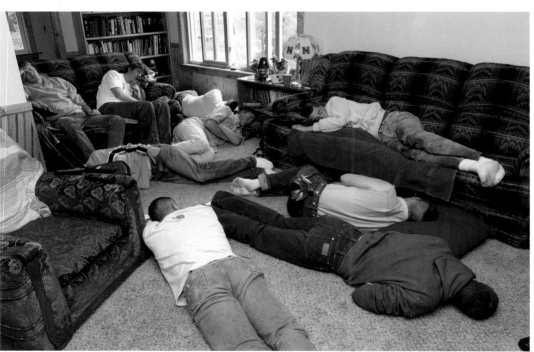

GORDON

Jecca Ostrander figures she and her husband Cash fixed lunch for about 75 friends and neighbors who showed up to help with that morning's branding. She mashed 30 pounds of potatoes to serve with prime rib, gravy, vegetables, salad, and pie. After lunch, everyone moved to another ranch for another roundup and another meal.
Photo by Don Doll, S.J., Creighton University

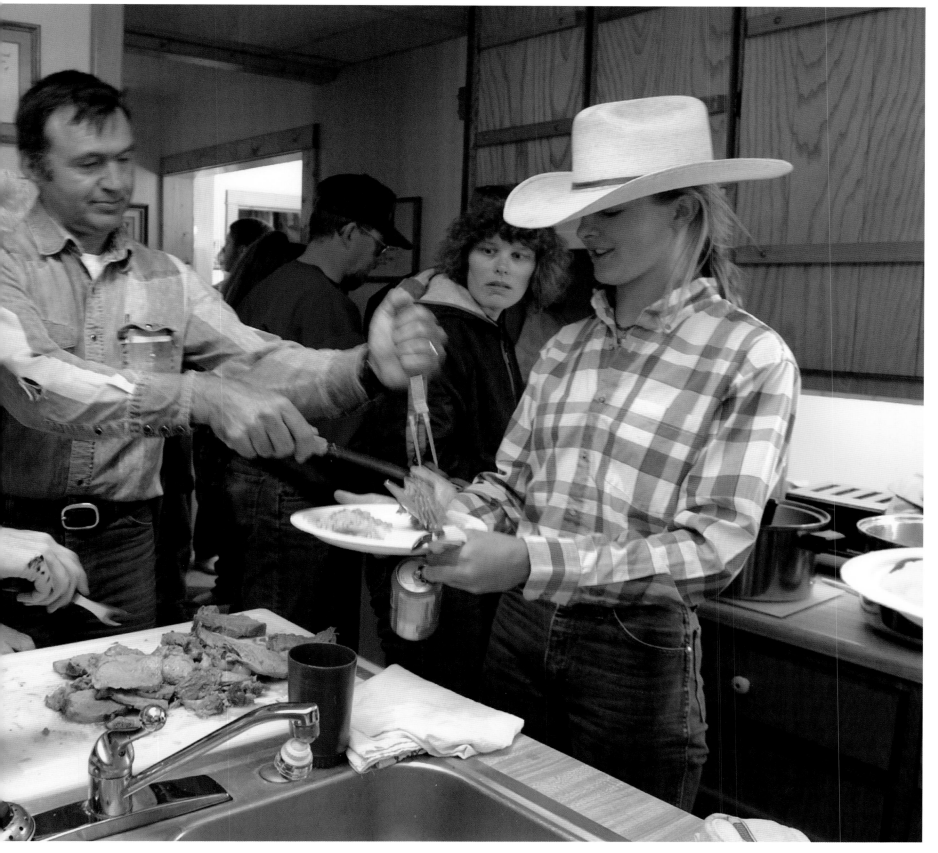

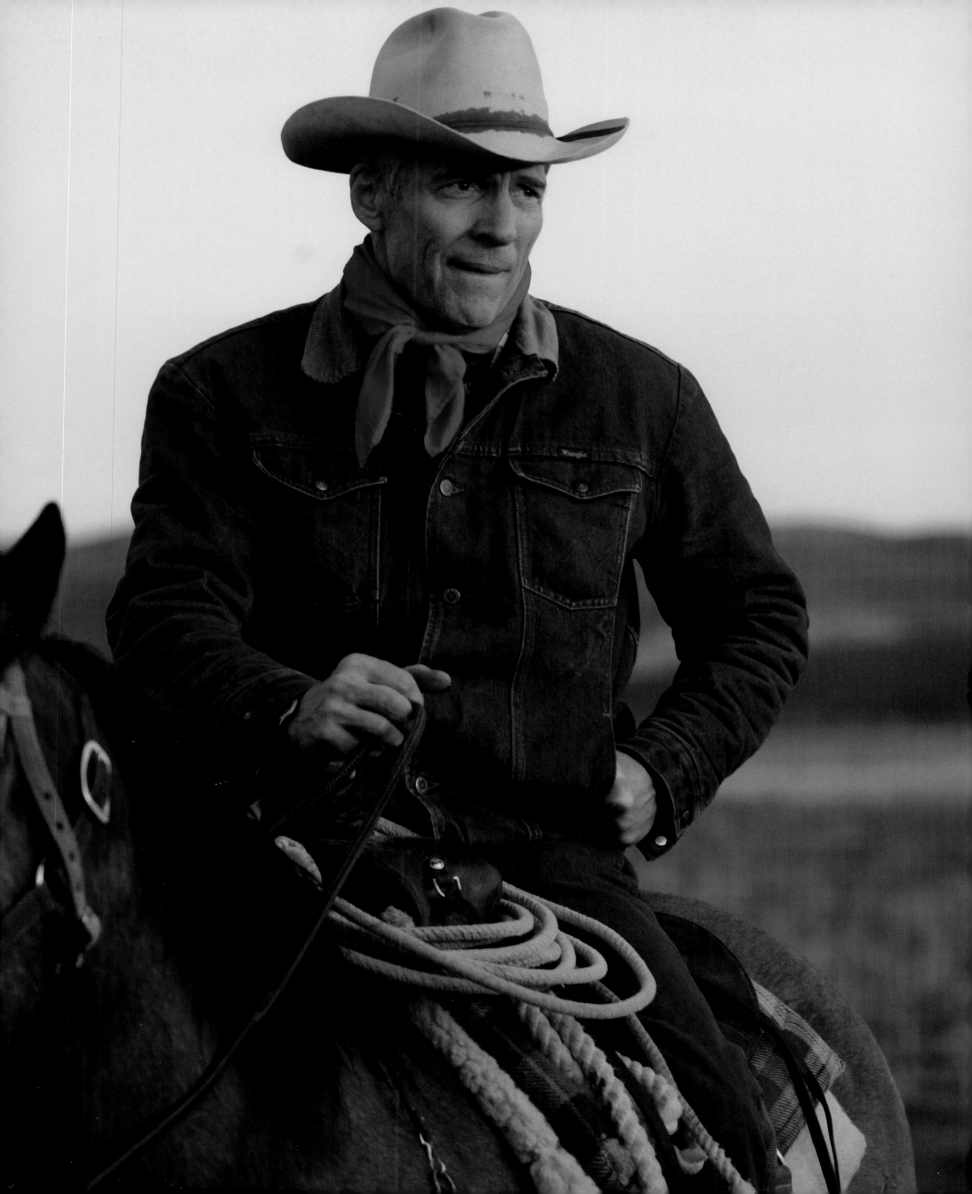

WHITMAN

Colorado resident Doug Butler—in town to help with Rex Ranch's branding—is a renowned farrier (horseshoe maker and fitter). With a PhD from Cornell in veterinary sciences, Butler teaches workshops and college classes. His *Principles of Horseshoeing* is one of the most widely used farrier textbooks in the country.
Photo by Matt Miller

SPARKS

Joe Fleming, 64, takes a smoke break during branding on his 800-acre ranch. Fleming runs 200 head of cattle from horseback. He says, "I been cowboying all my life, and any cattle work...I still saddle a cow horse and use a rope."
Photo by George Burba

WHITMAN

William Denninghoff started interning at Rex Ranch while studying at Ricks College in Rexburg, Idaho. Now a full-time employee at the ranch, the 26-year-old brings his own style to the job—he shapes the crown and brim of his Chris Eddy hat to look like the hats of his native Kentucky.
Photo by Matt Miller

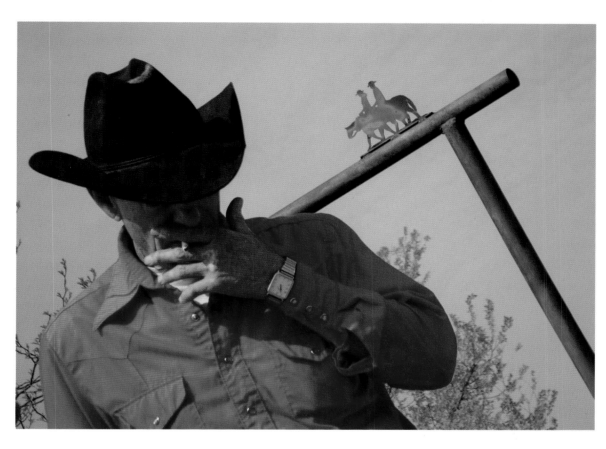

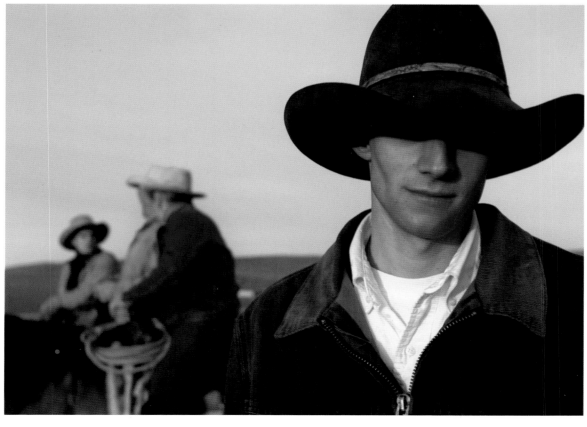

LINCOLN

Jill Wilken, manager at Bruegger's Bagel Bakery, scoops bagels from a kettle of boiling water after they cook, 50 at a time, for 90 seconds. Next stop is 13 minutes in the oven. "This procedure makes them soft on the inside, with a nice crust on the outside," says Wilken. The bakery produces 720 bagels a day.

Photo by George Burba

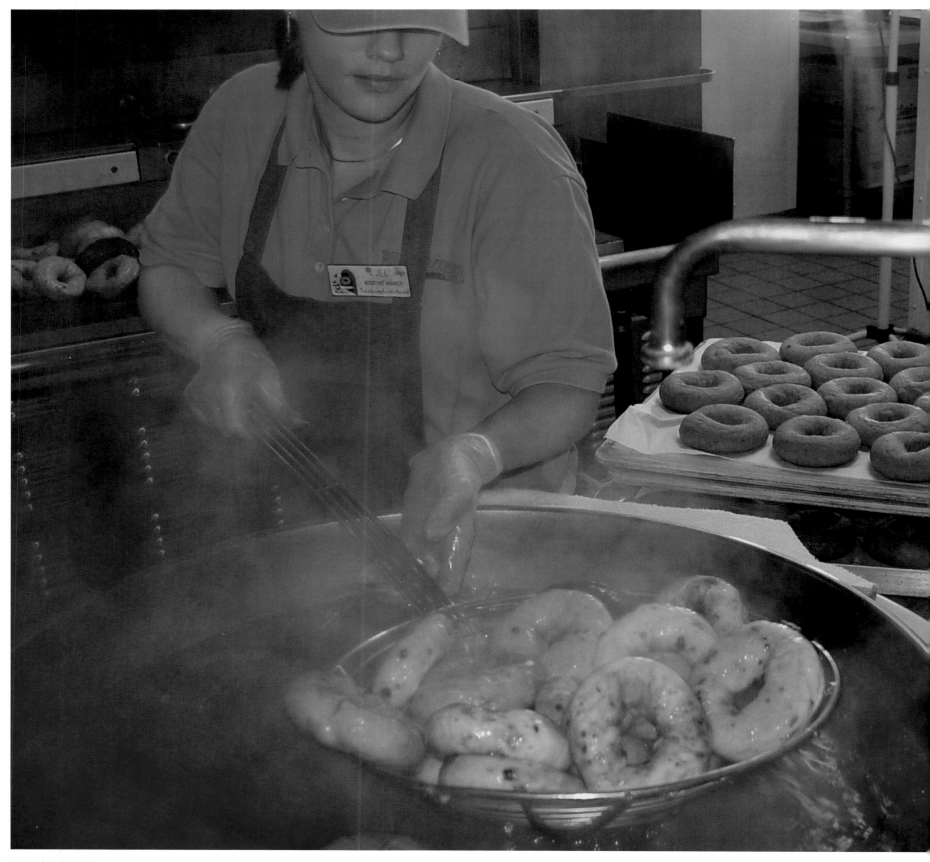

OMAHA

Heidi Schlicht loves dough. One of six bakers at Délice European Bakery and Café in the Old Market district of Omaha, she starts her shifts at midnight. As night wears on, she churns out breads, quiches, cookies, pastries, and cakes. "I get the satisfaction of working with my hands and producing something people appreciate," she says.

Photo by Kent Sievers

LINCOLN

Manager Joe Niedbalski prepares Runza Restaurant's famous *runzas*. A favorite savory dish of Eastern Europe, these beef and cabbage pies have been Americanized—with more beef.

Photo by Mikael Karlsson, arrestingimages.com

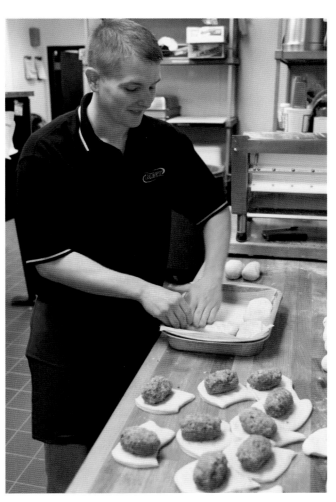

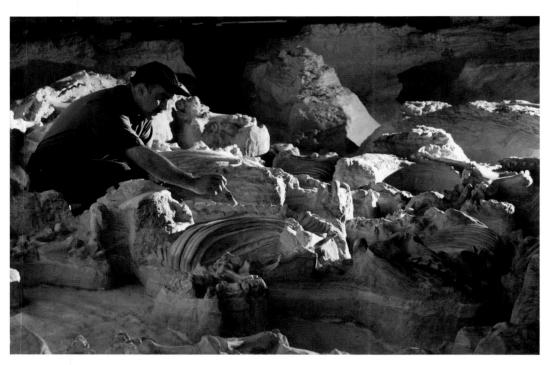

ANTELOPE COUNTY
A volcanic eruption 12 million years ago buried hundreds of animals—rhinos, camels, and deer—under a layer of ash in northeastern Nebraska. The bones were discovered in 1971, and the Ashfall Fossil Beds State Historical Park, opened in 1991, continues to be excavated by experts like park superintendent Rick Otto.
Photo by Darin Epperly

LINCOLN
Mikhail Frolov examines a laser experiment at a University of Nebraska physics lab. He's working on a collaborative project cosponsored by Big Red and Voronezh State University, where Frolov got his PhD in theoretical atom physics. When his assignment is done, he and his wife and child will return to Russia with enough money to buy an apartment.
Photo by George Burba

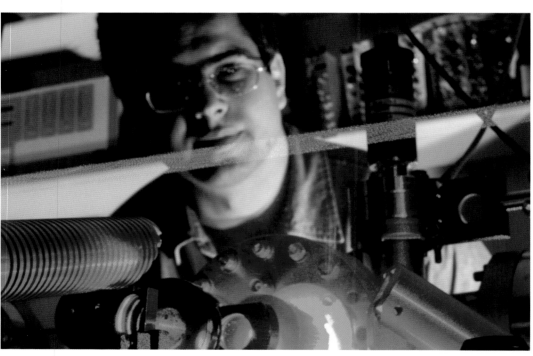

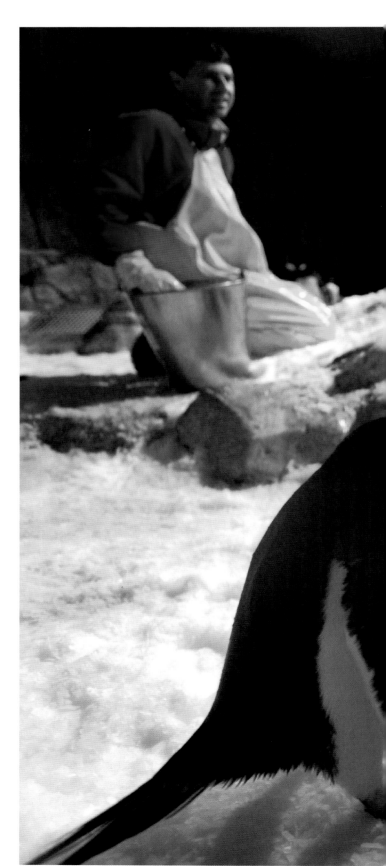

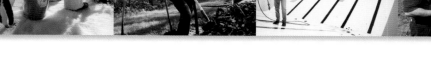

OMAHA

A gentoo penguin sneaks some extra fish while keeper Kim Janssen feeds a rockhopper at the Henry Doorly Zoo. The zoo makes snow year-round for the penguin pen, adjusting the light to mimic seasons in the animals' home areas.
Photo by Kiley Cruse

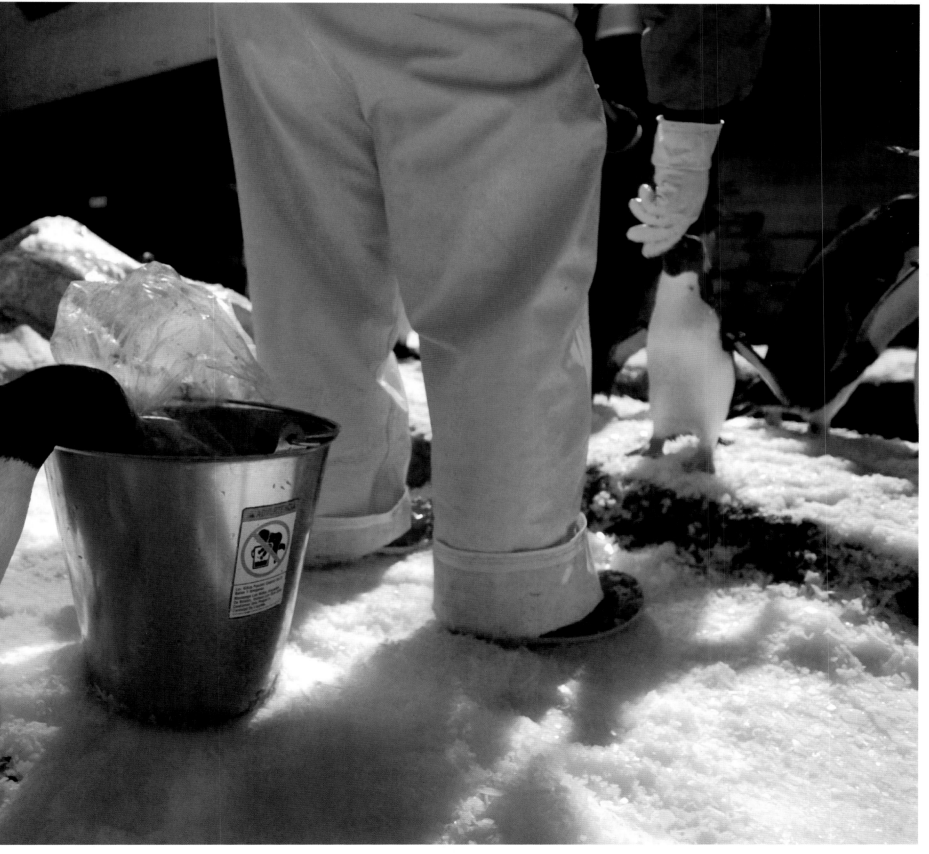

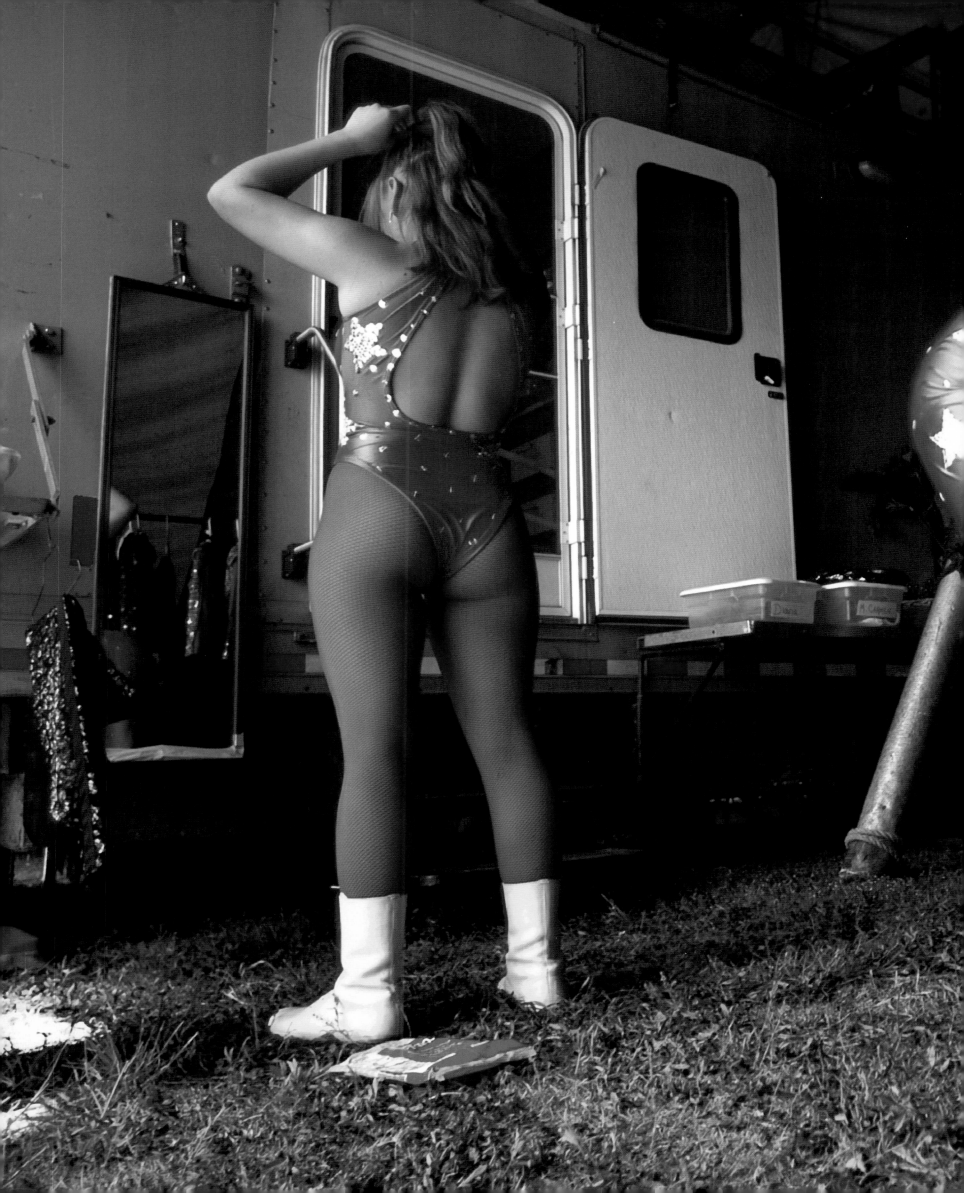

LINCOLN

Juggling Vicente Jr.'s needs with the demands of their daily aerial performances is a balancing act for Peruvian trapeze artists Vicente and Deonicia Ventura, seen here beneath the bleachers at the Nebraska State Fairgrounds. Like most of the performers in the traveling Carson & Barnes Circus, the Venturas split their year between South America, where they train, and America, where they tour.
Photo by Ken Blackbird

ASHLAND
Just a little off the top: Pat Stewart has been cutting hair for more than three decades. The 71-year-old opened Pat's Barbershop in 1971. Regulars like Edward Koutsky keep coming back. At $5 a cut, it's no wonder. "I do just about any style, but flat tops and crew cuts are most in demand," Stewart says.
Photos by Ken Blackbird

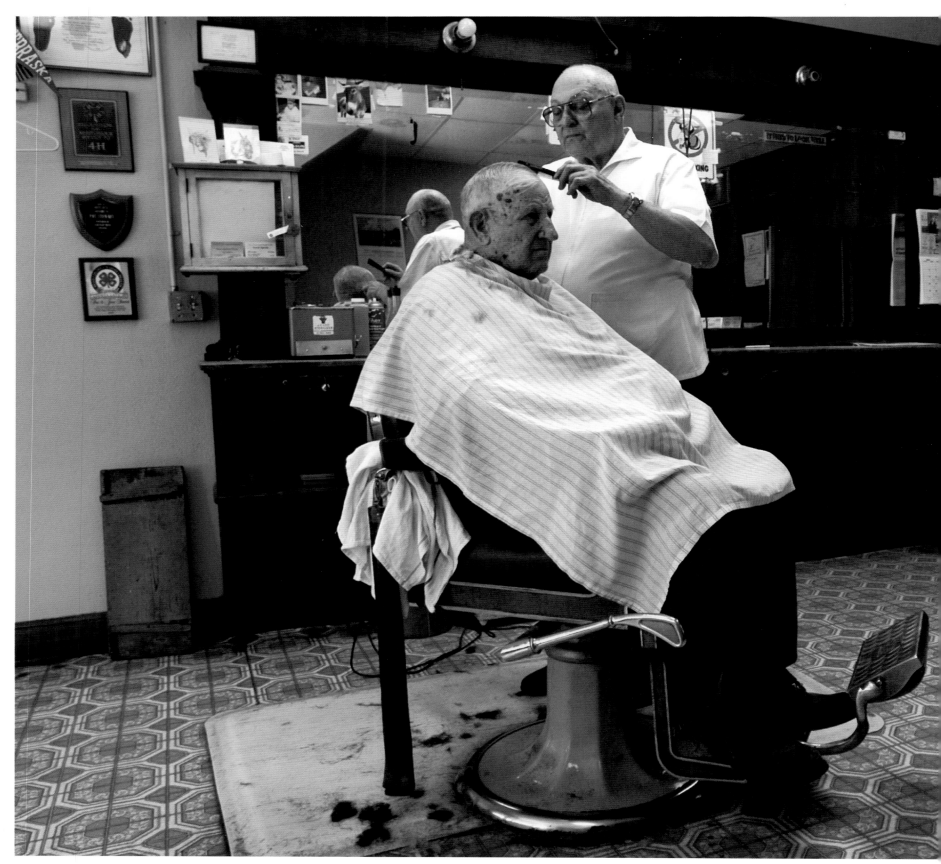

ASHLAND

In his barbershop, Stewart takes a break in his usual chair. While he waits for shaggy heads of hair to walk in, he plays five-card pitch with friends.

WAYNE
Gregory Brown feeds two kinds of polyester fibers into a blending machine at the Pacific Coast Feather Company. They will come out the other side as rolls to be used for mattress pad filler.
Photos by Bob Berry

WAYNE
Shane Baack stacks boxed mattress pads in the factory. Pacific Coast Feather employs 220 people who produce 5,500 pads a day.

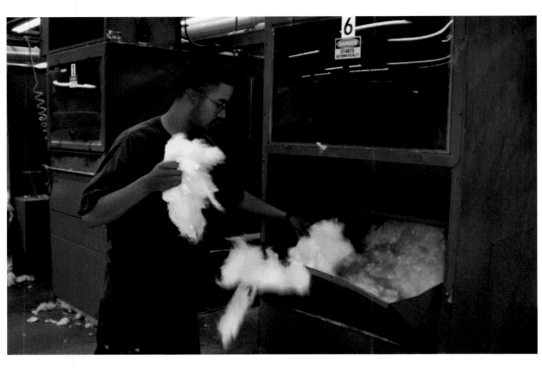

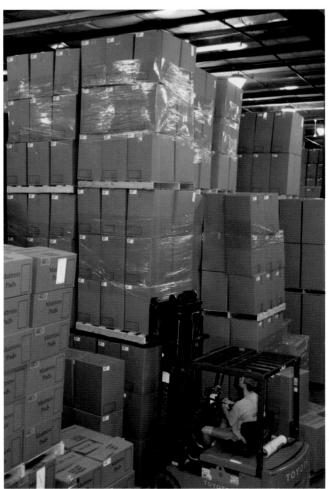

WAYNE

Julia Garza and the rest of the employees all know the history of the company's unusual geographical name. Twenty years ago, a business called Restful Nights started making pillows in an old building downtown. Business grew, and Seattle-based Pacific Coast bought the company out in 1995, changing the name. A year later, the factory switched to mattress pads.

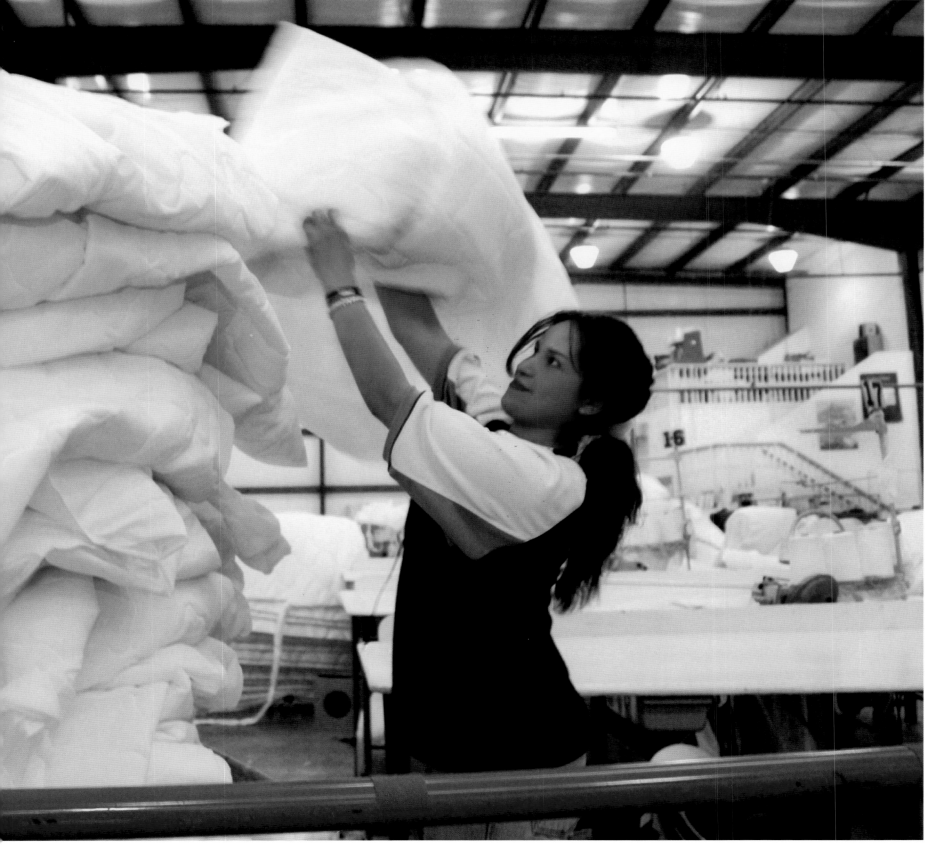

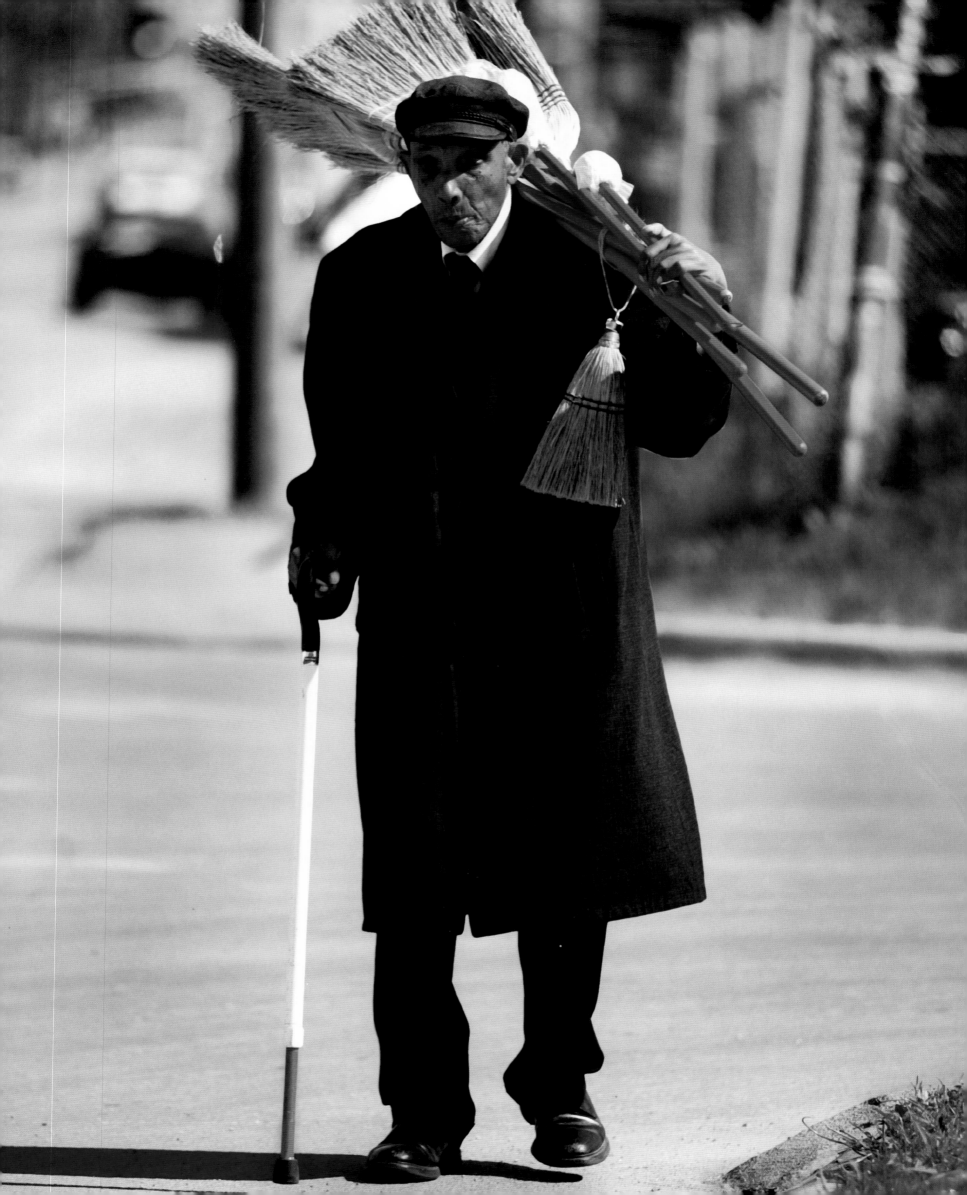

OMAHA

Livingston Wills, 85, is a familiar Omaha figure. Blind since birth, he navigates busy city thoroughfares with the tap of his cane. Walking south on 30th Street, he whistles one musical note, like sonar, guiding him home.

Photos by Kent Sievers

OMAHA

On his way home, Wills stops to check his mail at the post office. Friends help him respond to bills and letters.

OMAHA

Nicole McGruder and Paul Holbert peruse Wills's stock of brooms, which he sells to support himself. Holbert decides on the most expensive one—a $12 warehouse broom. He and McGruder know Wills as the "Broom Man." Since childhood, they've watched him peddle his merchandise.

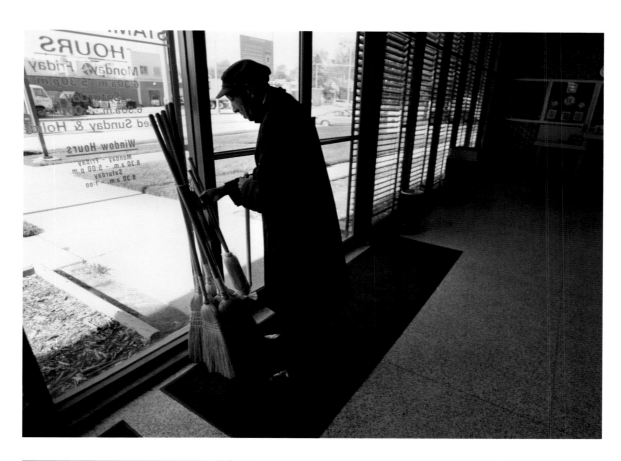

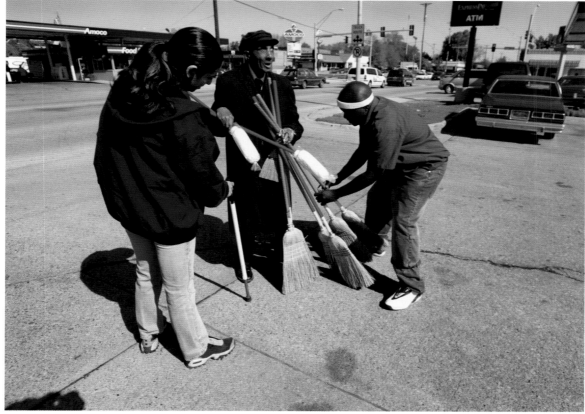

NORFOLK

This "candle tray" enables workers at the Norfolk Hatchery to determine which eggs, after incubating for 18 days, have embryonic chicks inside. Eggs that are fertilized show up as opaque and are transferred to the hatchers. Three days later, the chicks are born.

Photos by Darin Epperly

NORFOLK

From inside the incubator, Bill Hladik, 83, hands tray of eggs to his colleagues. The former grain farmer has worked at the Norfolk Hatchery pla since 1980. Well past retirement, he says this job is one of the things that keeps him going. Hladi usually works two days a week (including Wednesday, which is hatching day).

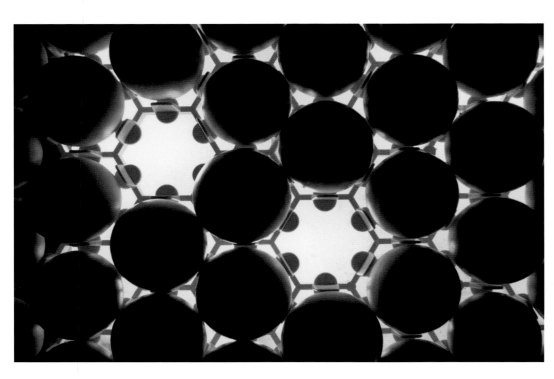

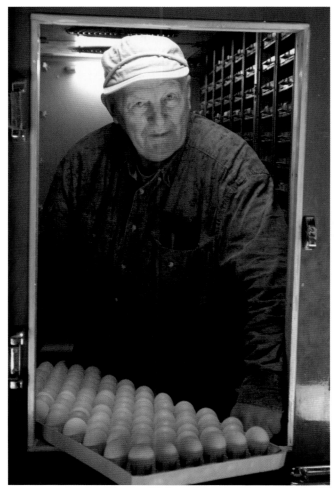

NORFOLK

Ken Rasmussen, Warren Wiborg, Jr., and John Walter "candle" the eggs. The hatchery gets most of its eggs from commercial producers in Arkansas and Iowa.

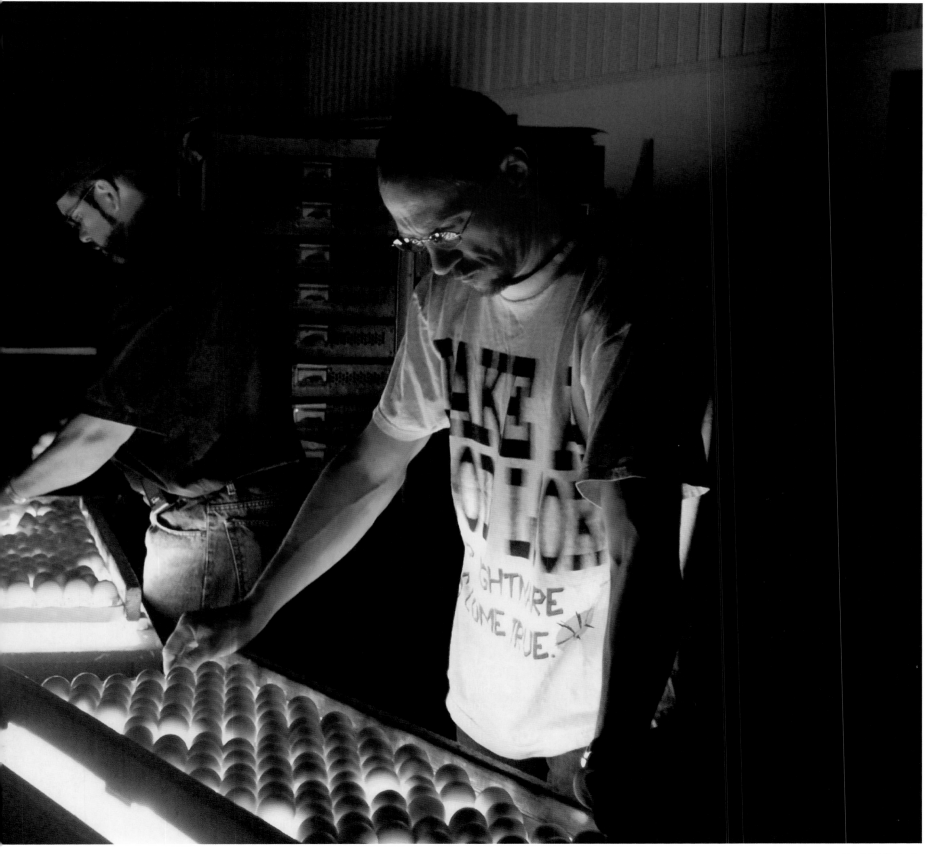

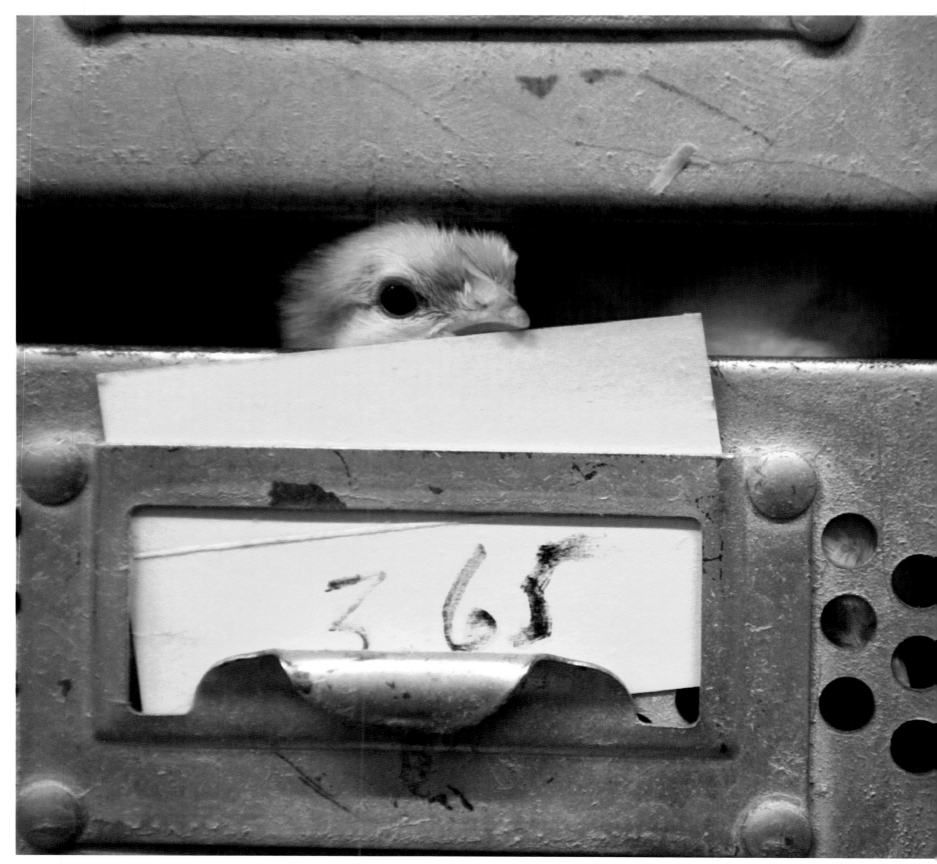

NORFOLK

A baby chick checks out the action from his hatching tray. Norfolk Hatchery improves the quality of chicks by introducing different breeding stocks. The "365" on this little guy's tray (males are yellowish-white; females are reddish-brown) means that he is from a line of Pennsylvania chickens purchased in 1965.

Photos by Darin Epperly

NORFOLK

Day-old chicks are removed from the tray where they hatched, put in boxes, and shipped to customers, mostly in the Midwest. Each box carries between 25 and 100 chicks and is hand-delivered or sent via priority mail.

NORFOLK

Warren Wiborg, Jr. pulls a rack of boxed live chickens along the production corridor. The company, which opened in 1926, shipped 500,000 chicks in 2003, down from its heyday in the 1950s and 60s. Owner Paula Rasmussen says many of its customers (primarily small, independent farmers) have been displaced by large corporations.

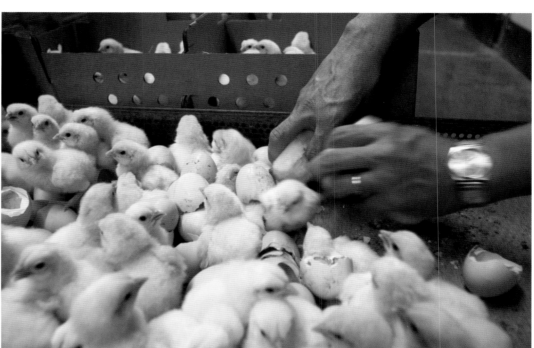

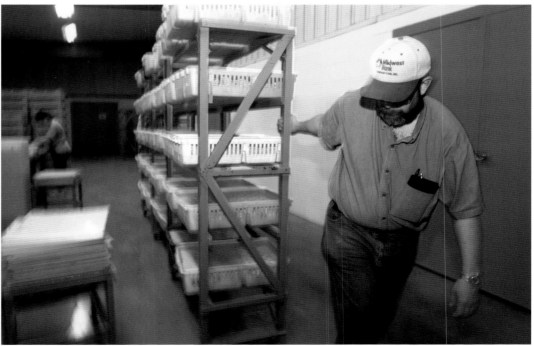

PALISADE
Smack in the middle of cattle country, Byron Alberts grows tomatoes during the cold season at Land-a-Life Farms. Seeding 900 tomato plants in December, he harvests 13.5 tons by August.
Photo by Jeff Bundy, Omaha World-Herald

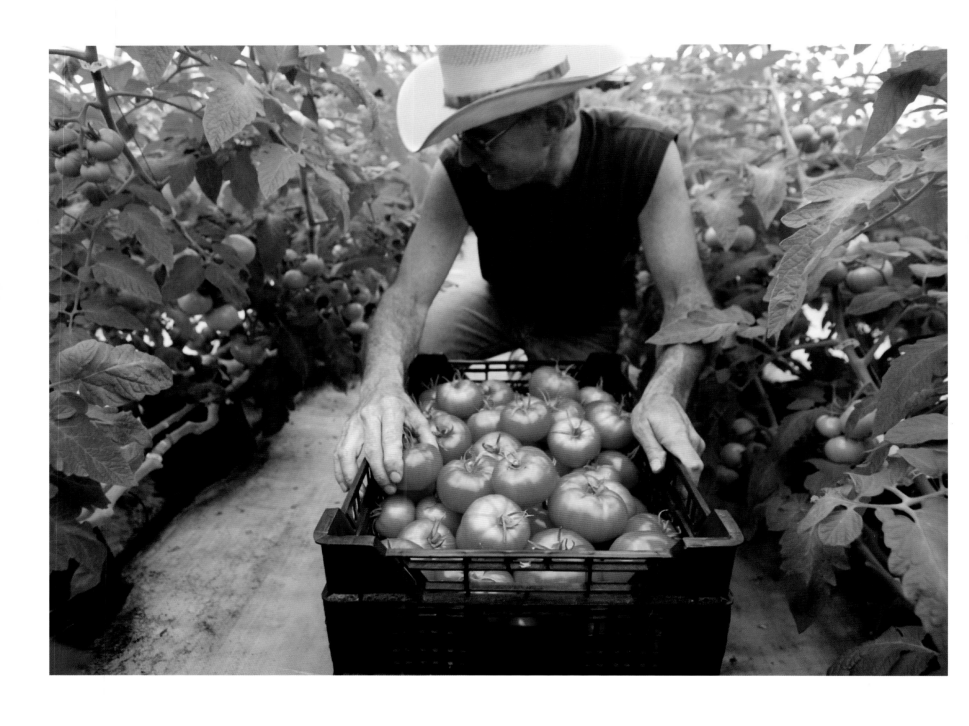

CLARKSON

When Harland and Shirley Hamernik (front with plants) started Bluebird Nursery in 1958, they had no idea it would someday become the biggest employer in town. As the state's largest nursery, Bluebird sells millions of perennials, herbs, wild-flowers, and grasses throughout America and Canada, employing more than 100 of Clarkson's 699 residents.

Photo by Bill Ganzel

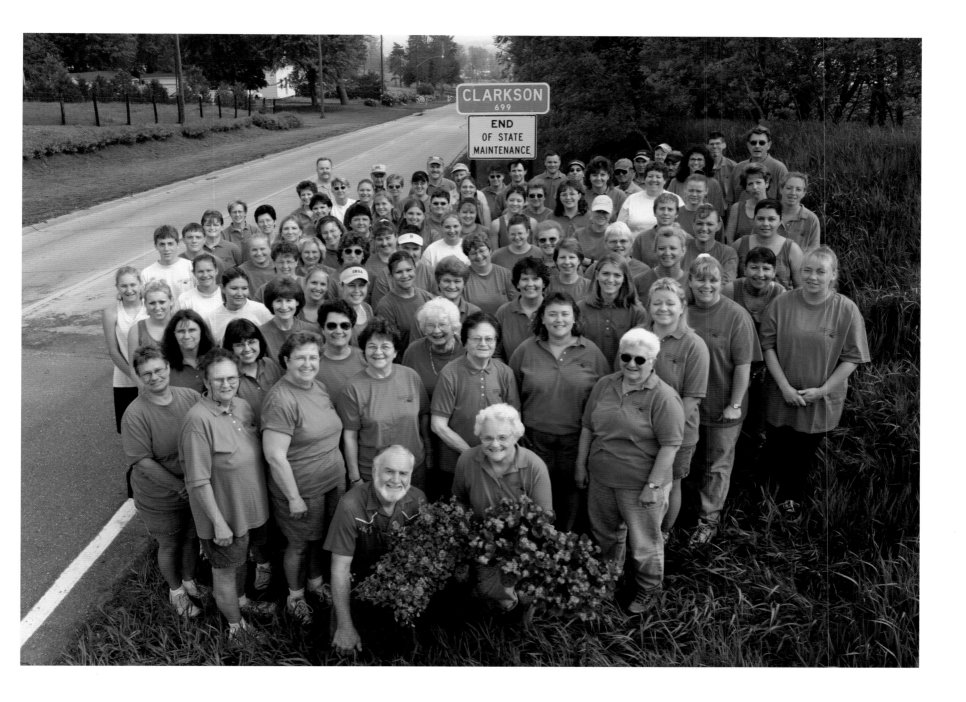

NORFOLK

Joseph Pinkston checks the slide gate on the bottom of a ladle at Nucor Steel. Once he gives it the "okay," the ladle will be stood upright and moved to the furnace area. The red glow indicates that the ladle's interior is being preheated to withstand the next step, when it will receive a batch of 3,000-degree molten steel.

Photos by Darin Epperly

NORFOLK

Sparks and smoke create quite a blaze in the furnace room. A worker, behind a protective screen of Plexiglas, controls the size of the opening and tilt of the furnace as molten steel is poured into the ladle, where it gets mixed with alloys. Nucor, Nebraska's only steel mill, runs 24/7 and annually ships 850,000 tons of the product.

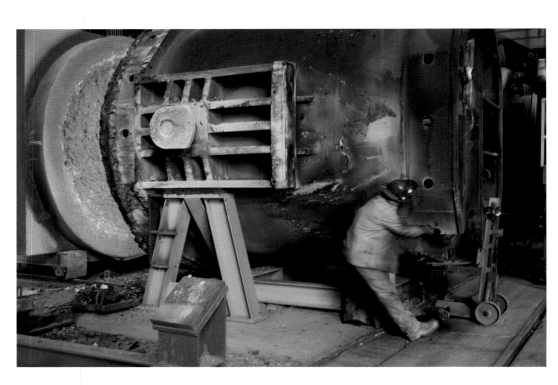

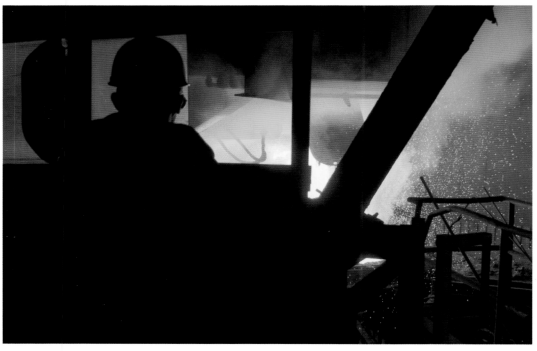

NORFOLK

Steel scrap arrives by rail at Nucor. Scott Austin, a 25-year employee, maneuvers a magnetic crane over the scrap, choosing between seven different types for that day's production order. His catch is then dumped into the furnace. Once the furnace is full (with about 110 tons of scrap), the heat is revved up and the melting process begins.

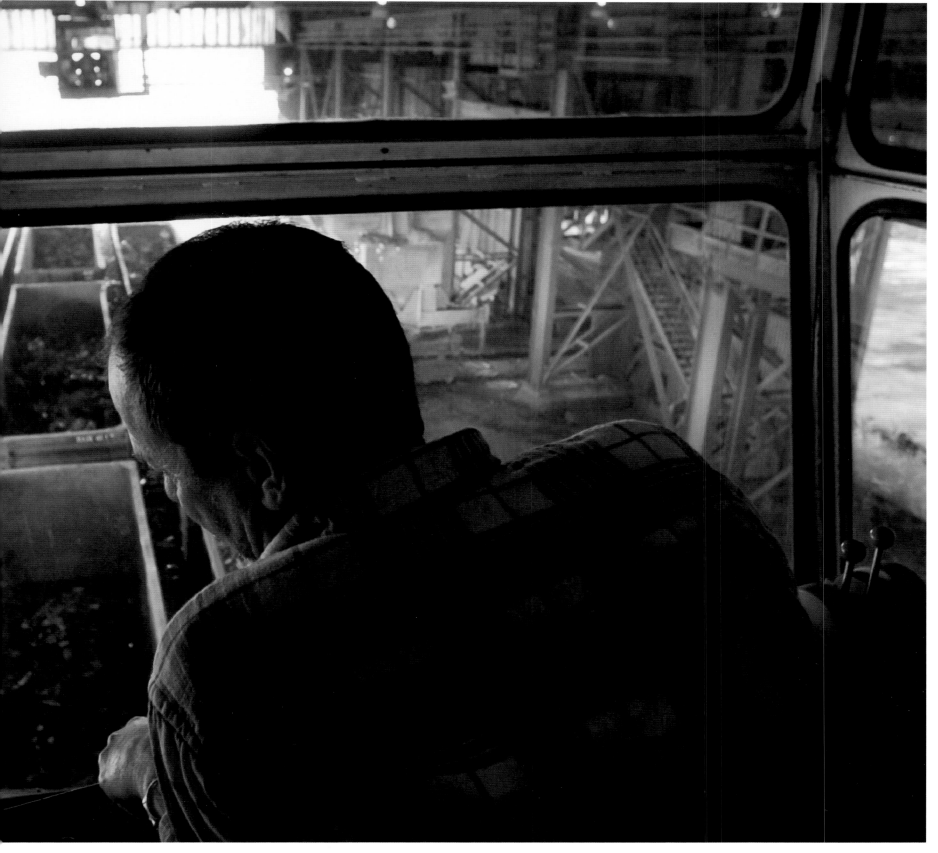

ST. LIBORY

Larry Grabowski lost part of his leg in a farming accident in 1988 , but he still milks his 35 Holsteins twice a day. Grabowski and wife Rosemarie run their 11-acre dairy farm (and 170-acre hay farm) by themselves. Rosemarie insists the operation is "small enough" to manage without hired help.
Photo by Scott Kingsley

SUPERIOR

Veterinarian L. D. Hauptmeier prepares an antiviral shot at the Animal Hospital on Highway 8 East. Local farmers bring their cattle to the clinic where young cows are tagged before being sent out to pasture for the summer.
Photo by Crystal Corman

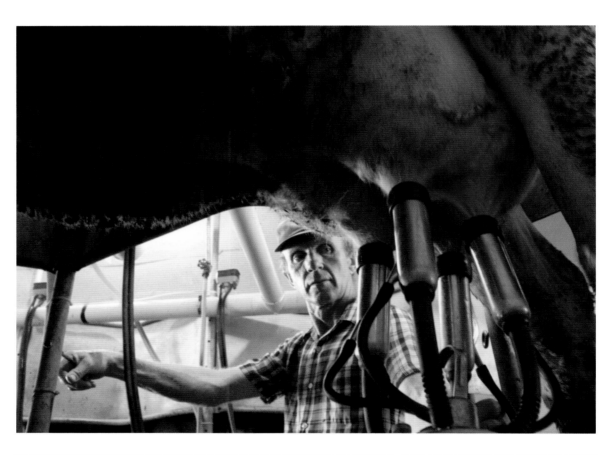

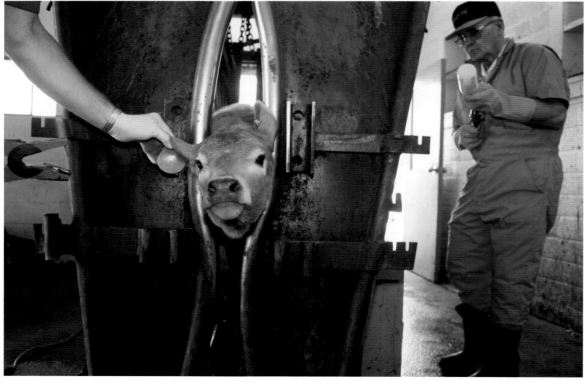

PENDER

On their farm in Pender (pop. 1,148), Russell Tonjes helps his dad Milon repair a broken tiller. A mechanic at the John Deere dealership in town kindly spliced the damaged hose so they could finish planting their cornfields.

Photo by Josh Wolfe

WAKEFIELD

While planting an onion crop, Larry Sherer and son Joedy ride a specially designed Transplanter that punches holes in the soil and injects a small amount of water. The Sherers then drop in each new plant. Their 30-acre truck farm produces fruits and vegetables for the nearby Sioux City, Iowa, farmers' market. "Tough business," says Larry. "You gotta know what you're doing."

Photo by Bob Berry

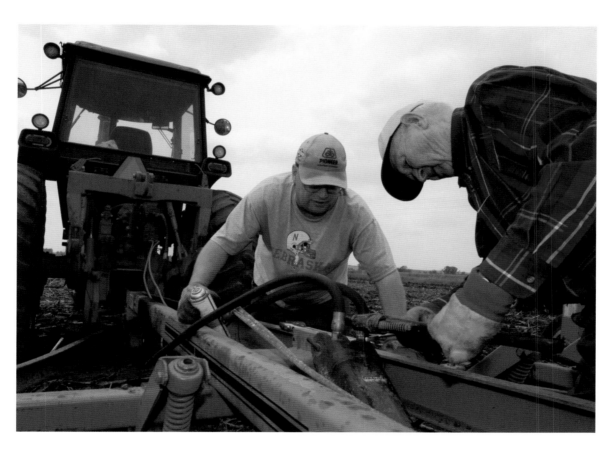

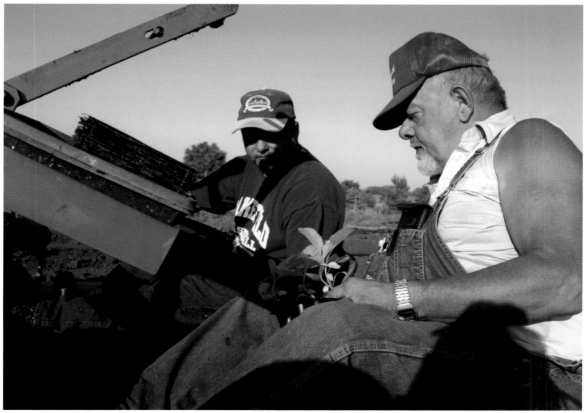

LINCOLN
Nebraska's capitol building is home to America's only unicameral state legislature. In 1934, voters approved a one-house governing body. The 49 members are called senators and are elected on a nonpartisan ballot without political party labels.
Photo by Josh Wolfe

LINCOLN

Lobbyists gather like locusts outside legislative chambers in the capitol building as senators debate a tax bill.

Photo by Richard Wright

LINCOLN

Lobbyist Richard Lombardi gets on his cell phone right after a meeting with state legislators at the capitol building. Most of his clients come from the nonprofit sector such as health care and labor. He coaches them in becoming effective policy makers. "As the saying goes, democracy belongs to those who show up," he says.

Photo by Josh Wolfe

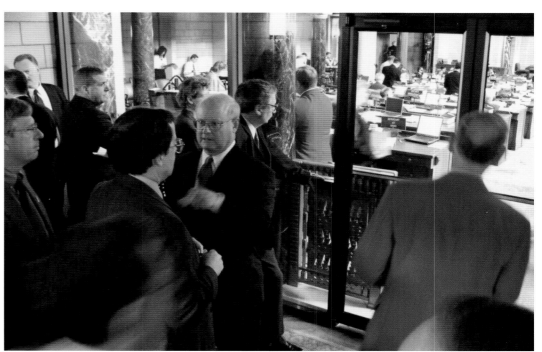

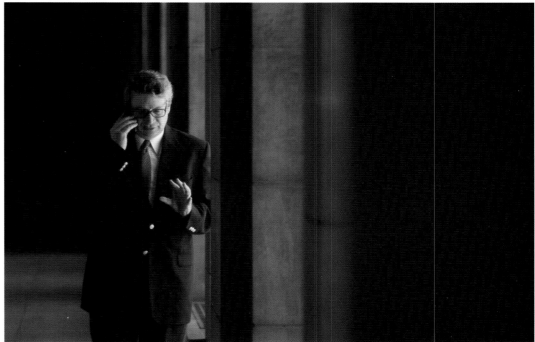

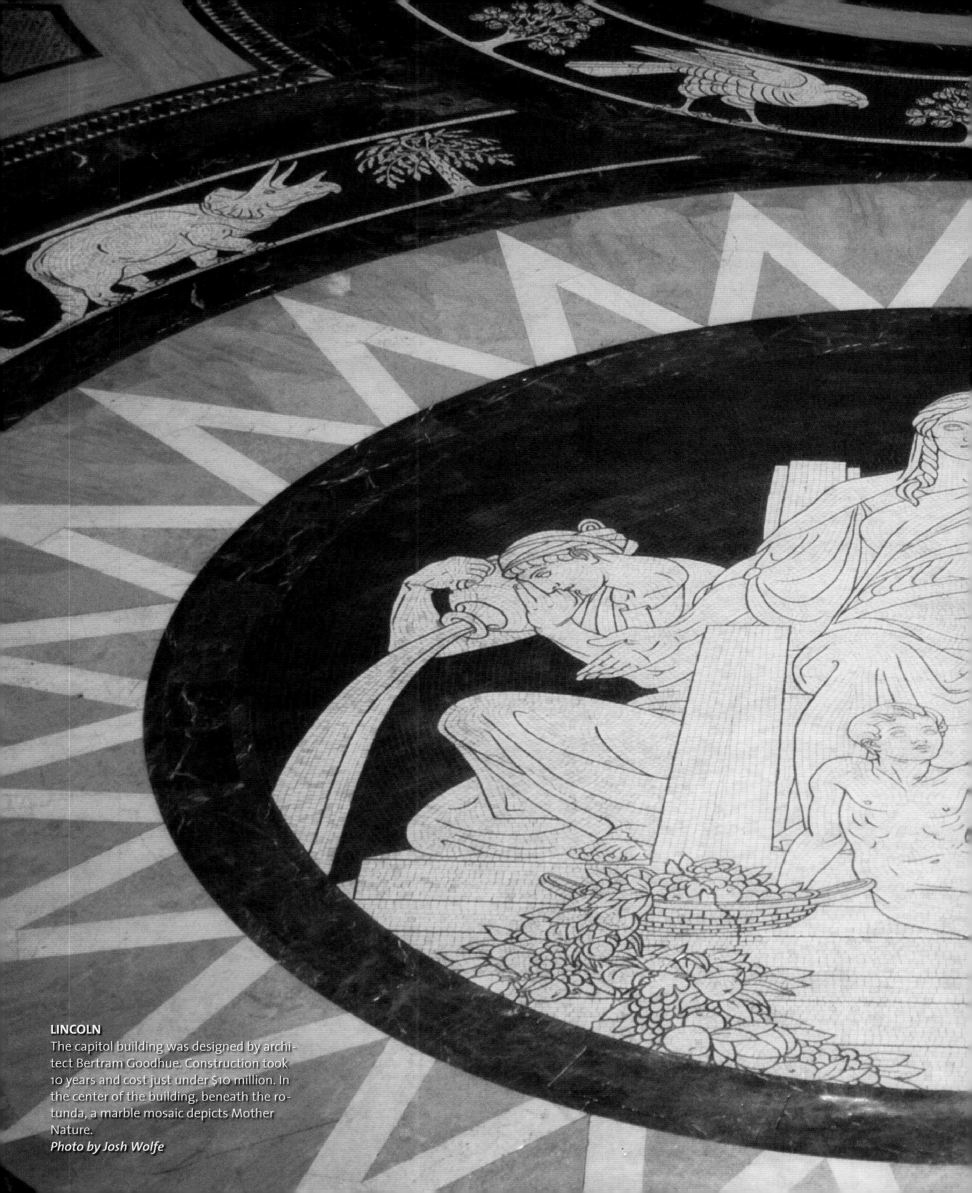

LINCOLN
The capitol building was designed by architect Bertram Goodhue. Construction took 10 years and cost just under $10 million. In the center of the building, beneath the rotunda, a marble mosaic depicts Mother Nature.
Photo by Josh Wolfe

LINCOLN

Preparing newspapers to be microfilmed, this Nebraska State Penitentiary inmate works on a project for a historical society, arranged by the Cornhusker State Industries work program. Convicts can also learn skills in furniture building, tailoring, and printing. "Inmates who have been through the work program don't usually come back to prison," says John McGovern, who oversees the crews.

Photo by Mikael Karlsson, arrestingimages.com

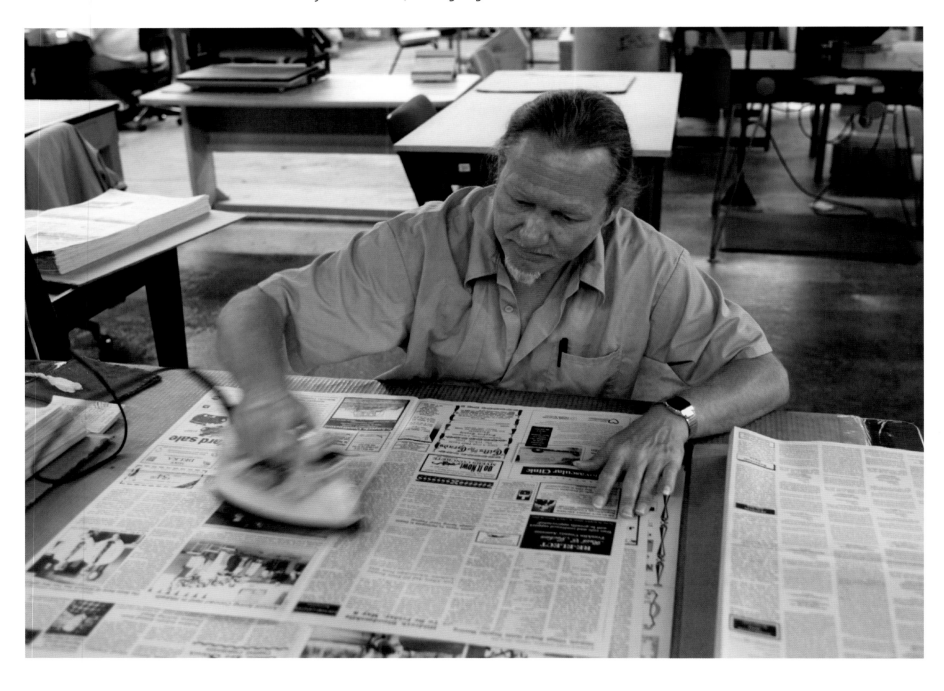

STRATTON

It's 2 p.m., and Landon Scott, 13, rolls 42 copies of the *McCook Daily Gazette* for his afternoon route through this southwestern Nebraska town (pop. 423). "He's very responsible about it," says mom Connie. "I think he's saving money for a car."
Photo by Lane Hickenbottom

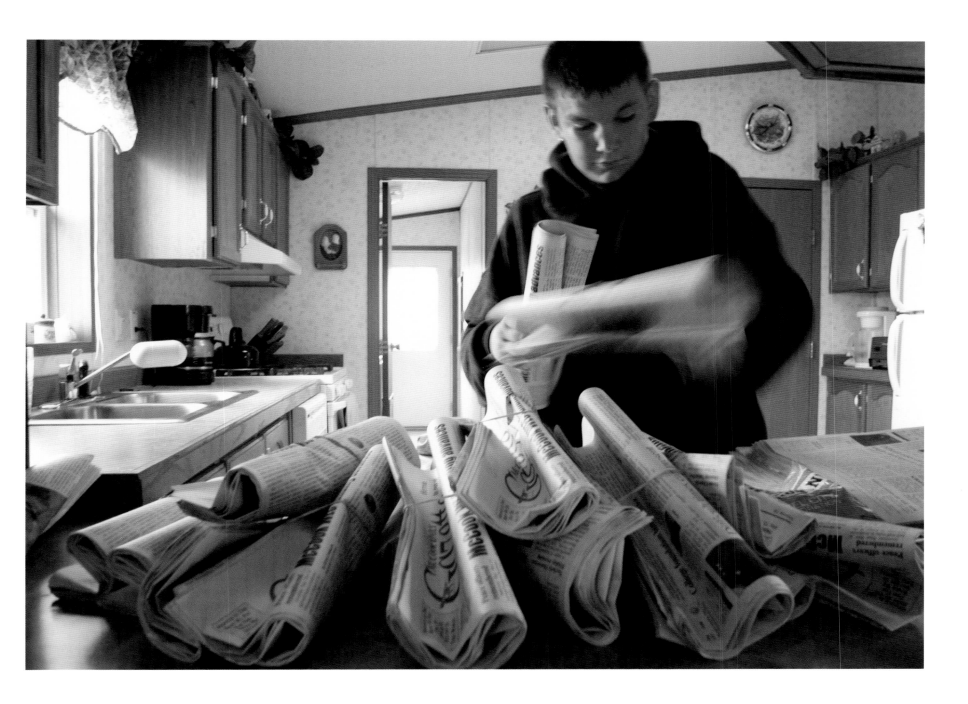

WILBER

Kazan is the second K-9 dog for the Saline County Sheriff's office. The Belgian Malinois lives with Sergeant Ken Uher, his handler for six years, and will retire in a year. The breed is good at finding drugs, searching buildings, and protecting officers. When Uher became sheriff in 1995, the problem was marijuana; now, it's methamphetamine.
Photo by Mikael Karlsson, arrestingimages.com

LINCOLN

Nebraska has 96,000 miles of highways and public roads. Trooper Curt Prohaska, one of 312 Nebraska State Patrol officers, stops a speeder on Highway 77.
Photo by Mikael Karlsson, arrestingimages.com

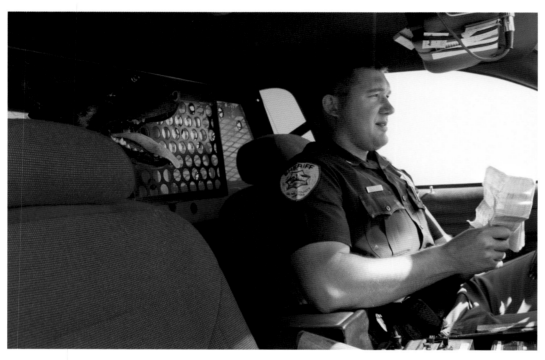

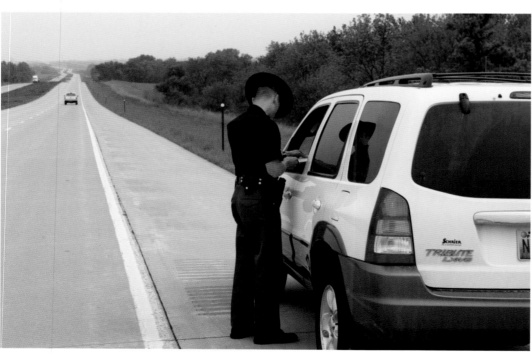

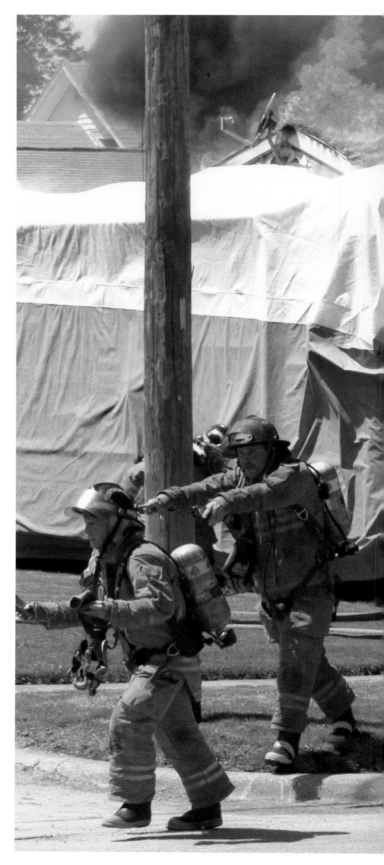

LINCOLN

Members of Fire Station 1 arrive on the scene at a Kearney Avenue house fire. The blaze started when a propane tank exploded in the garage. Flames quickly spread to a motor home and speedboat parked in the driveway, but no one was hurt.

Photo by Ken Blackbird

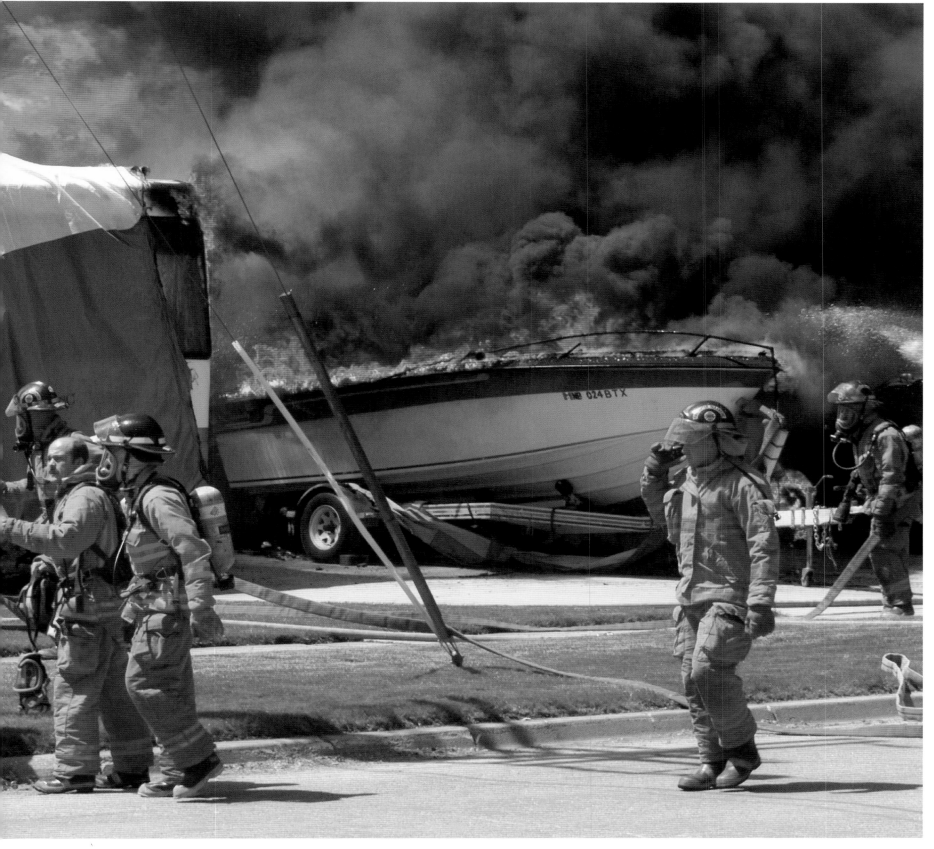

OMAHA

Susan Reed screws in scaffolding brackets for the Habitat for Humanity's Women Build spring project. The all-woman crew appeals to Reed. "When my husband and his friends found out I was building a house, they would ask, 'What's the foreman's name? Maybe I know him,'" she says. She has worked on two houses so far and plans to do it again.

Photo by Kiley Cruse

ANSELMO

That's not a margarita; it's soap. At Shepherd's Dairy, Cathy Thompson pours a mixture of sheep's milk, lye, oil, shortening, and scents into blenders. Her employers, the Curtis family, tried selling their sheep's milk in 1993, but no one was interested in drinking it. Six years later, they tried a new product—sheep's milk soap—with more success.

Photo by Bill Ganzel

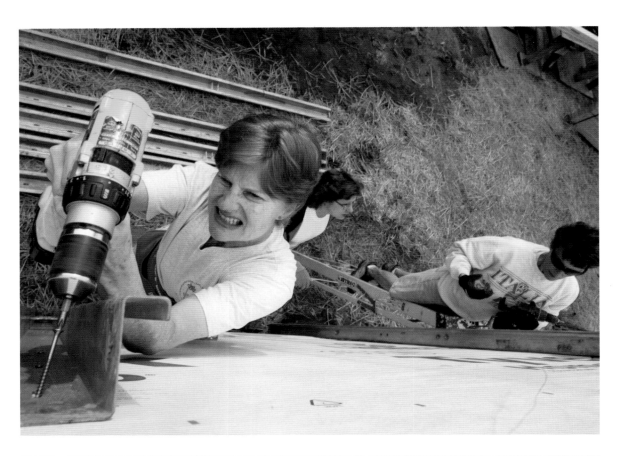

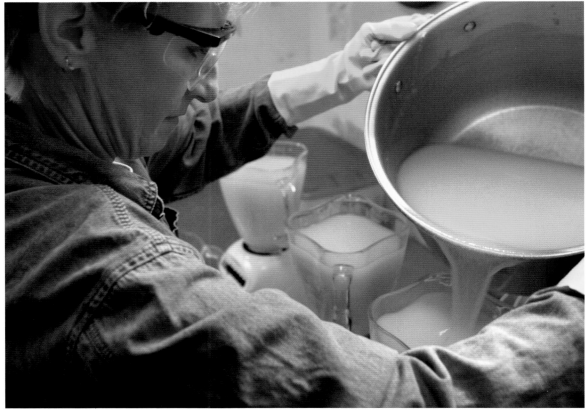

WAYNE

Workers pour concrete for a driveway into a new residential tract. Unlike many of Nebraska's small towns, Wayne (pop. 5,500) is booming. "Housing can't keep up with the demand," says photographer and insurance agent Bob Berry. Located 40 miles southwest of Sioux City, Iowa, Wayne has a healthy manufacturing base with employers like Heritage Homes, Great Dane Trailers, and Pacific Coast Feather Company.

Photo by Bob Berry

ST. PAUL

These days, a lot of ranches aren't set up for the slaughtering of animals, but ranchers still want their families to eat the meat they've raised. The employees at Twin Loups Quality Meats butcher cattle and hogs for local customers. Hiram Abel Rosario washes a side of beef with 165-degree water to "carcass pasteurize" it.

Photo by Gerik Parmele

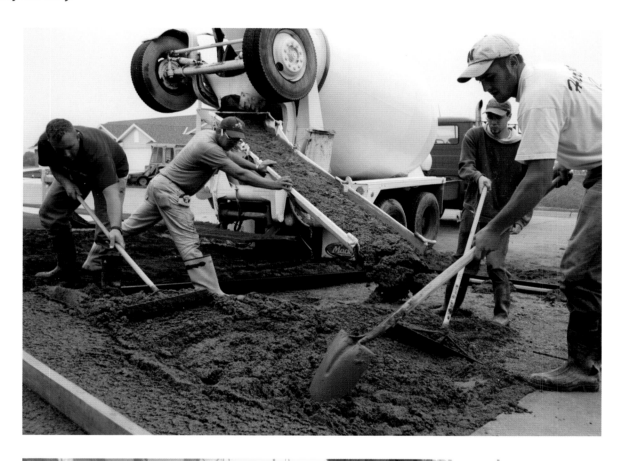

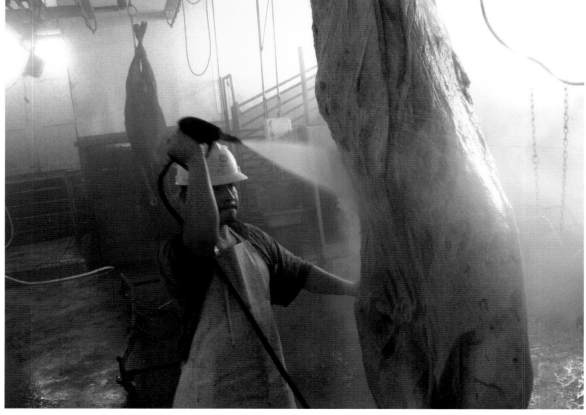

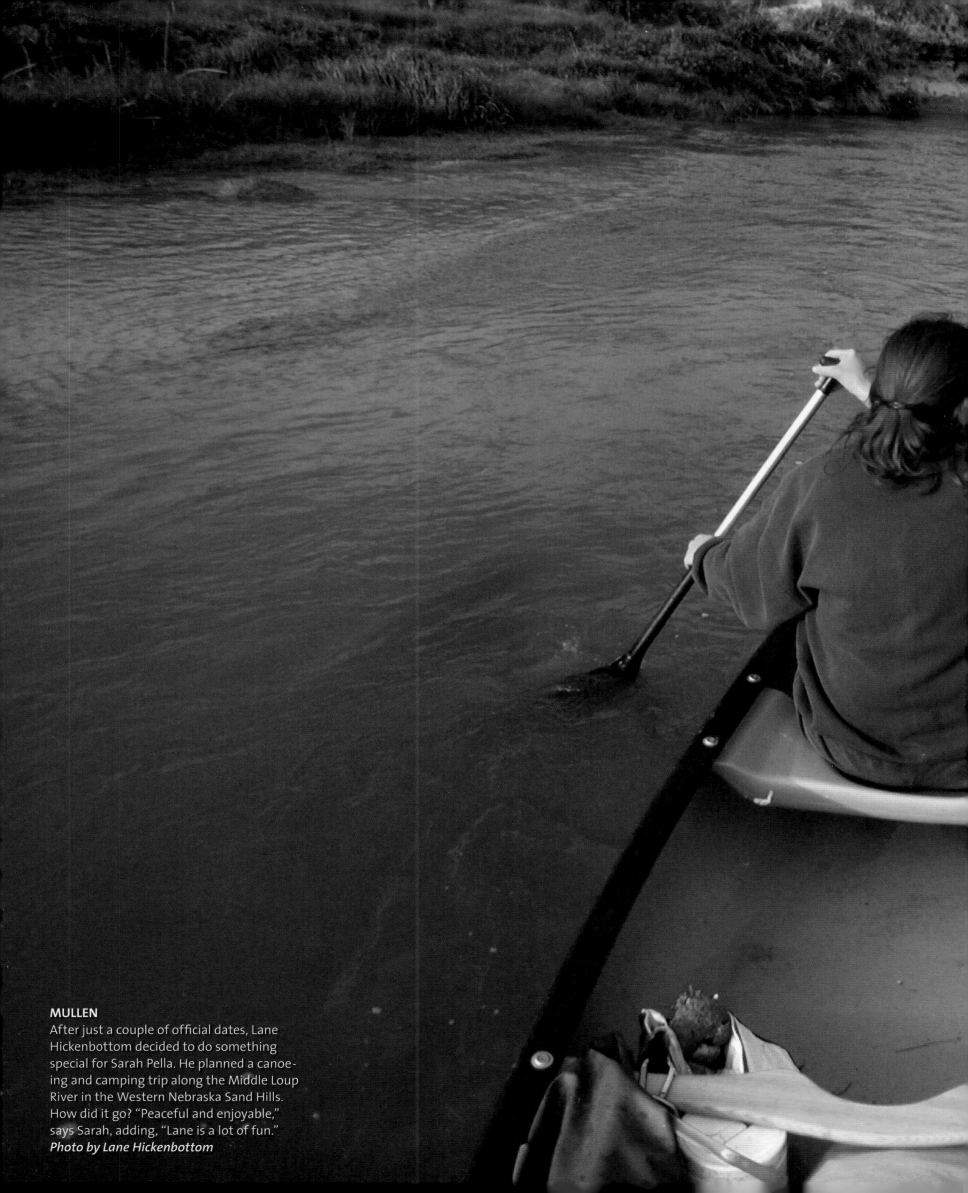

MULLEN
After just a couple of official dates, Lane Hickenbottom decided to do something special for Sarah Pella. He planned a canoeing and camping trip along the Middle Loup River in the Western Nebraska Sand Hills. How did it go? "Peaceful and enjoyable," says Sarah, adding, "Lane is a lot of fun."
Photo by Lane Hickenbottom

Nebraska At Play

LINCOLN

At a University of Nebraska Cornhuskers home game, the Baylor Bears' catcher dives to catch a foul ball. In front of a reddened sea of Nebraska fans, he succeeds.

Photos by Ken Blackbird

LINCOLN

After beating the Baylor Bears (nationally ranked number 14), the Huskers (number 8) huddle for a team cheer. While it may be America's pastime, baseball will always play second fiddle to football in the hearts of Nebraskans. Looming behind Hawks Field is Memorial Stadium, home of Big Red football, which seats more than 78,000 fans.

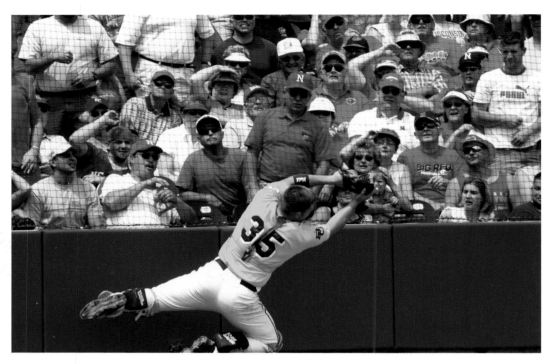

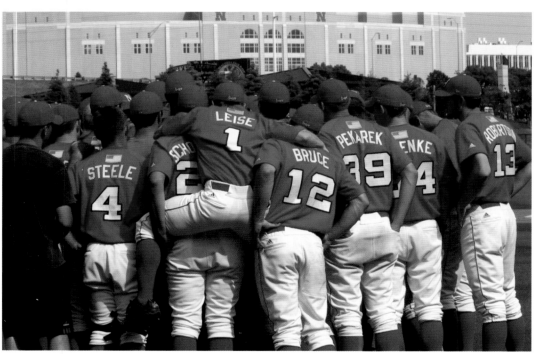

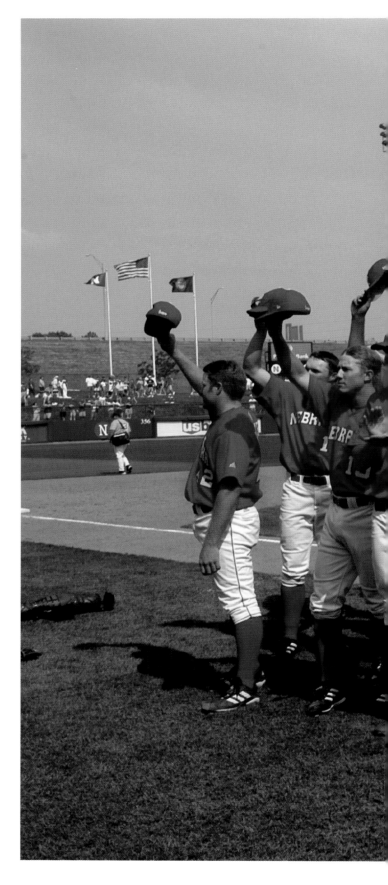

LINCOLN

The victorious Huskers wave thanks to their loyal fans after vanquishing Baylor. The game was a close one, 7–6, but the men in red capitalized on their home-field advantage. Hawks Field is rated one of the top playing turfs in the country.

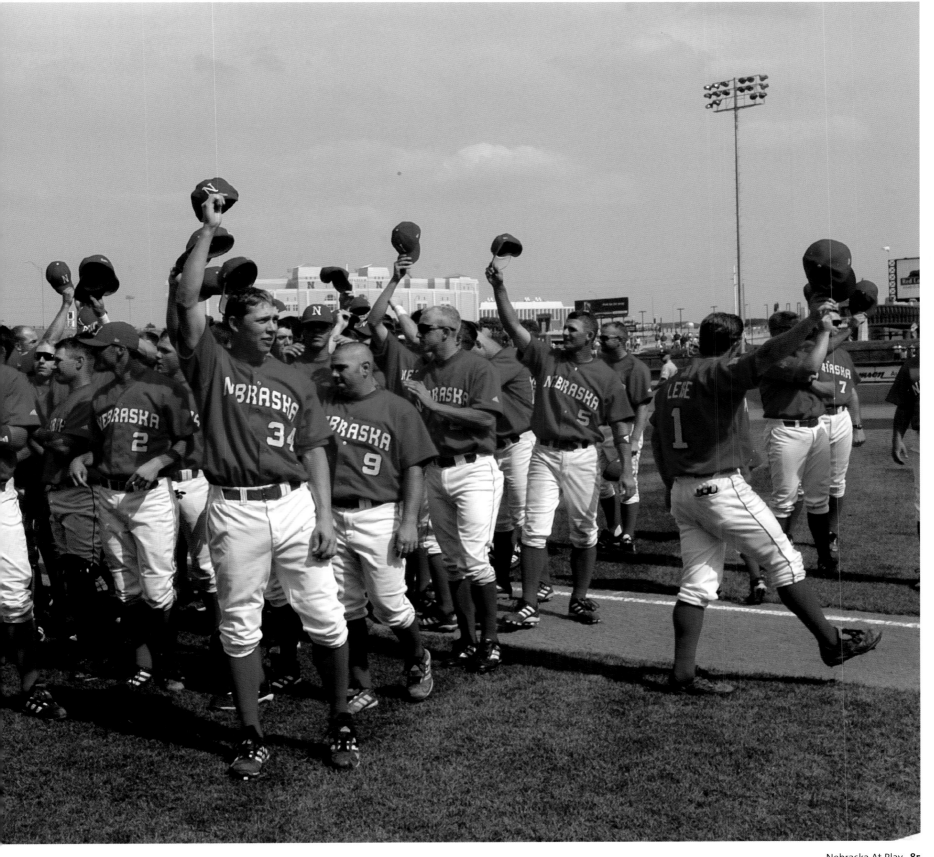

EMERALD
No fish stories here. At the Emerald Mini-Mart and bait shop on Highway 34, fishermen (and women) stop by with "the one that didn't get away" for a Polaroid. Nearby are the Salt Valley Lakes, filled with catfish, bass, and bluegill.
Photo by Richard Wright

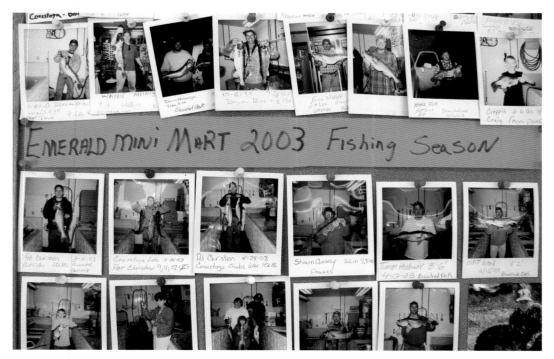

VENICE

When Jim Gresham has a hard day at his Allstate office in Omaha, he knows the perfect antidote: Hop in the car and head west on Highway 92. Half an hour later, he's casting a fly into one of the myriad lakes and waterways in the Two Rivers State Recreation Area.

Photo by Doug Carroll

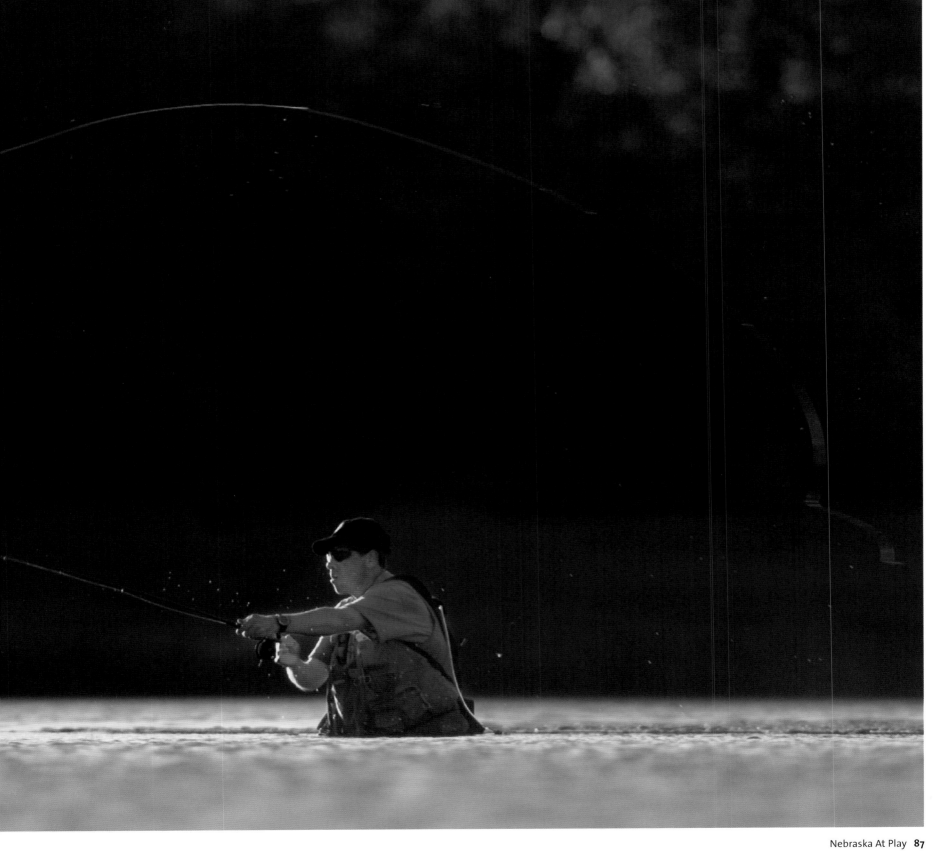

OMAHA

For six years, friends and neighbors have gathered at this vacant lot on 24th Street for a game of dominoes. When the weather is good, players circulate through the lot all afternoon.
Photos by Kent Sievers

OMAHA

On a Tuesday afternoon, Dicky Davis studies the domino chain and considers his next move.

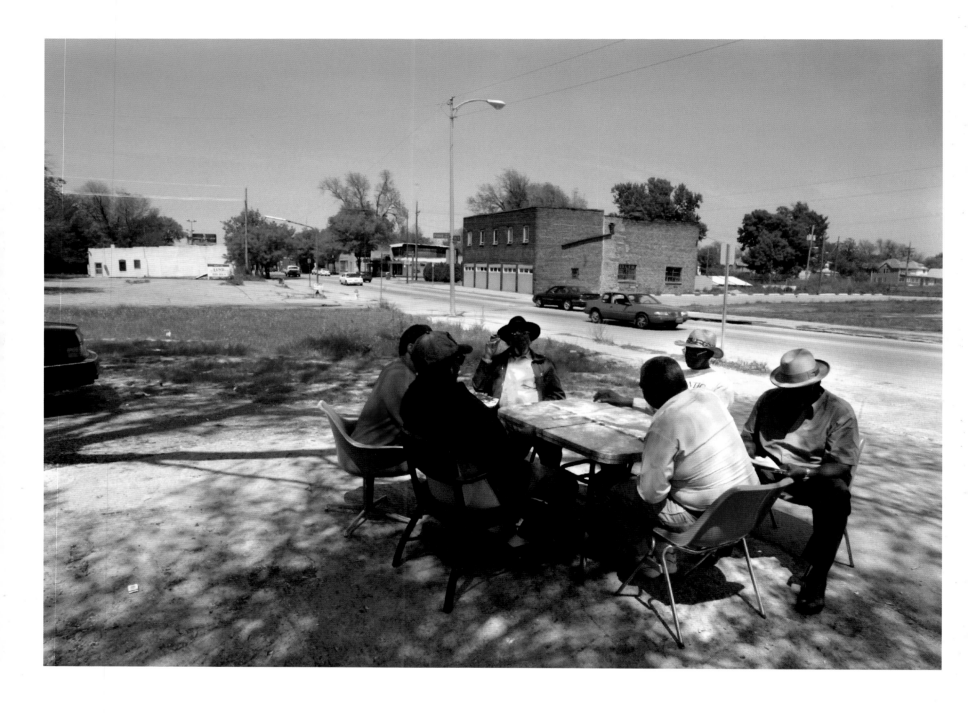

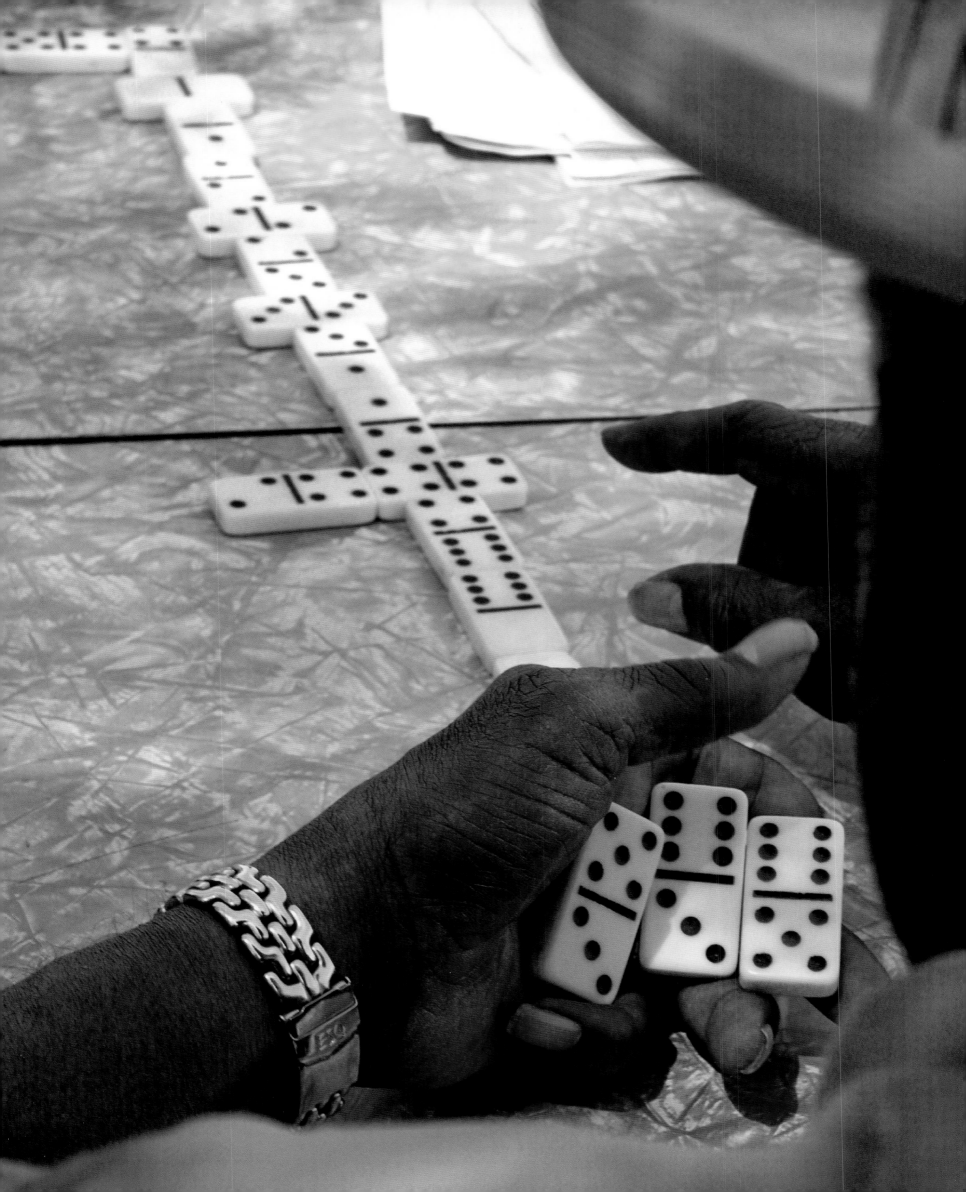

NORFOLK
Rianna Nicholson flips over the Skymaster ride at the D.C. Lynch Carnival. The attraction, which looks like a spaceship, tests the fear factor of up to 32 riders at a time.
Photo by Darin Epperly

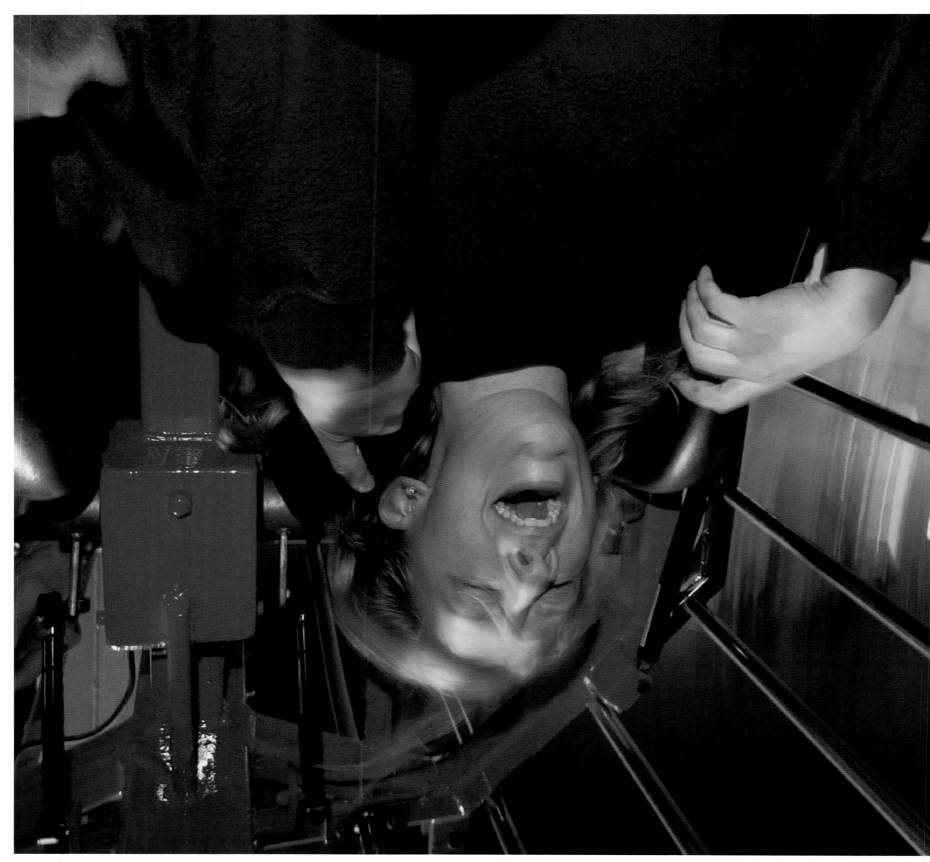

NORFOLK

Taking a spin on the Octopus. Run by Dennis Lynch, a third-generation carny, the D.C. Lynch Carnival has been a Nebraska fixture since 1974. The traveling amusement park begins touring in early May and visits 32 towns before shutting down for the winter in mid-September.

Photo by Darin Epperly

OMAHA

Night and day: The 3/4-acre Kingdom of the Night at the Henry Doorly Zoo is a great place for high school hijinks on a class trip. In the Kingdom's Bat Cave, the lighting is manipulated so daytime visitors can watch the goings-on of 1,000 nocturnally active bats.

Photo by Kiley Cruse

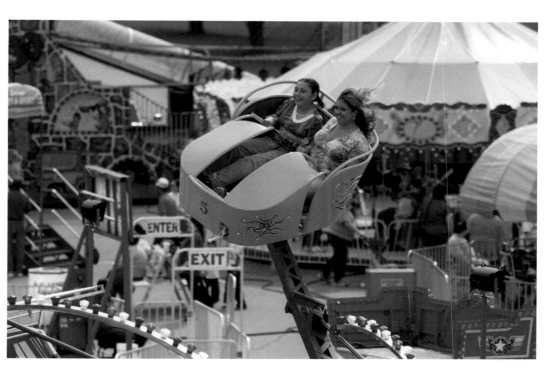

OMAHA
Amateur and professional boxing has a long history in Omaha. Native son Max Baer won the 1934 heavyweight championship. Continuing the tradition, Downtown Boxing Club offers its facilities free to aspiring pugilists ages 12 and over.
Photos by Jeff Beiermann, Omaha World-Herald

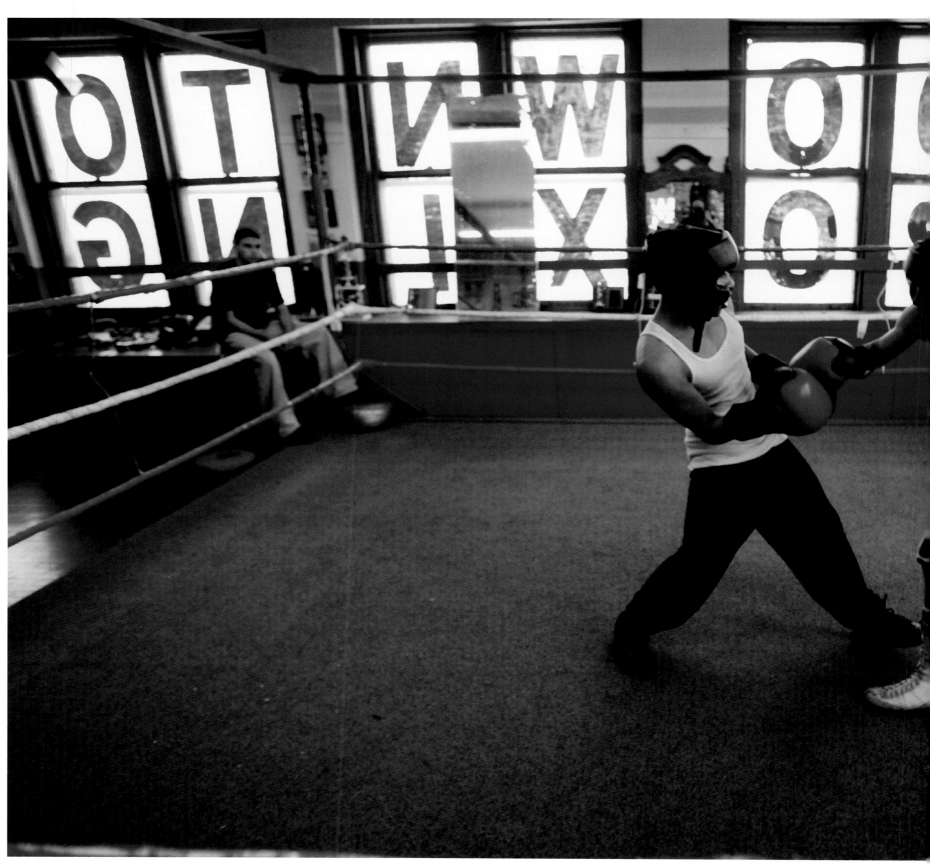

OMAHA

Kenny Wingo has run the boxing gym on South 24th Street for more than 30 years. Interest in the sport has waned with more kids choosing soccer and baseball. "You gotta be a certain kind of person to want to get hit in the face," says Wingo.

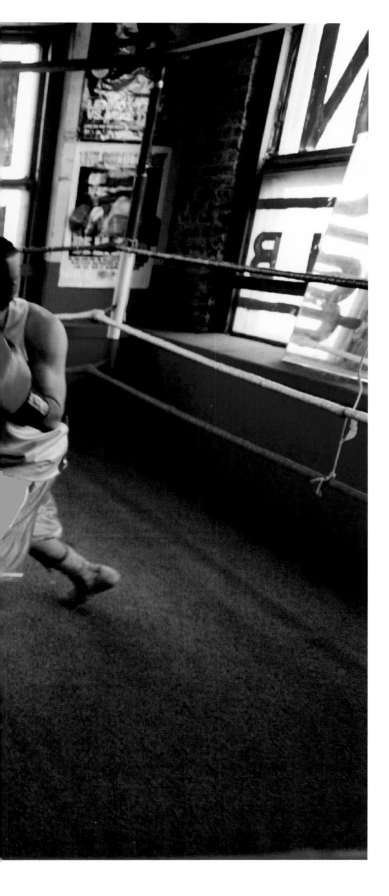

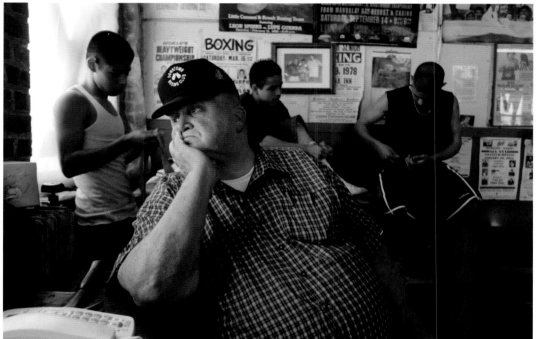

EAGLE
Sprint cars speed past the grandstand during an amateur B feature race at Eagle Raceway, the country's fastest 1/3-mile dirt track. Born in the 1920s, sprint car racing is highly specialized. Light, custom-built chassis are fitted with 360-cubic-inch, 600-horsepower Chevrolet engines that push the contraptions to more than 100 mph.
Photos by Richard Wright

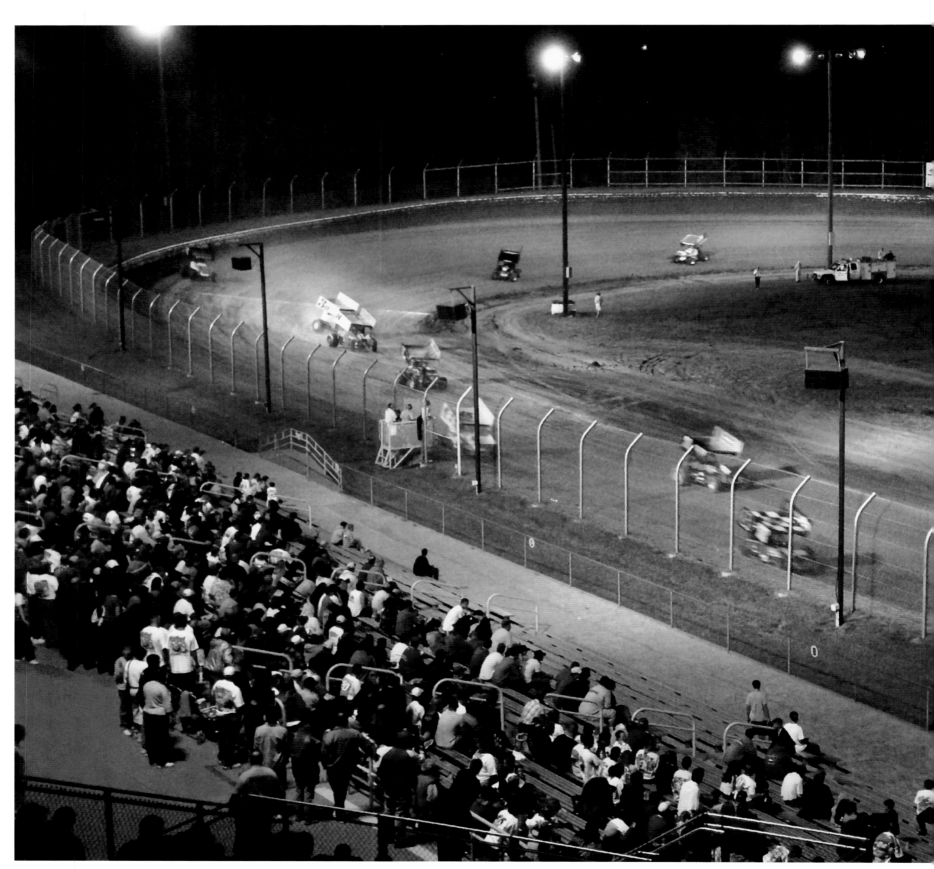

EAGLE

Before racing begins, the dirt track is wetted down with 3,000 gallons of water. The result: lots of mud—some of which pit crew members Matt Wilson and Kevin Gilmore scrape off the wing of sprint car 13, owned by driver Chad Fegley. During a race, the wing pushes down on the rear wheels, giving the car more traction.

EAGLE

Sprint cars skid through a turn during an eight-lap qualifying heat. The cars are pushed onto the track and started while moving. Because there is only one forward gear and no idle, the driver controls the car with the gas pedal—if the car stops, the engine dies.

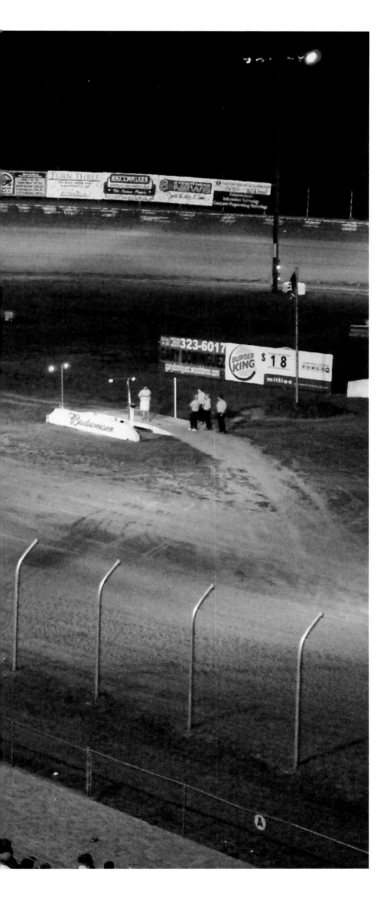

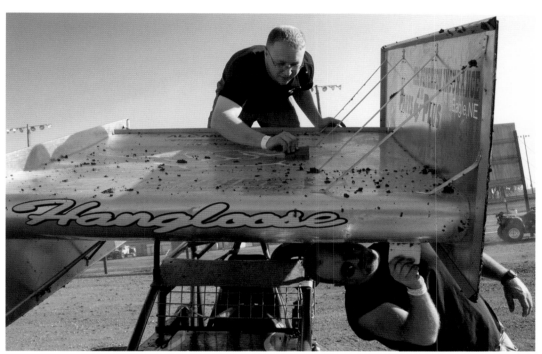

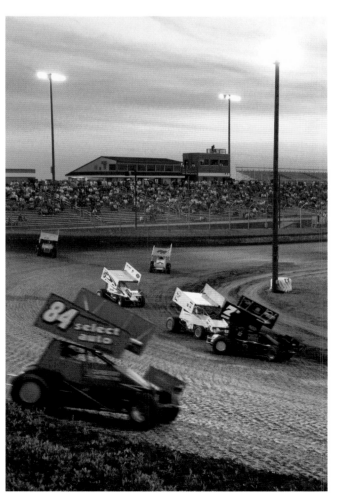

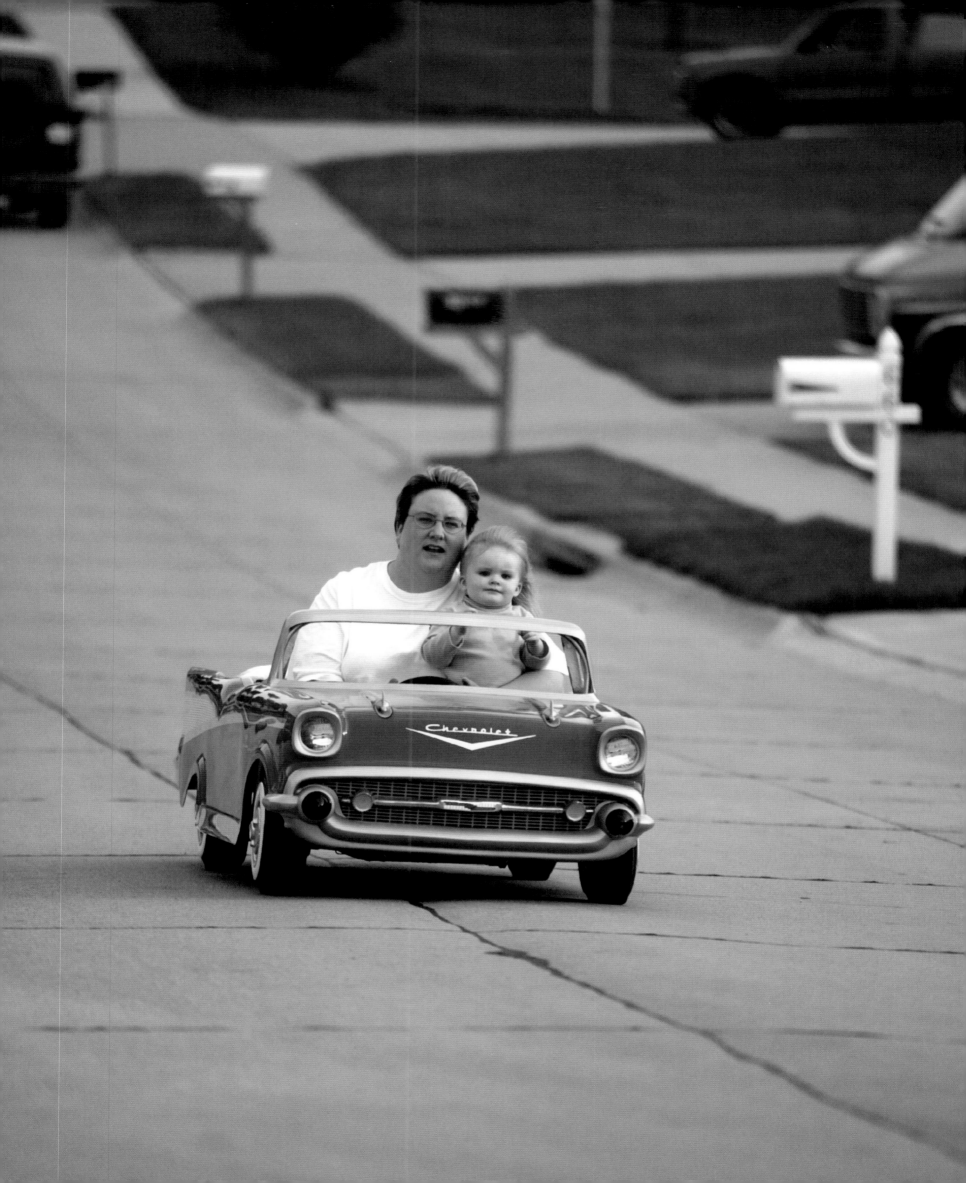

SPRINGFIELD

Joyride: In Springfield, Shelley Dahlgren and her daughter Emily motor down 6th Street. Their hot wheels? A six-horsepower go-cart tricked out as a '57 Chevy. Shelley's father, a Shriner, drives the minicar in about 20 parades a year.

Photos by Kent Sievers

SPRINGFIELD

Here comes Speedracer! At a garage on 1st Street, Troy Daly fires up his '95 Larry Shaw Dodge Intrepid race car before a tune-up. His daughters Taylor and Madison are in awe. In the summer, Daly races twice a week on a dirt track.

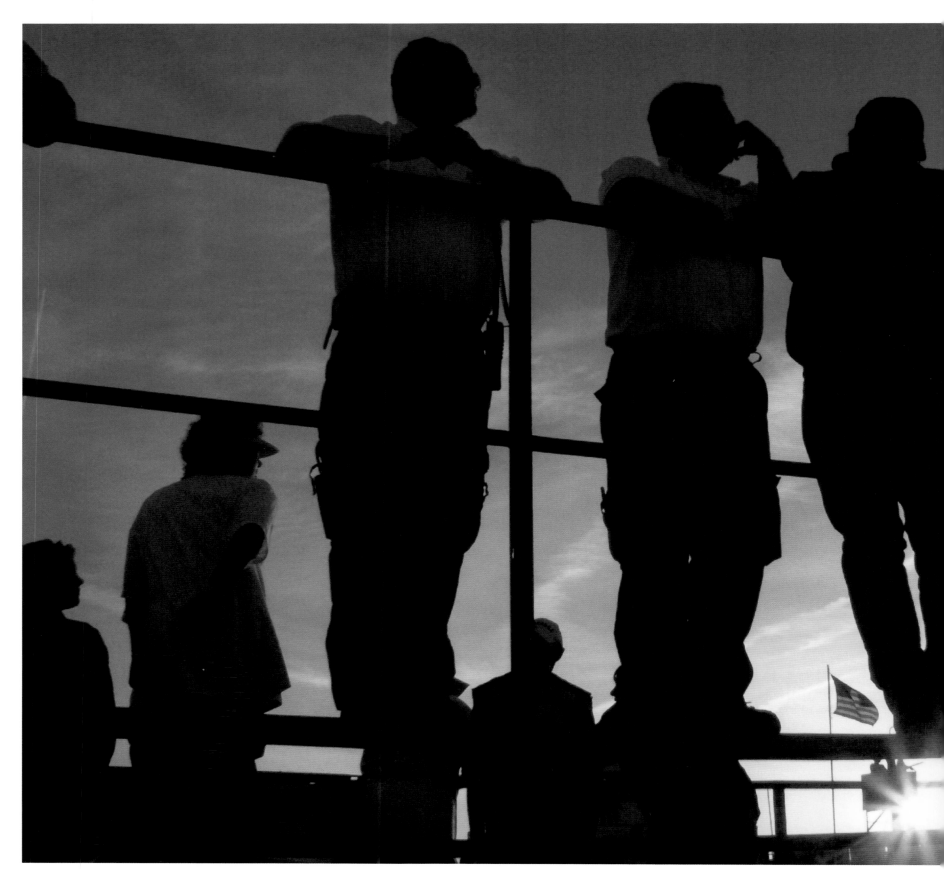

DONIPHAN

Mechanics John Kehr and Michael Nolan inspect the engine in Jeff Rosenburg's street stock car at Mid-Nebraska Speedway. These cars must have an engine that is specifically manufactured or a higher-compression engine from one of the muscle cars made in the 1960s.

DONIPHAN

Michael Nolan cools down Jeff Rosenburg's stock car with water after it placed eighth in the A feature, the final race of the night. Two weeks later, Rosenburg won the A feature with the same car. "If you get your thrill from fear, you'll never make it as a driver," he says.

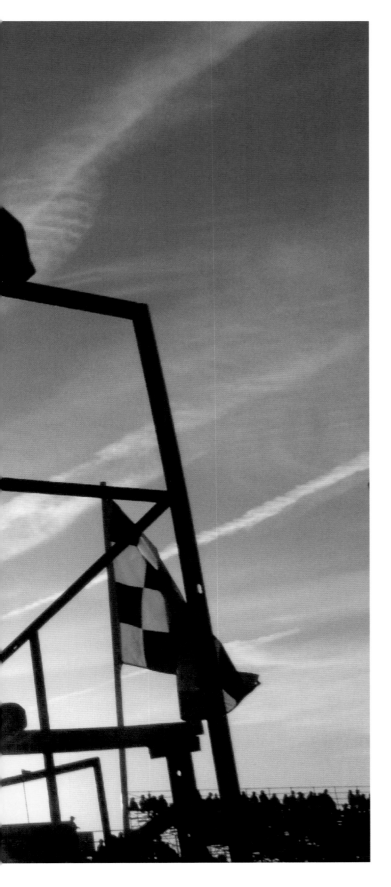

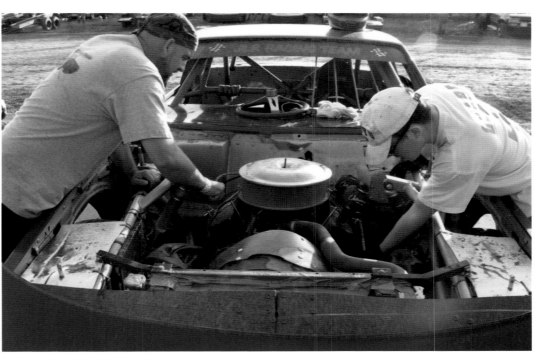

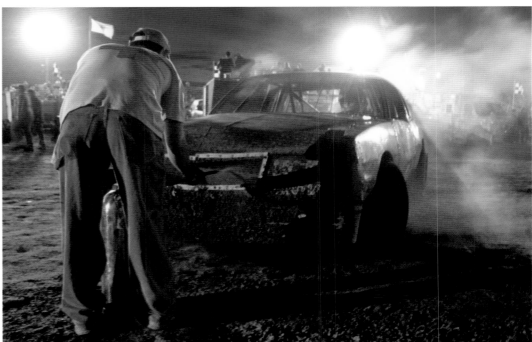

LINCOLN
Allison Hinrichs retrieves a soccer ball during half-time at her sister Victoria's game in Spirit Field.
Photo by Doug Carroll

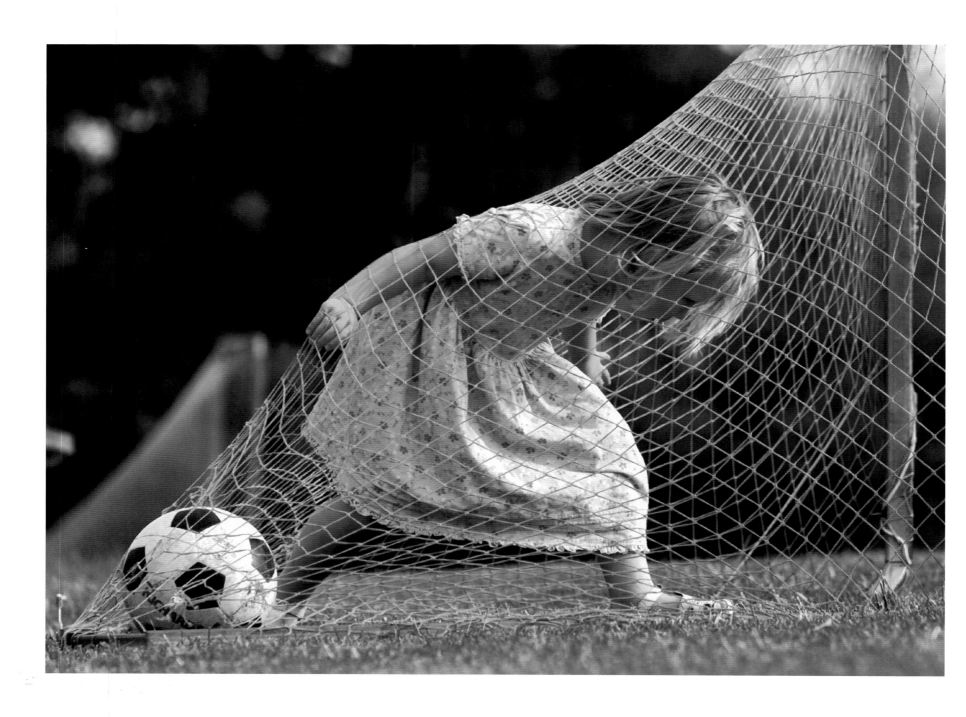

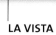

LA VISTA

Stephanie Stevens, 10, practices her swing at the public courts in La Vista, a burgeoning bedroom community just south of Omaha. Incorporated in 1960, it's Nebraska's newest city, full of people who work at Offut Air Force Base and Eppley Airfield.

Photo by Kent Sievers

BURWELL

Every May, more than 250 high school kids from around the Midwest and West travel to central Nebraska to compete in the Burwell High School Rodeo. Parents organize and local businesses sponsor the two-day event, held at the Garfield County Fairgrounds.

Photos by Doug Carroll

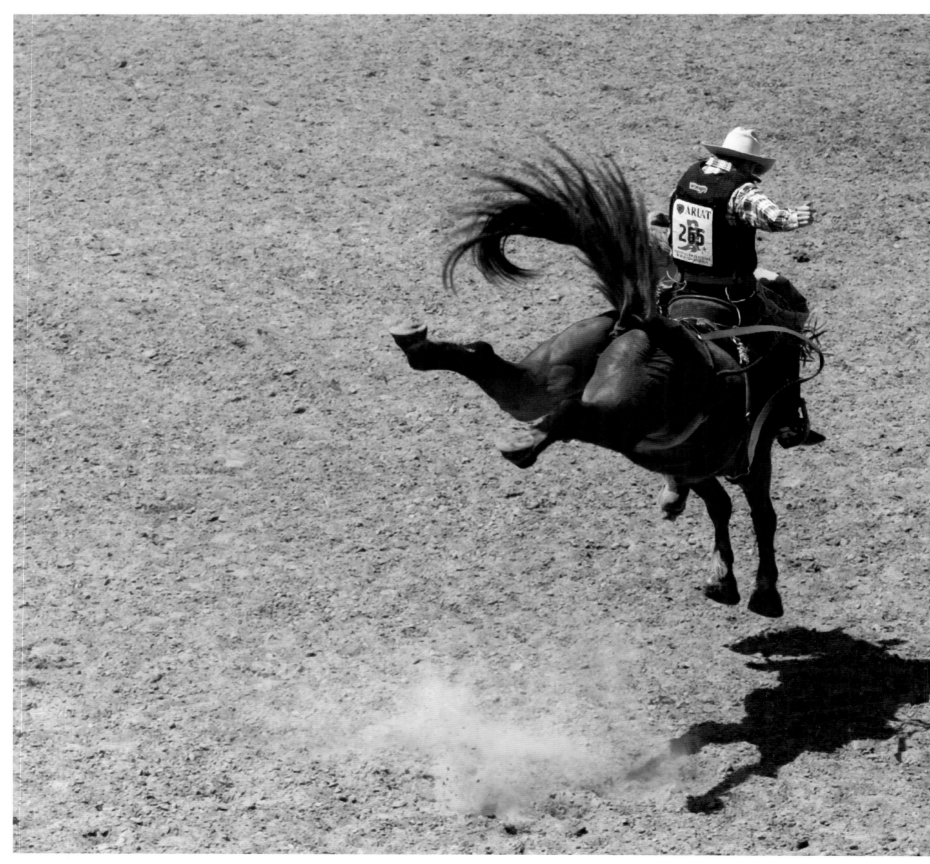

BURWELL

Willie Grimm tries to hang on during Sunday's bull riding competition. The high school senior drove from his hometown in Harrison—a six-hour drive. Nebraska held the first high school rodeo in America on April 12, 1947, in Curtis.

BURWELL

"I've been competing ever since I can remember," says Teri Coffman. She and her horse Bay did not win the pole bending event, but she did nab the goat tying competition.

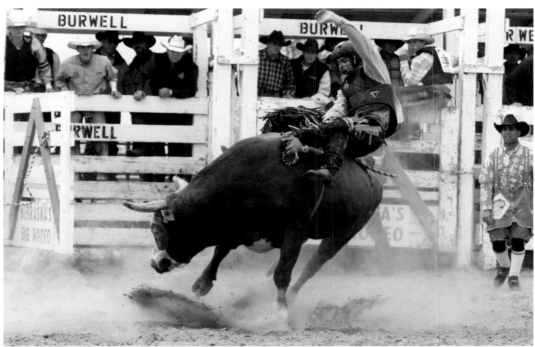

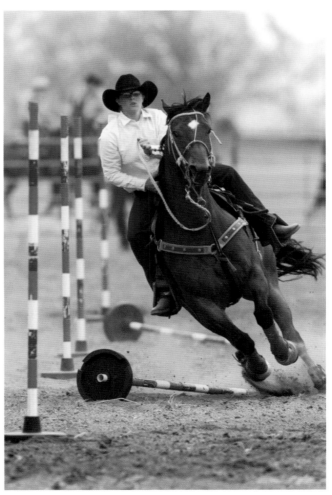

BURWELL

Body armor: Legend has it that in the 1930s, a rodeo belt buckle saved a cowboy's life. Celebrating his win at a local saloon, the drunken cowboy got into an argument that ended with a gunshot. The bullet hit the champion's buckle and ricocheted, shattering the bar mirror instead of the cowboy's innards.
Photos by Doug Carroll

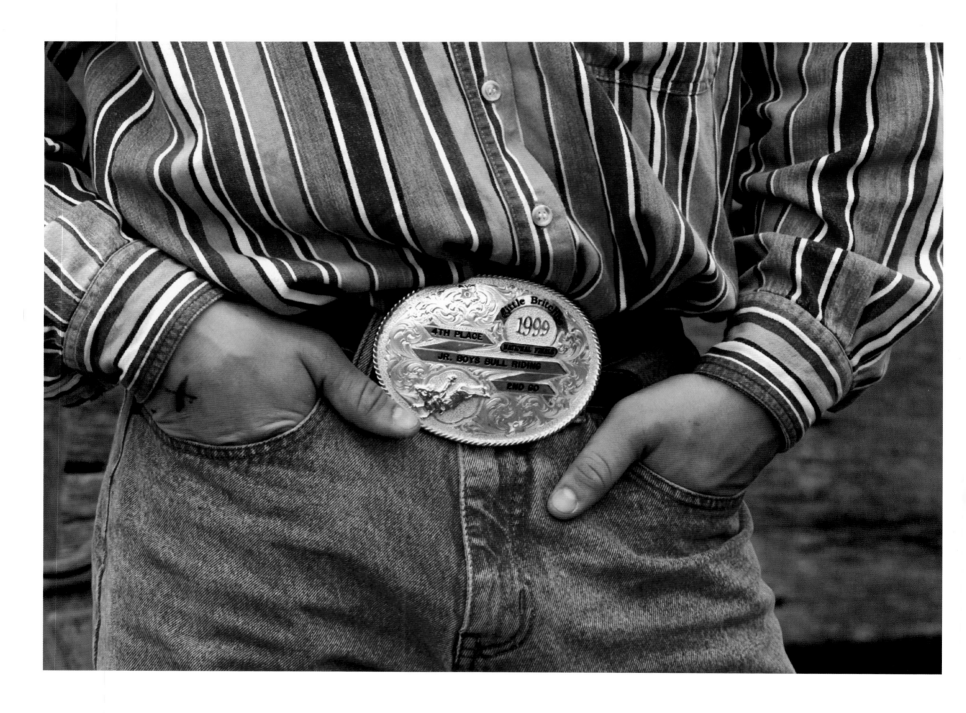

BURWELL

Badge of honor: Rodeos award custom belt buckles for the top finishers in each event and to the rider with the most overall points—the "all around" buckle.

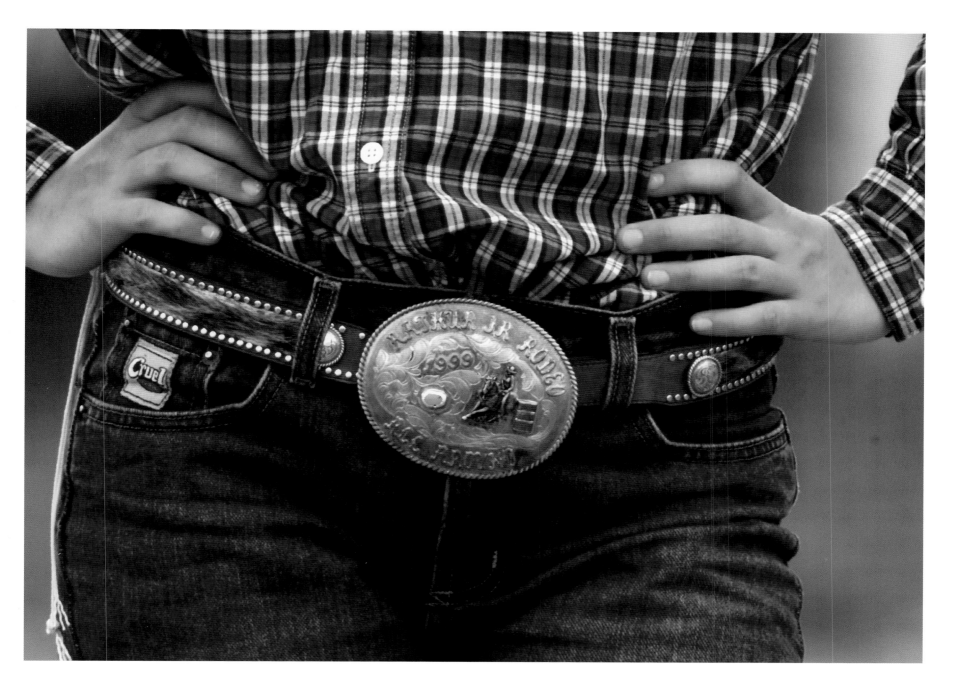

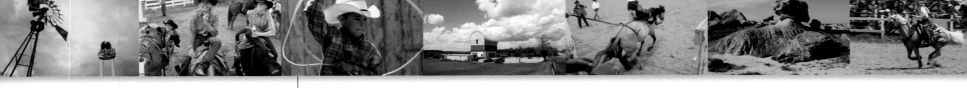

BURWELL
Cole Svoboda practices throwing a loop. The
8-year-old competes in junior rodeos with his
pony Blizzard.
Photos by Doug Carroll

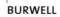

BURWELL

A veteran cowgirl at the age of 7, Tanner Stec has won three first-place buckles and $200 in prize money.

OMAHA

It's a penguin world for Mary and Lydia Miller at the Henry Doorly Zoo. Young visitors can climb into this alcove in the 72,000-square-foot Scott Aquarium to watch Antarctic penguins wing through the 38-degree water.

Photo by Kiley Cruse

GORDON

Billy Gibbons and national fiddle champion Harry Hanson play weekly at a nursing home in Gordon. Gibbons, a Lakota Sioux who grew up on South Dakota's Pine Ridge reservation, wasn't allowed to play in local venues 40 years ago. Now, he invites ranchers to join the Old Time Cowboys Memorial Museum, of which he's president.

Photo by Don Doll, S.J., Creighton University

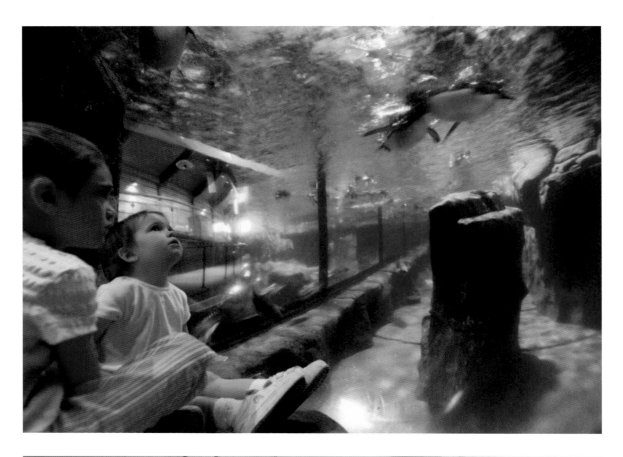

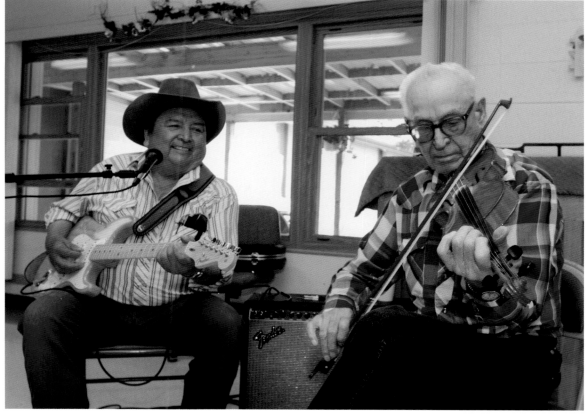

NORTH PLATTE

Dixie, a Labrador puppy, loves playing fetch with Lena Askvig at Cody Park on the Platte River. "There's a leash law," Askvig says. "And we usually get in trouble, but, you know, a dog can't play fetch on a leash."

Photo by Lane Hickenbottom

ASHLAND

Coty Surrounded and Mario Szlapka play rock, paper, scissors as their bus leaves Randolph Elementary School. They're part of a fourth-grade trip to Camp Carol Joy Holling, located halfway between Lincoln and Omaha. For two days, they'll erect tepees, study aquatic life, and scout for owls.

Photo by Richard Wright

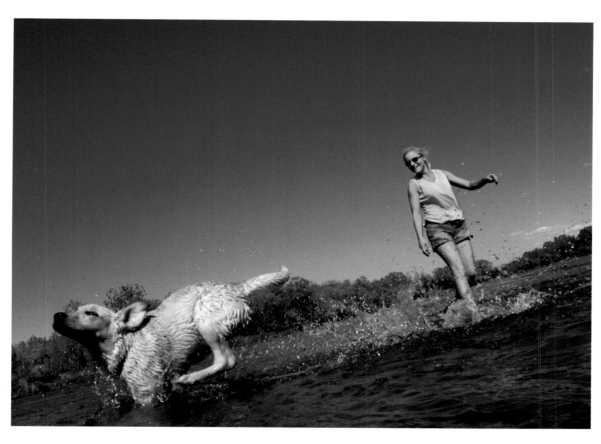

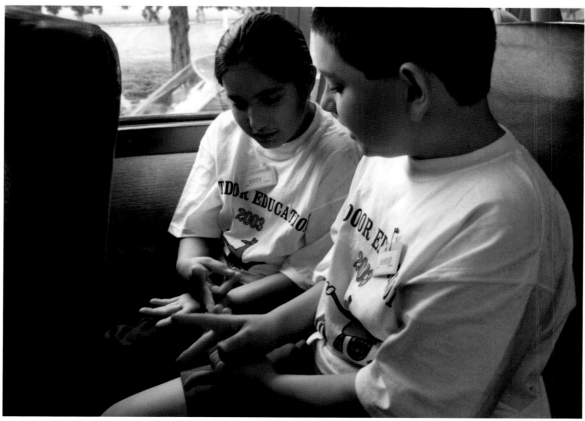

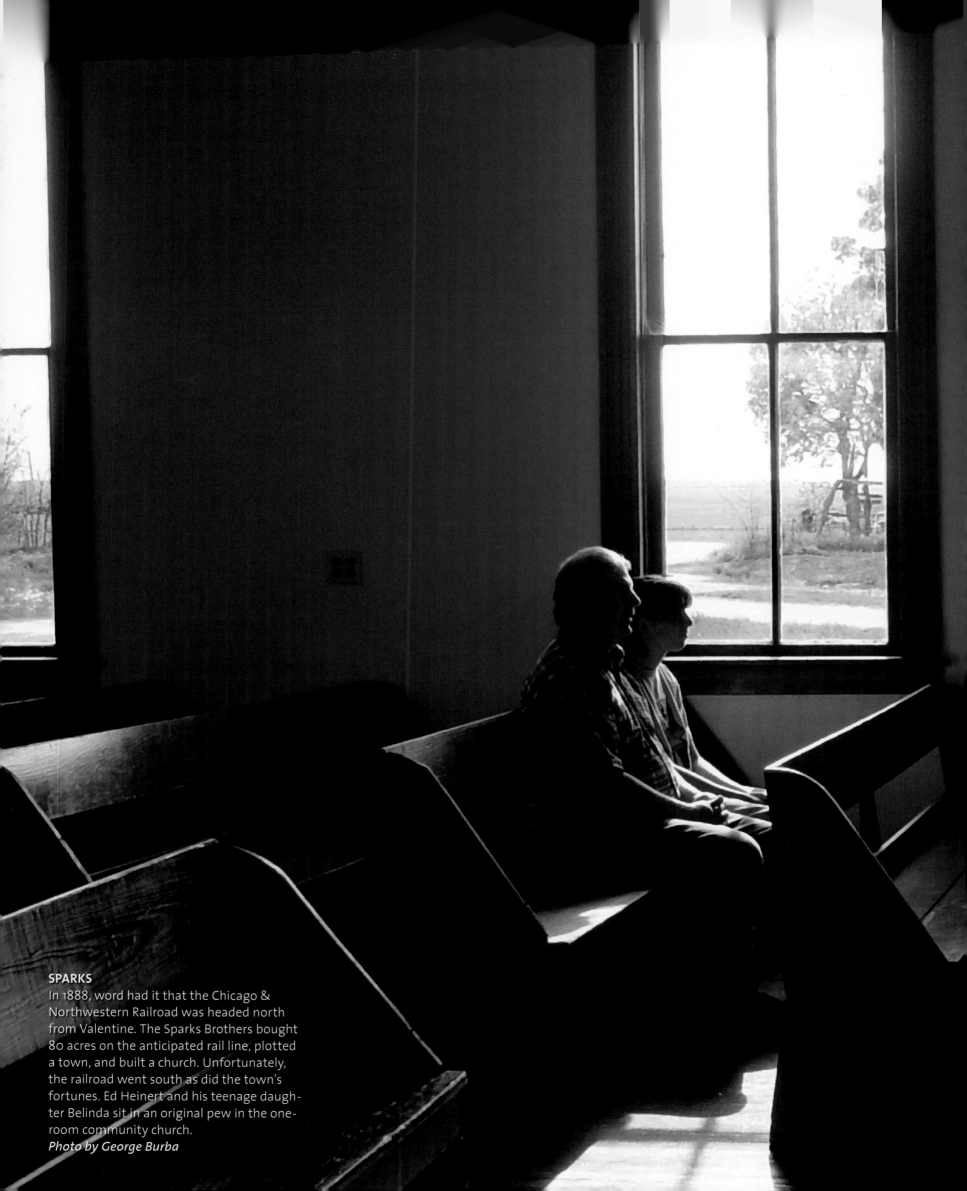

SPARKS

In 1888, word had it that the Chicago & Northwestern Railroad was headed north from Valentine. The Sparks Brothers bought 80 acres on the anticipated rail line, plotted a town, and built a church. Unfortunately, the railroad went south as did the town's fortunes. Ed Heinert and his teenage daughter Belinda sit in an original pew in the one-room community church.

Photo by George Burba

Reason To Believe

NORFOLK

Sister Norma Silva of Brazil prays at the Immaculata Monastery. The Benedictine Sisters' motto is *"Ora et labora"* (pray and work). To meet the latter goal, the monastery operates several medical facilities and teaches literacy to local Hispanic and Native American communities.
Photos by Darin Epperly

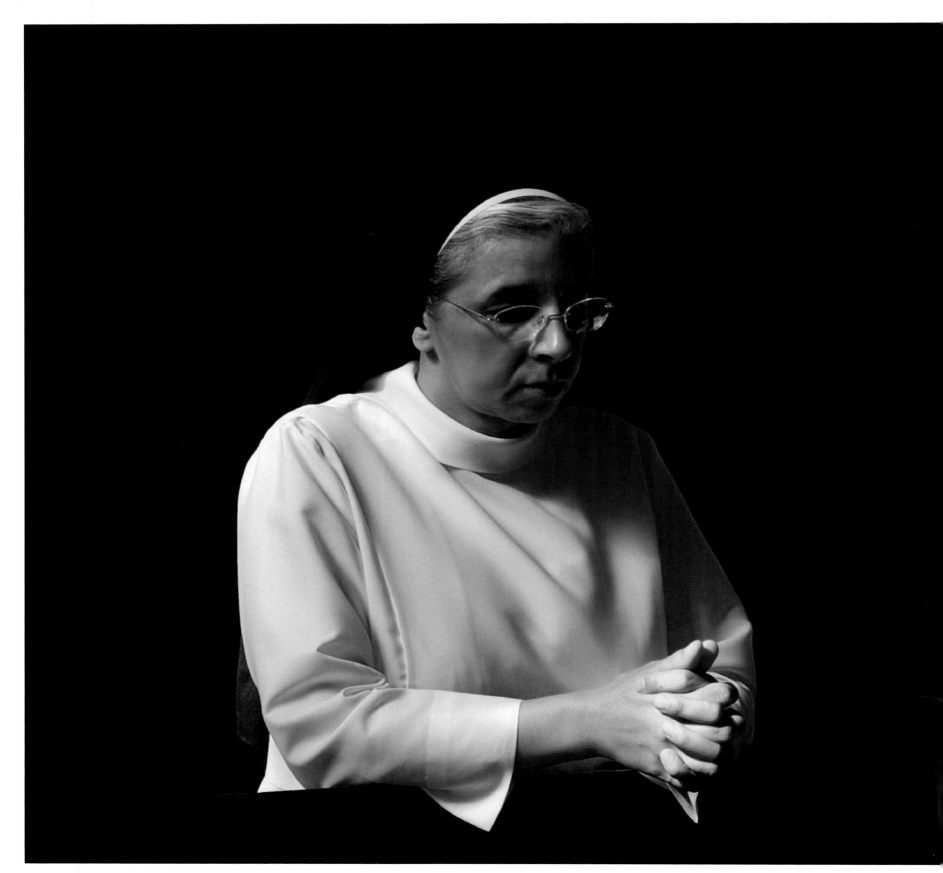

NORFOLK

Of the 35 nuns now living at the monastery, nine are from overseas. Sisters line up four times a day before heading into the chapel for common prayer. Called the *statio* (standing still) hall, the corridor is a reminder that they are on their way to God.

NORFOLK

One of four organists, Sister Matilda Handl likes to play barefoot. According to Sister Kevin Hermsen, the Prioress, none of the nuns played the organ before coming here. "They're very game, since it's basically on-the-job training," she says.

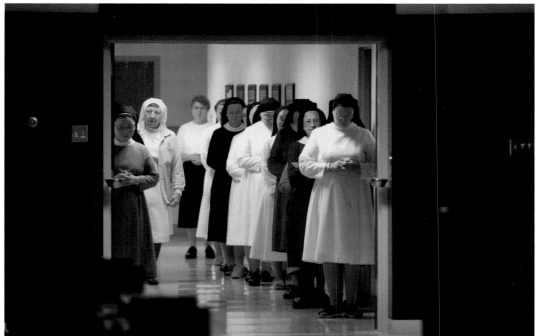

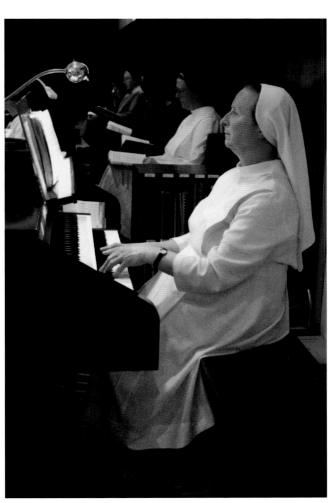

LINCOLN

Despite Parkinson's disease, Monsignor Leonard Kalin still says mass every morning in his Legacy Retirement Home apartment. The retired priest conducts the service at an altar that was once a closet. Gene Helget, who met the Monsignor through a mutual acquaintance, is one of several regular attendees.

Photos by George Burba

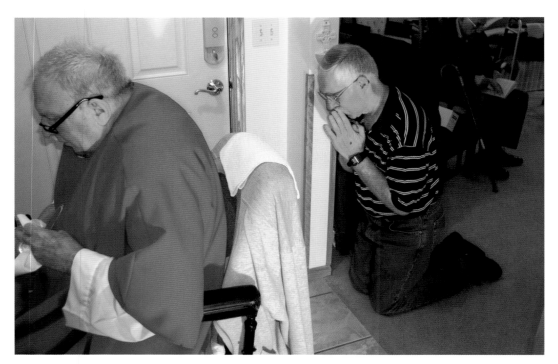

LINCOLN
Gene Helget helps Monsignor Kalin with his stole while he prepares for mass. As Vocations Director at the Lincoln Diocese for 28 years, the monsignor was legendary for recruiting new priests. It's said he inspired 500 vocations.

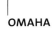

OMAHA

St. Cecelia Cathedral's new $1.1 million dual-temperament organ is still getting "voiced," a process which sets the volume, tone color, and intensity of its 5,000 pipes. One of four in the world, the organ can be tuned two ways, enabling sacred music from different periods to sound as authentic as possible.
Photo by Kiley Cruse

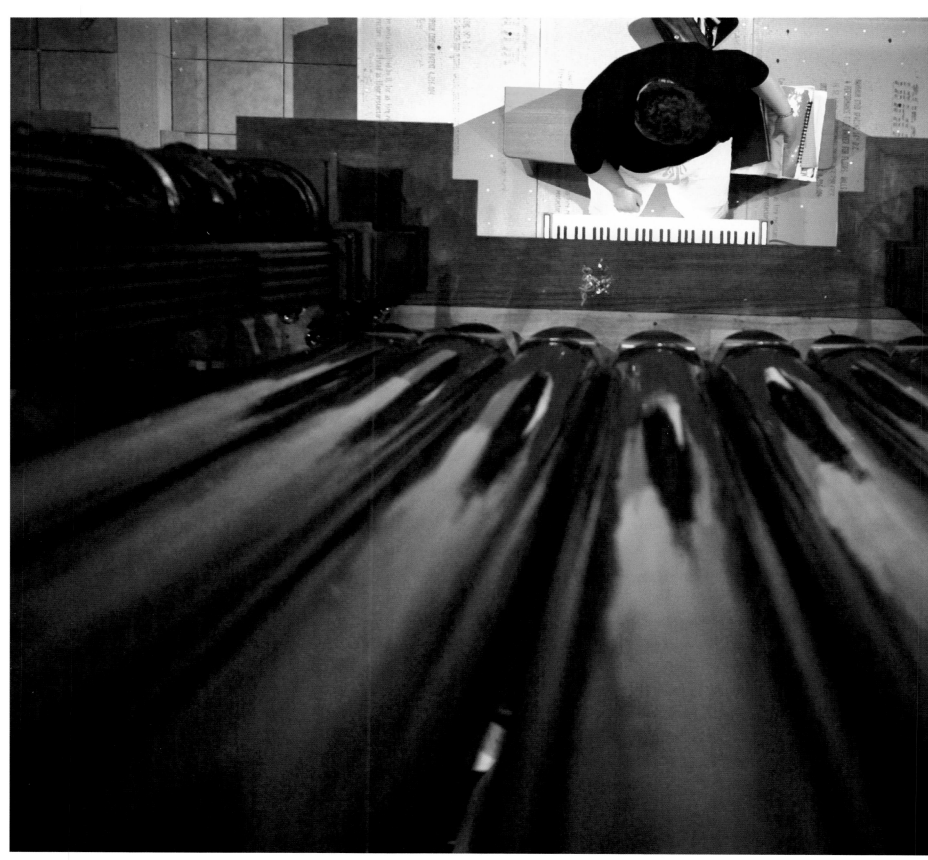

OMAHA

Tera Henrich, 16, attends church services at Grace Apostolic Church with her surrogate mother, Vira Brooks. Pastor William Barlowe pairs young women in his congregation who come from difficult home environments with older, caring women like Brooks, a cancer survivor.
Photo by Laura Inns

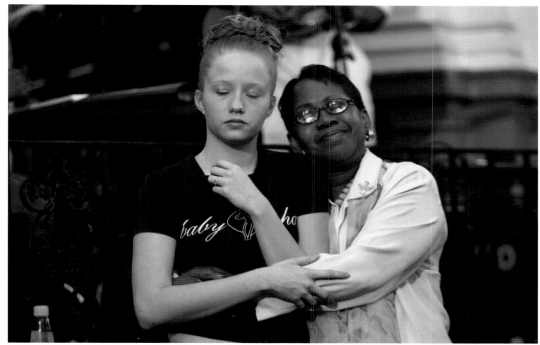

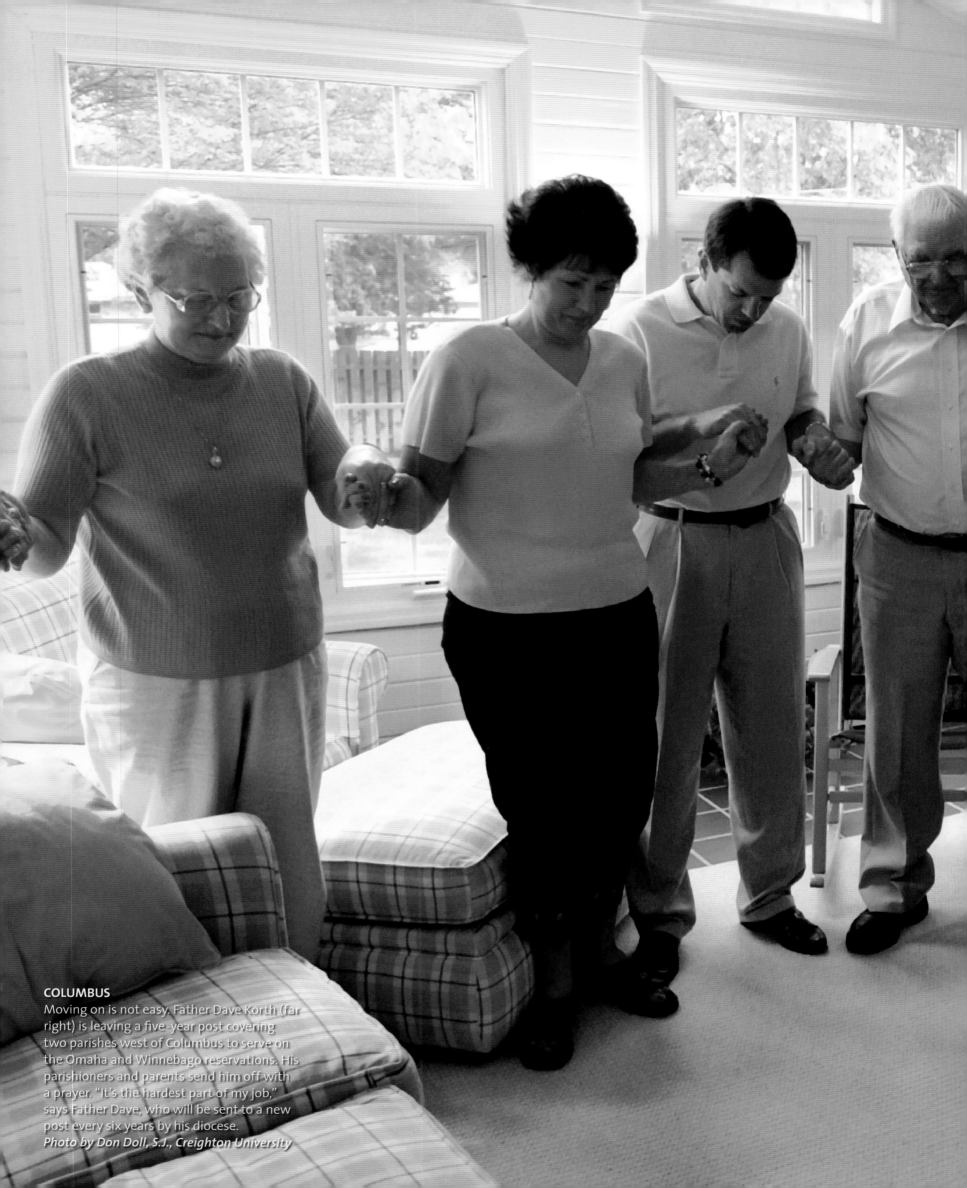

COLUMBUS
Moving on is not easy. Father Dave Korth (far right) is leaving a five-year post covering two parishes west of Columbus to serve on the Omaha and Winnebago reservations. His parishioners and parents send him off with a prayer. "It's the hardest part of my job," says Father Dave, who will be sent to a new post every six years by his diocese.
Photo by Don Doll, S.J., Creighton University

OMAHA

Pastor William Barlowe runs his controversial ministry, Grace Apostolic Church, from the converted Military Theater in North Omaha. The youth-oriented congregation first met in a storefront in 1986. "My centerpiece has always been the young people," says Barlowe. "I openly welcome gang members from the neighborhood —kids hungry for a father figure."

Photos by Laura Inns

OMAHA

A beaming TeQuila O'Neal-Moore exchanges wedding vows with Terrell Moore. Pastor Barlowe presides over the ceremony. The tough-talking minister encourages marriage because, he says, it's a commitment that gives women a sense of dignity. "A big problem in the black community is the sleeping around and the whoring."

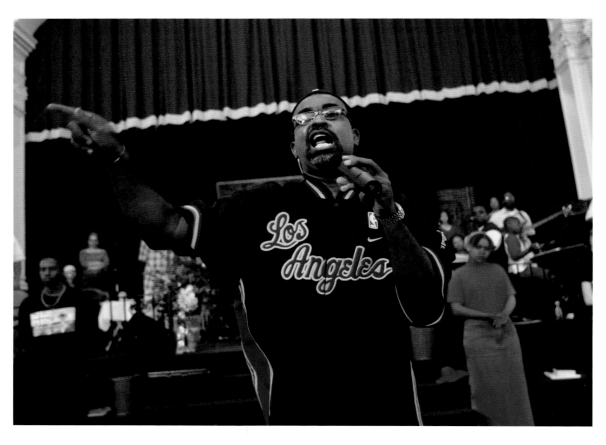

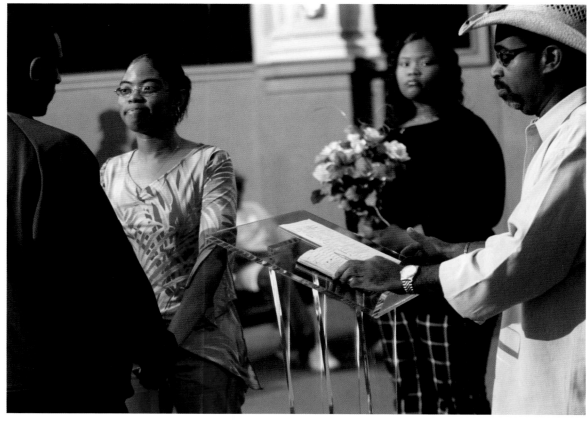

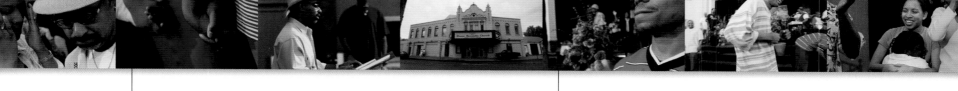

OMAHA

The congregation gathers at the 8 a.m. pre-church pep rally, Firestarters. "We pray and get in the right frame of mind for the Sunday service," Pastor Barlowe explains. "A lot of young people come in here angry. We clean out the bad spirits and pray for an atmosphere of healing."

OMAHA

Pastor Barlowe preaches as Ano J. Crowdy-Peak, a member of the church security detail, watches the congregation. Rival gang members attend services, and even though the church is considered neutral territory, the Pastor counts on men like Crowdy-Peak to be an extra set of eyes.

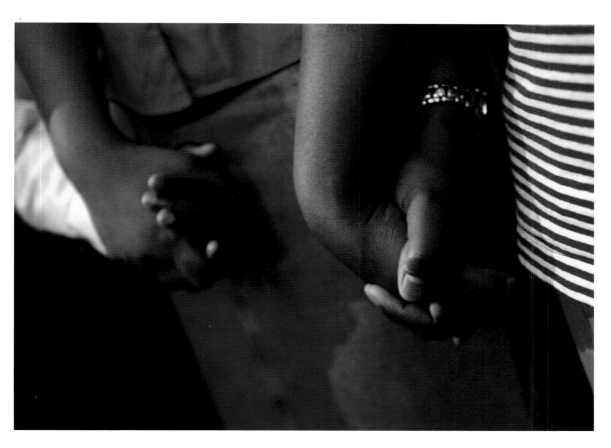

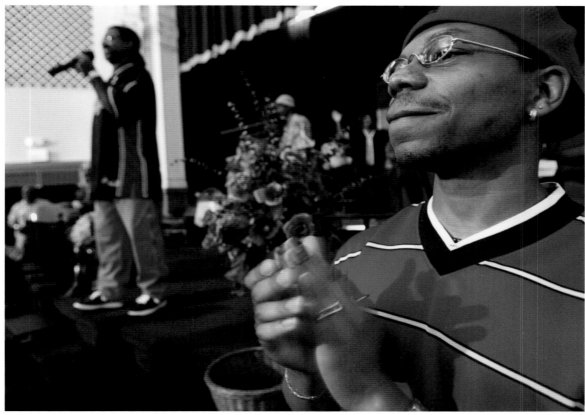

ALLIANCE
Sitting in a lonely field in Box Butte County, and patterned after Stonehenge, *Carhenge* (completed in 1987) by artist Jim Reinders consists of 38 vintage automobiles welded together to form arches. Photographer Matt Miller used a near-full moon, a flash, and a 30-second time exposure to project his image on the cars.
Photo by Matt Miller

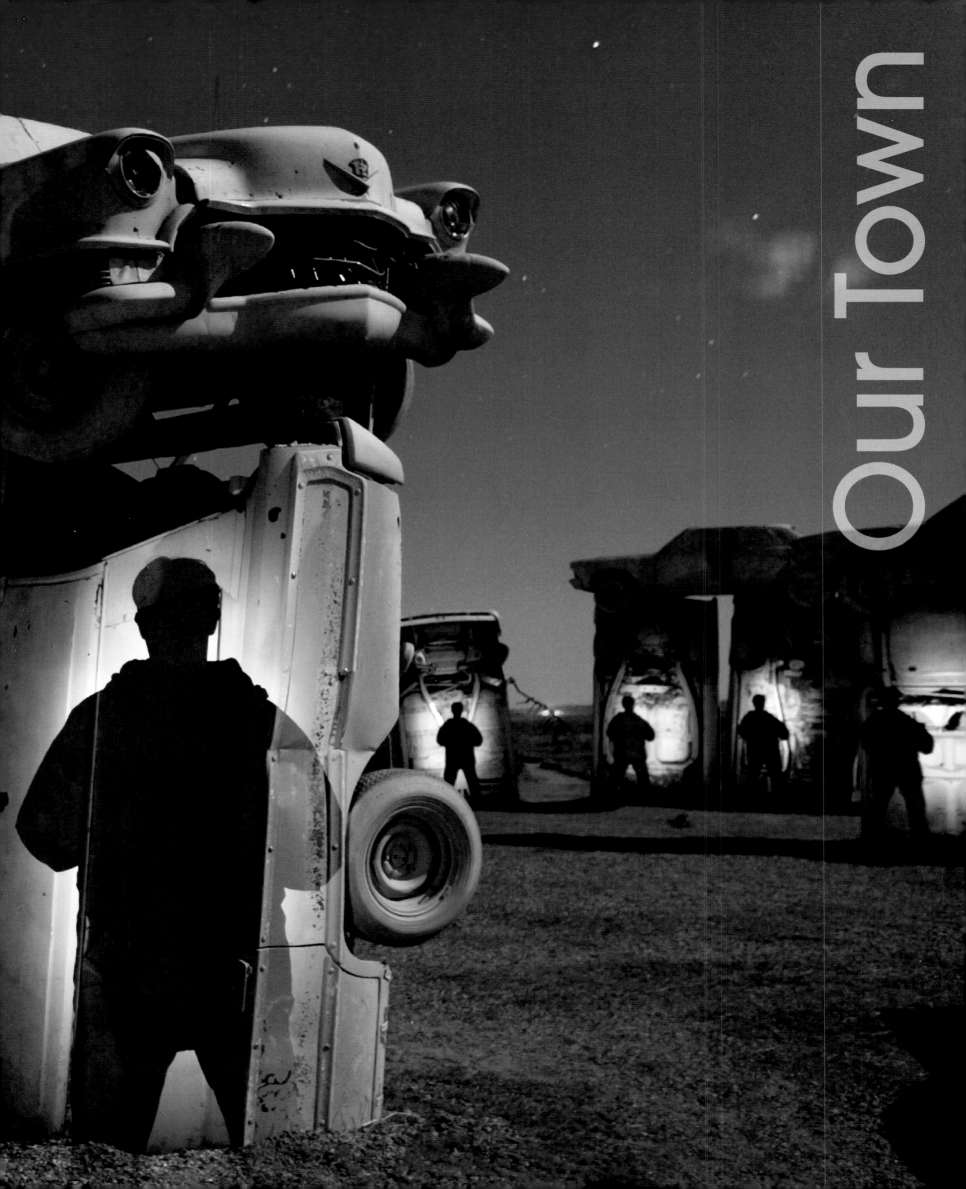

Our Town

Opened in 1952, the Starlite Drive-In is the oldest
of three remaining outdoor cinemas in Nebraska.
Haley Hoffman and Alyssa Blair, both 9, watch a
movie under the stars for the first time. Alyssa's
parents, Beth and Scott Blair, provide the seating.
Photos by Kent Sievers

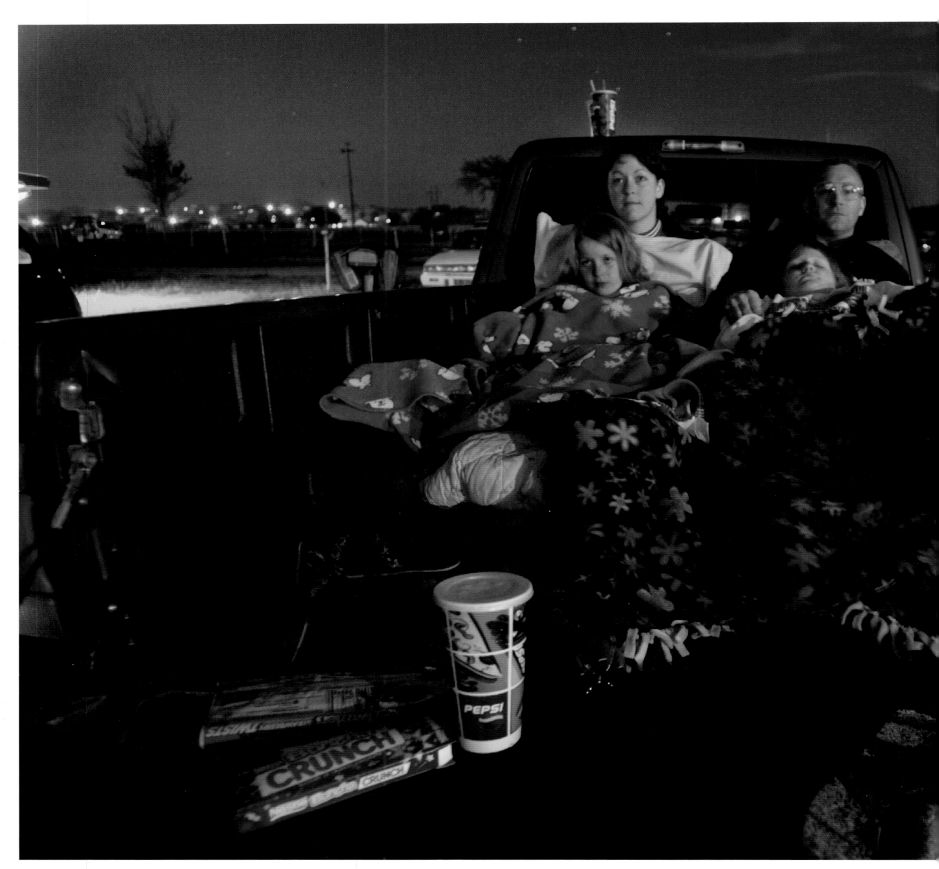

NELIGH

Today's fun at yesterday's prices: Owner Franklin Johnson works the booth. Since 1979, Johnson has run the Starlite and Main Street's New Moon Theatre. He plans to retire in a few months and hand off the movie reels to his son.

NELIGH

Moviegoers soak up *Daddy Day Care*. Rather than using the speaker poles of yore, patrons tune in with their car radios (550 AM or 89.9 FM) to catch the dialogue. In the 1950s, the heyday of outdoor cinemas, there were more than 40 drive-ins in Nebraska.

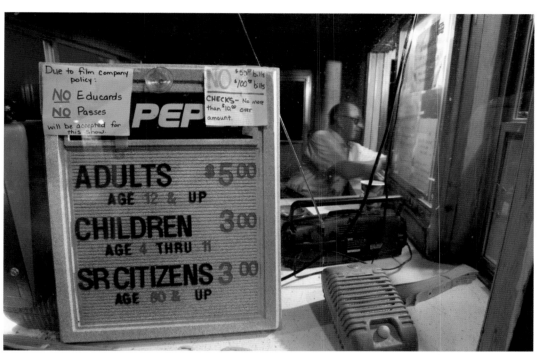

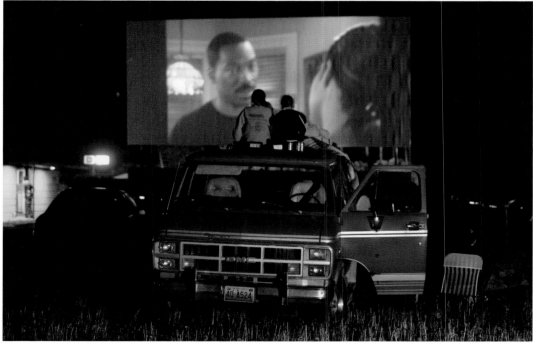

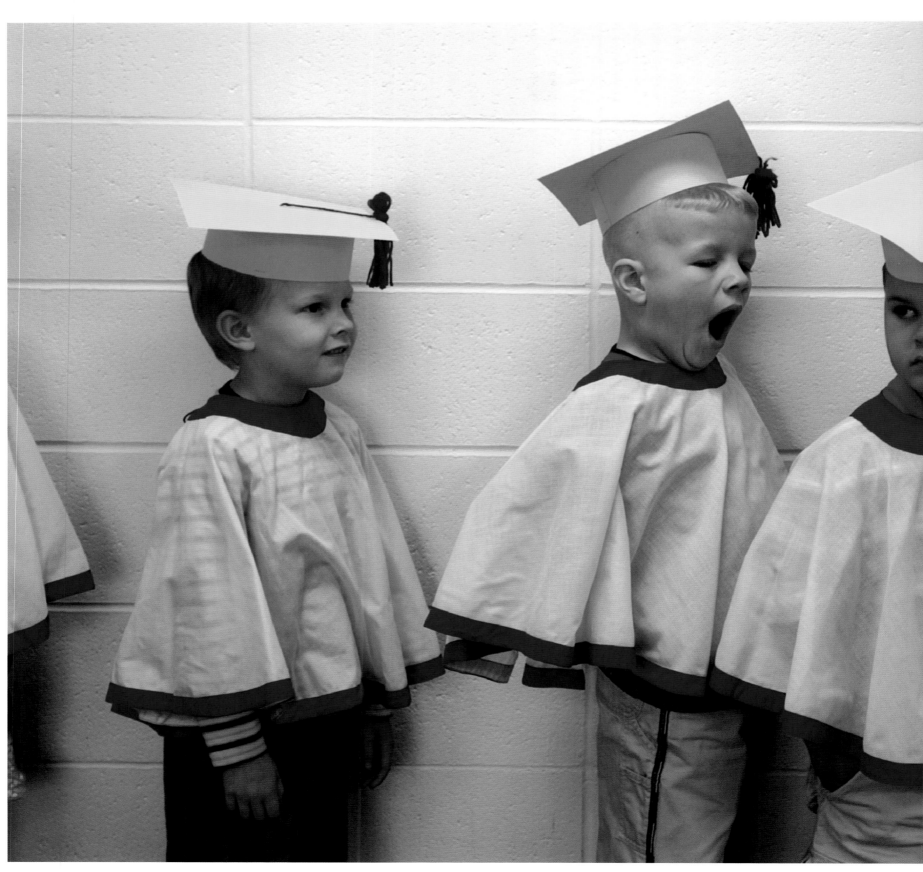

OMAHA

South High School holds graduation exercises for 300 seniors at the Civic Auditorium. The information technology and arts magnet school has a student body of 1,600. In 1889, when South first held classes, there were five students.

Photo by Laura Inns

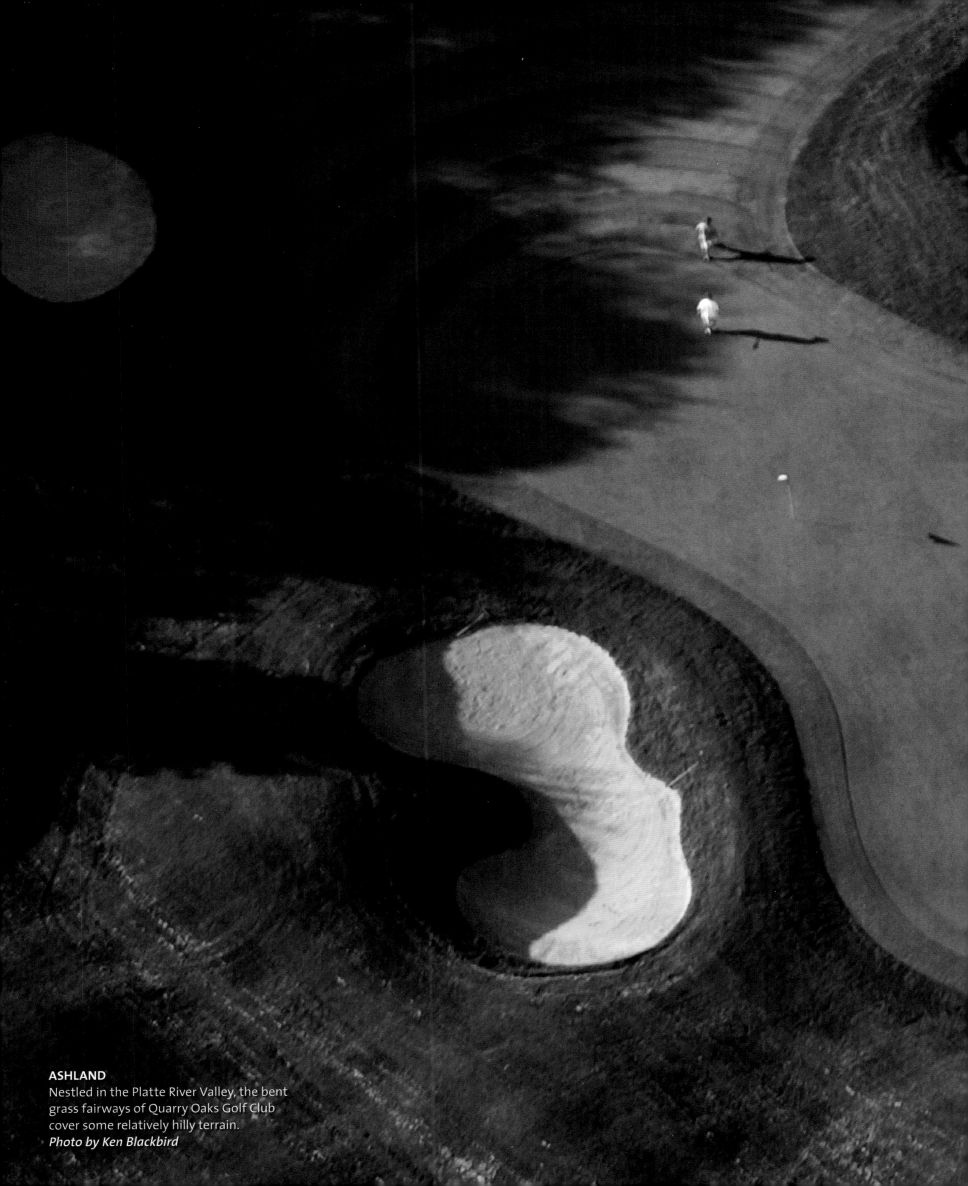

ASHLAND
Nestled in the Platte River Valley, the bent grass fairways of Quarry Oaks Golf Club cover some relatively hilly terrain.
Photo by Ken Blackbird

MONOWI

Nebraska hieroglyphics: Various ranch brands—
recorded on the bead-and-batten wall of the
town's defunct post office—add up to a cryptic
history of ranching in the Sandhills. In its heyday,
the building also served as a general store and a
cowboy bar.
Photo by Laura Inns

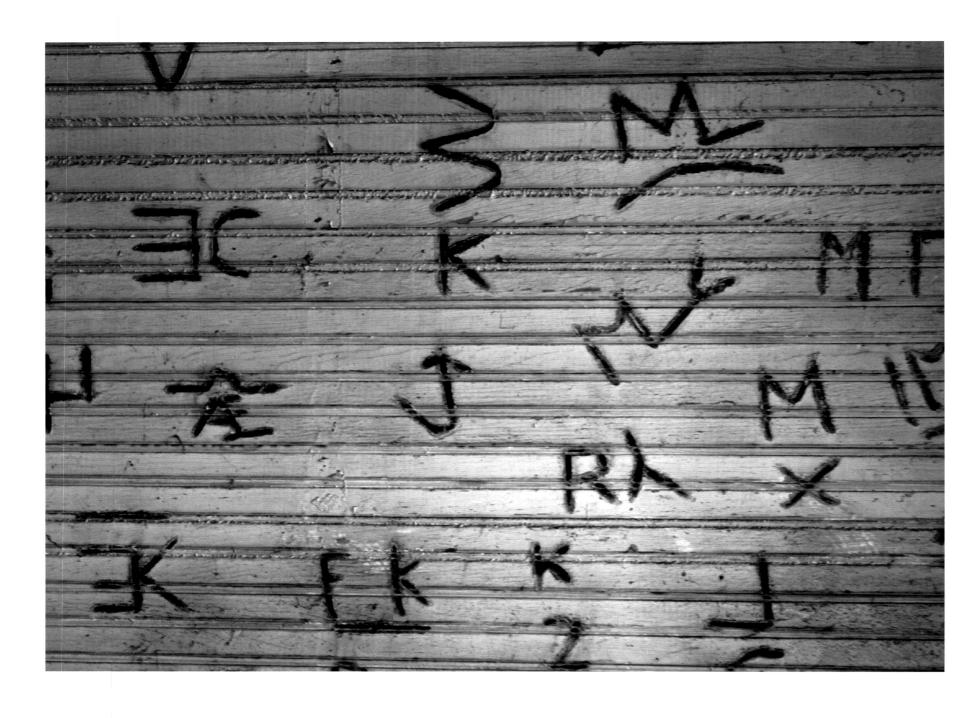

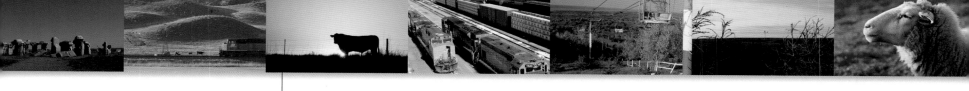

SPRINGVIEW

Cattle land: With only 1.6 million residents, Nebraska sells almost 5 million head of cattle, worth $5 billion, annually. By comparison, Texas with a population of 17 million, sells the same amount of beef.

Photo by George Burba

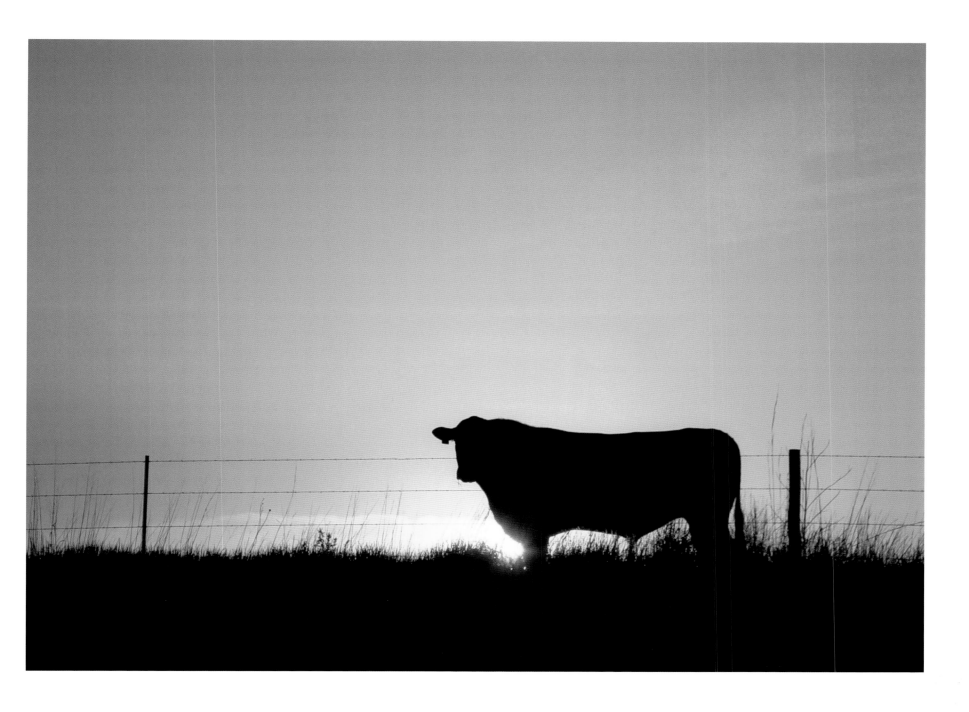

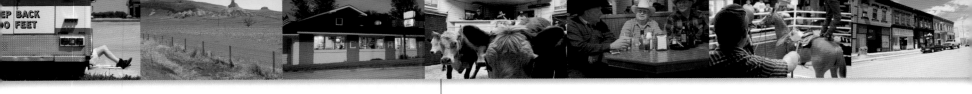

GRAND ISLAND

The Bradstreet Livestock Commission is one of a dwindling number of auction barns remaining in the state. Competing with the livestock conglomerates that buy straight from farms at set prices, auctions are competitive bidding environments where true-market value prevails. It works here at Bradstreet—they sold more cattle in the first half of 2003 than in the preceding five years.

Photos by Scott Kingsley

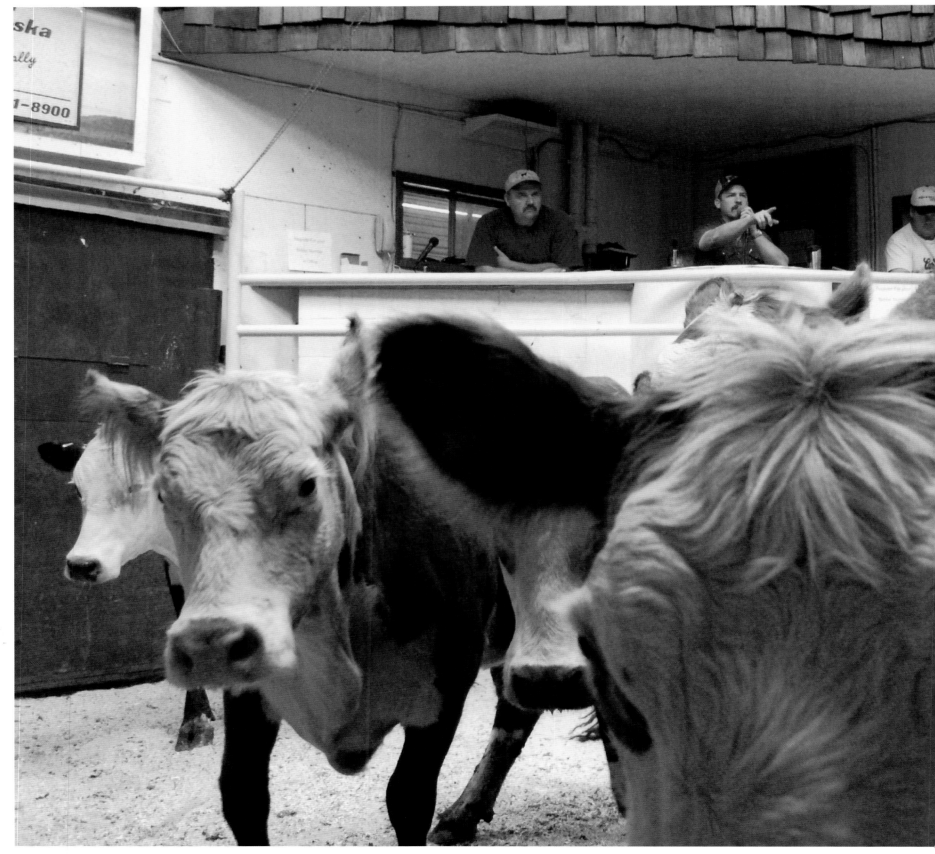

GRAND ISLAND
Slate Watson cozies up with his grandpa Albert Walton, who eyes the calves at the Bradstreet auction. Walton is looking for a calf for Slate's sister to raise as a 4-H project.

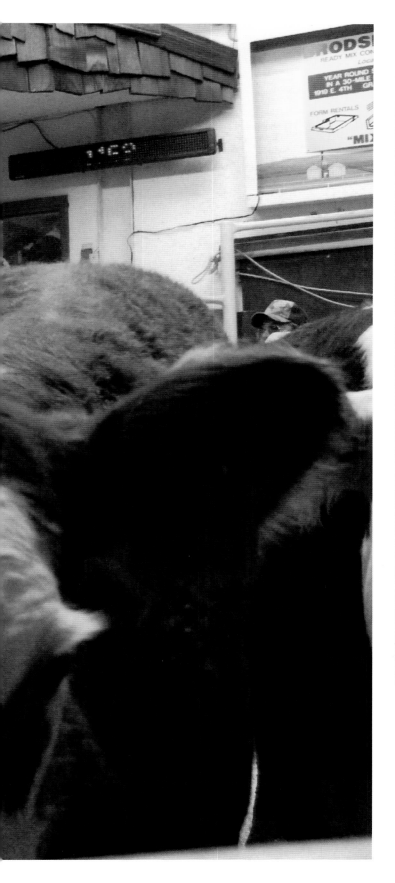

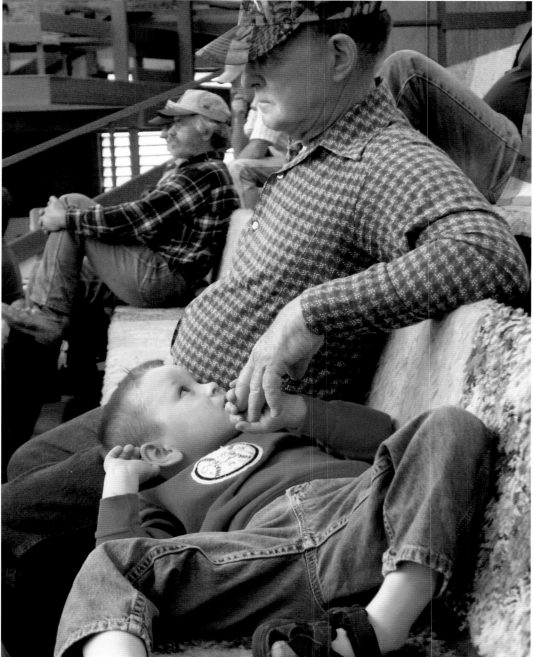

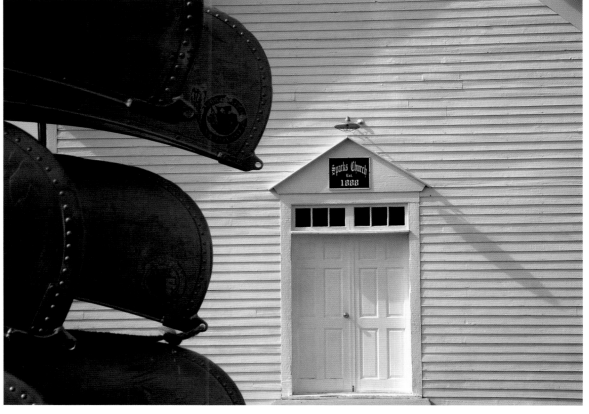

BREWSTER

North Loup River winds through Blaine County. Thousands of square miles of sandy soil and a close-to-the-surface aquifer form vast grasslands and wetlands. Local ranchers are working with government and conservation agencies to protect the biologically diverse habitat.
Photo by Don Doll, S.J., Creighton University

SPARKS

It took three days to build this town's one-room church in 1888. Afterward, there was a two-day celebration—a tradition that continues today as Old Settlers Days. The whole town, consisting of Ed and Louise Heinert and their daughter Belinda, turns out, along with more than 300 people from the surrounding area.
Photo by George Burba

LINCOLN

Forged from bronze, the statue of the Sower atop the capital building peers northwest toward the plains of the Cornhusker state.

Photo by Doug Carroll

LINCOLN COUNTY

Near the town of North Platte, a mesocyclone takes shape. The rotating column of air might turn into a tornado if its downdrafts intensify. On this particular afternoon, the storm passes; it's just another day on the plains.

Photo by Allan E. Detrich

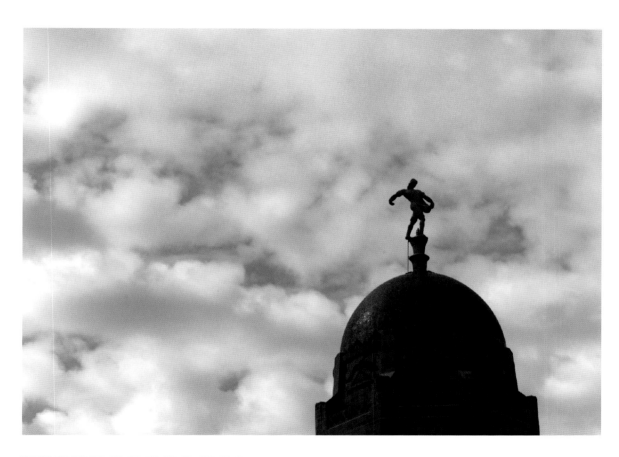

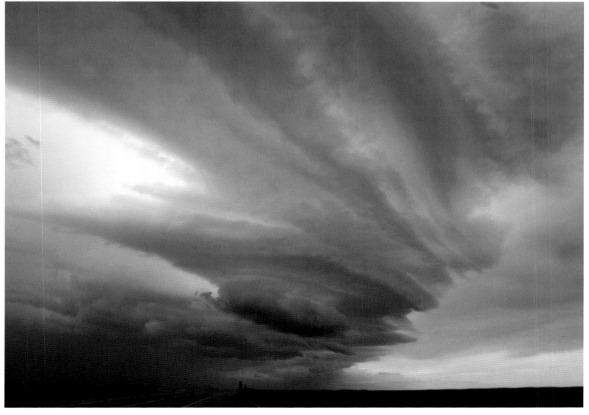

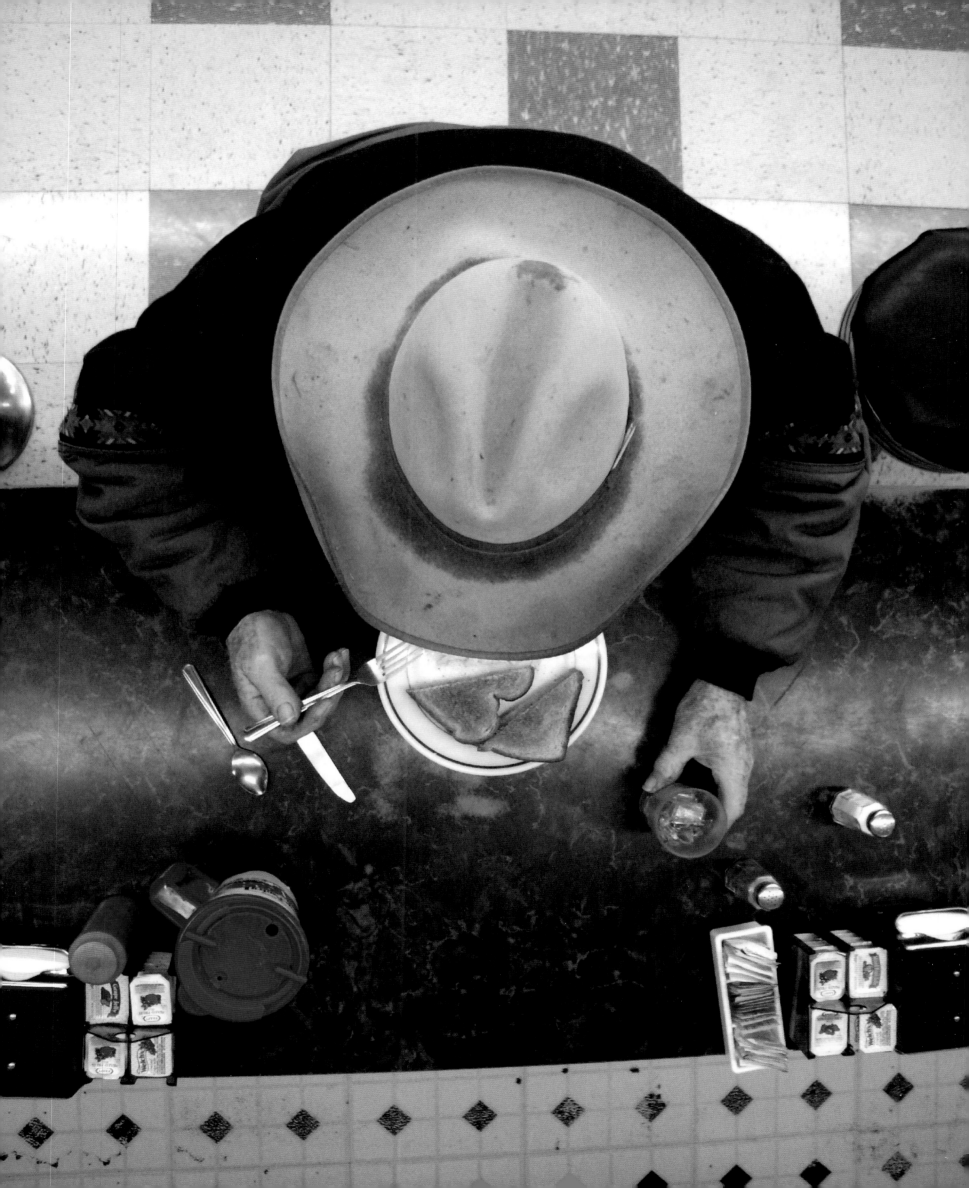

CENTRAL CITY

Breakfast at Donna's Prairie Cafe: "I like it because I can get 'falsies,'" says Marlin Wells. He's on a restricted diet, so he orders oatmeal most mornings, but once in awhile it has to be eggs, even if they're fake.

Photos by Scott Kingsley

CENTRAL CITY

Donna Graham took over the restaurant on Highway 30 a year ago. She's at work by 3 a.m. to bake pies, make gravy, and set up for locals, truckers, and tourists. "You know what your regulars want, and you worry about 'em if they don't come in," she says.

CENTRAL CITY

John E. Fishler arrives at Donna's at 5:30 a.m. to read the *Omaha World Herald* over coffee before going to work on the county road sign crew. "The kids keep me pretty busy—they shoot 'em up and steal 'em," he says. "I call it job security."

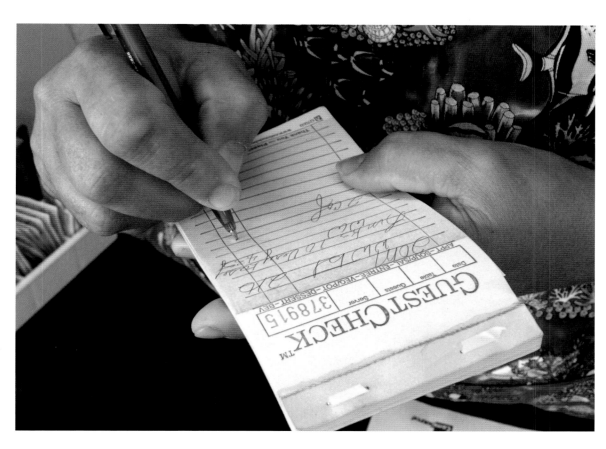

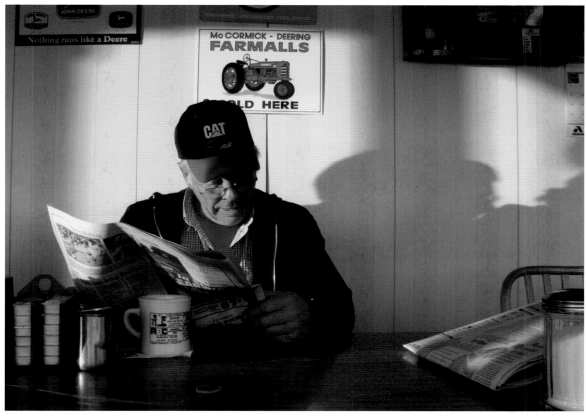

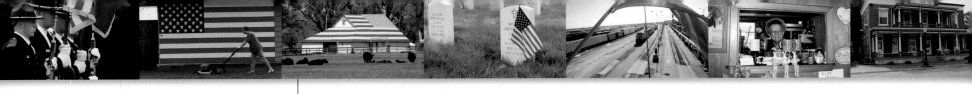

BASSETT

When Angus breeders Dick and Susan Tracy bought this farm in 1993, the turn-of-the-century barn was in bad shape. They reinforced the inside, replaced windows and doors, and rebuilt the roof. A former U.S. Marine who served in Vietnam, Dick chose red, white, and blue asphalt shingles to create the flag.
Photo by Darin Epperly

LINCOLN

A 14- by 10-foot corncrib door (rescued after a windstorm) found new life as a flag painting. Ed Ehrenfried displays his creation on an abandoned barn just outside the city limits, where motorists on Highway 34 can see it.

Photo by Khara Marae Lintel

RED WILLOW COUNTY

A tractor near McCook does double duty as proud platform. Ninety-five percent of Nebraska's landscape belongs to agriculture—wheat, soybeans, corn, and sorghum. What was once considered a part of the Great American Desert is today the country's breadbasket.

Photo by Allan E. Detrich

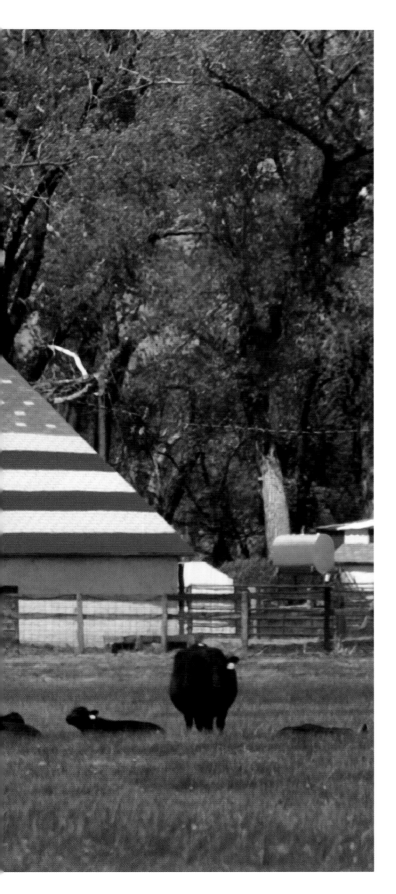

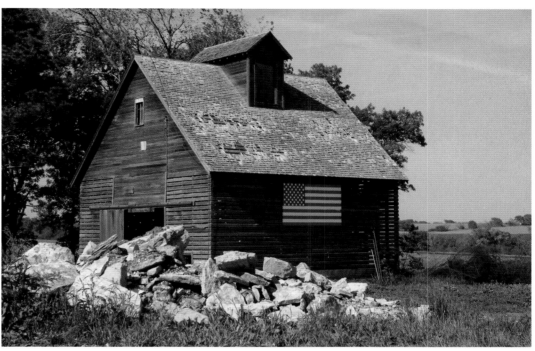

LINCOLN COUNTY
When dinosaurs ruled the Interstate 80 truck stop. Near North Platte, a Sinclair service station's Dino beckons travelers. Founded in Kansas by Harry F. Sinclair, the company began using a brontosaurus as its mascot in 1930 and inadvertently spun the lore that crude oil is but a soup of decayed dinosaurs.
Photo by Allan E. Detrich

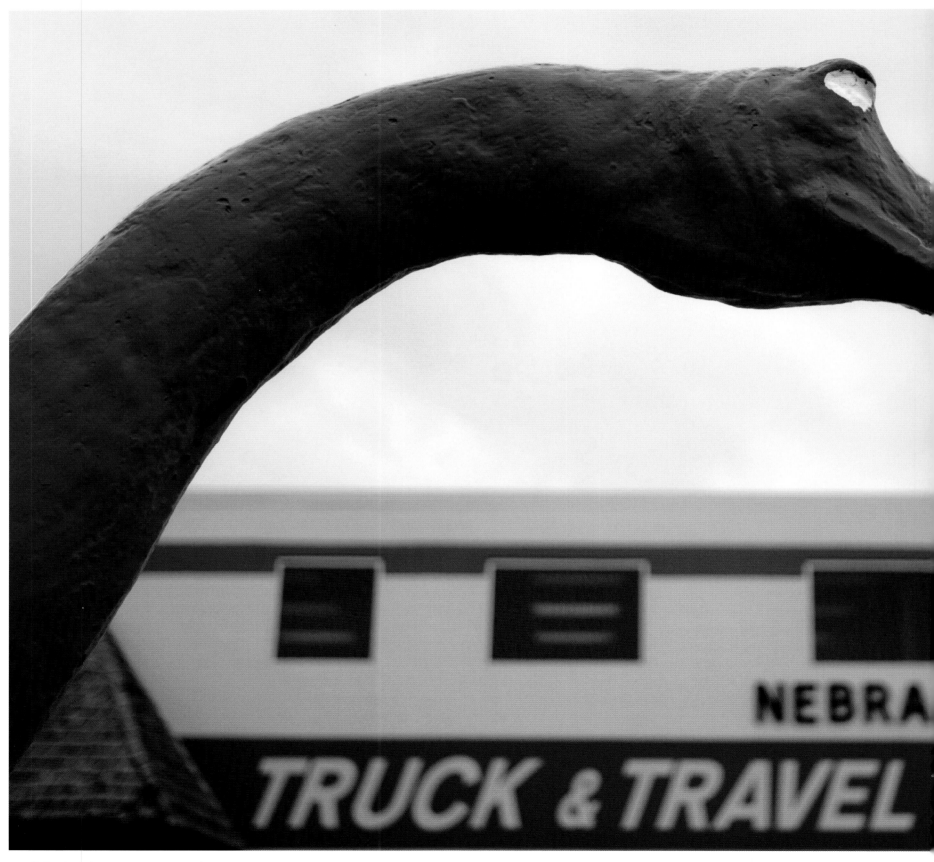

OMAHA

She's alive! During Lauritzen Gardens' Spring into Spring Festival, a living tableau called "The Fountain" spouts delicate jets of water. She is part of The Living Garden, a touring troupe of performance artists based in Orlando, Florida.
Photo by Lane Bleess

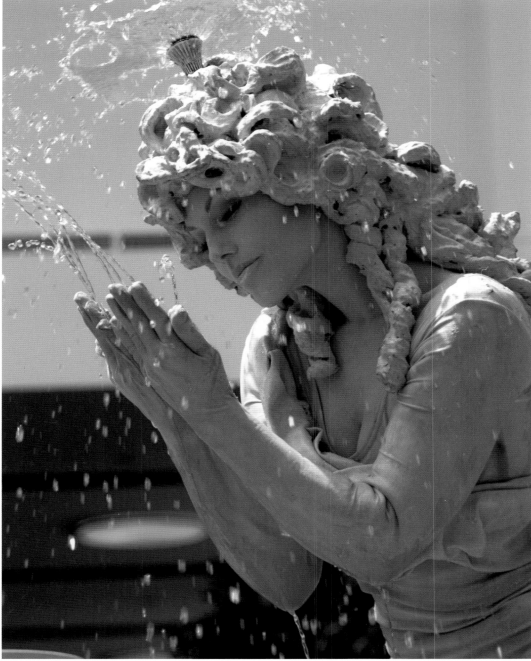

LINCOLN

Founded in 1937, the Oklahoma-based Carson &
Barnes Circus presents astounding, death-defying
acts under the traditional big top: aerial acrobat-
ics, ferocious animals, and, of course, clowns.
When it's over, performers leave the audience
with a big, flag-waving bang.
Photos by Ken Blackbird

LINCOLN

The show must move on: Carson & Barnes Circus
tent wranglers pack up the polyvinyl after a per-
formance. From stake-line to stake-line, the big
top is 300 by 130 feet, creating a show area of
360,000 square feet. The circus packs up almost
daily, traveling from one community to another,
putting on two shows per day. Next stop: Wayne,
Nebraska.

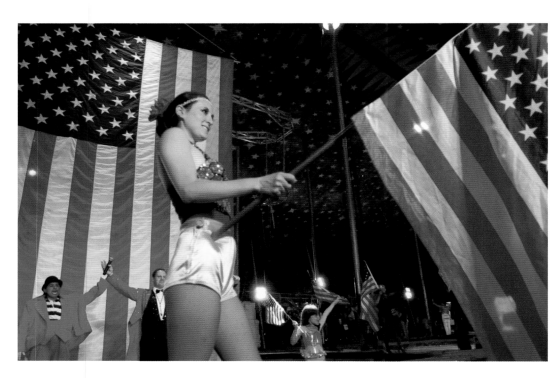

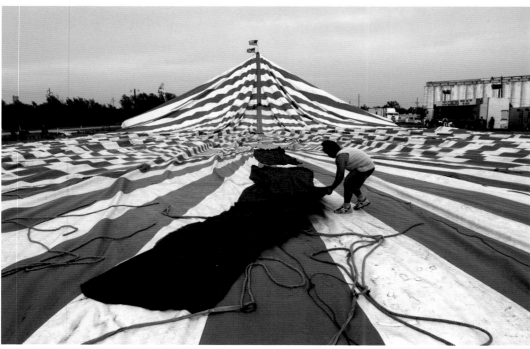

LINCOLN
With glitter and greasepaint, grit and grace, circus performers entertain the masses. The Carson & Barnes Circus travels continuously for eight months, a nomadic city on wheels.

SPARKS

A troop of Boy Scouts, their dads, and a dog ride Ed Heinert's bus to a paddling adventure on the Niobrara River. This shuttle service is part-and-parcel of Heinert's canoe-rental business, which he runs out of his convenience store in Sparks.
Photo by George Burba

ARNOLD

Marilyn Brohman's 19 sixth-graders give her a bouquet of 19 roses to mark her retirement after 49 years in the classroom. Brohman started teaching at age 17 in a country schoolhouse. "This is the best group I've worked with in 10 years," she says.
Photo by Lane Hickenbottom

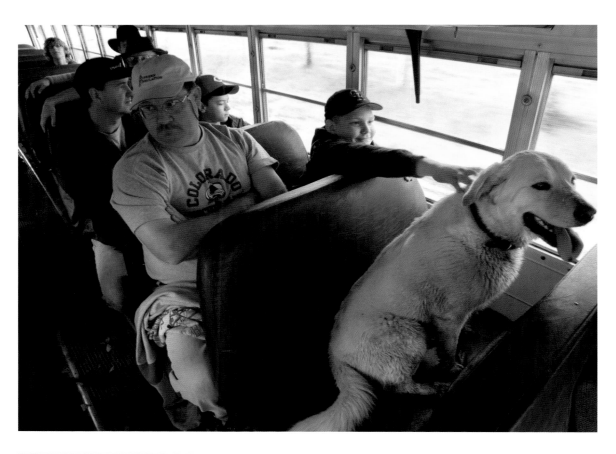

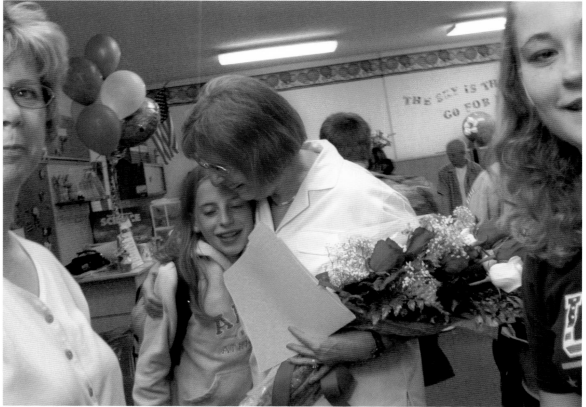

OMAHA

Tornado warnings are out. Students hustle down North 24th Street to get home.

Photo by Jeff Bundy, Omaha World-Herald

VALENTINE

It's Nicholas Sasse and Torie Lindsey's turn to take down the flag at Hart Lake, a one-room school. Ranches in the area are so large and far apart that Cherry County supports 21 one-room schools to educate kids close to home. Hart Lake has five.

Photo by Don Doll, S.J., Creighton University

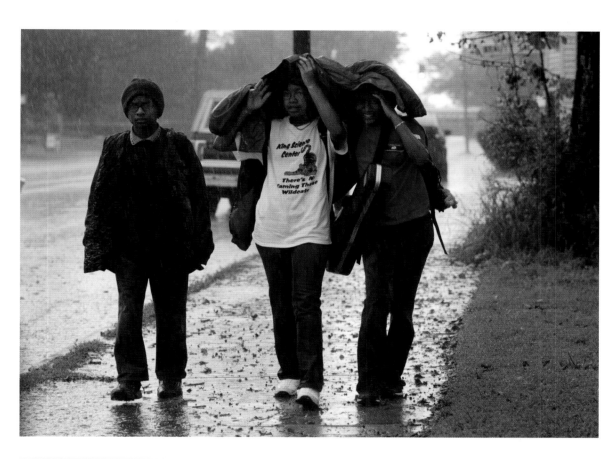

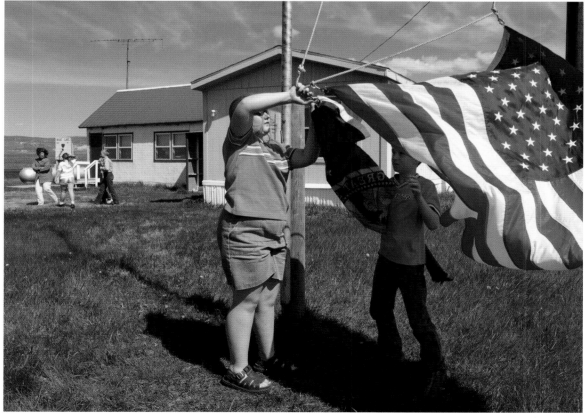

LINCOLN
A small bull elk herd takes it easy in the prairie
flora in a fenced section of Pioneers Park. Located
at the southwest fringe of Lincoln, this 900-acre
park was laid out during the Great Depression
and paid for by President Franklin Roosevelt's
Works Progress Administration.
Photo by Doug Carroll

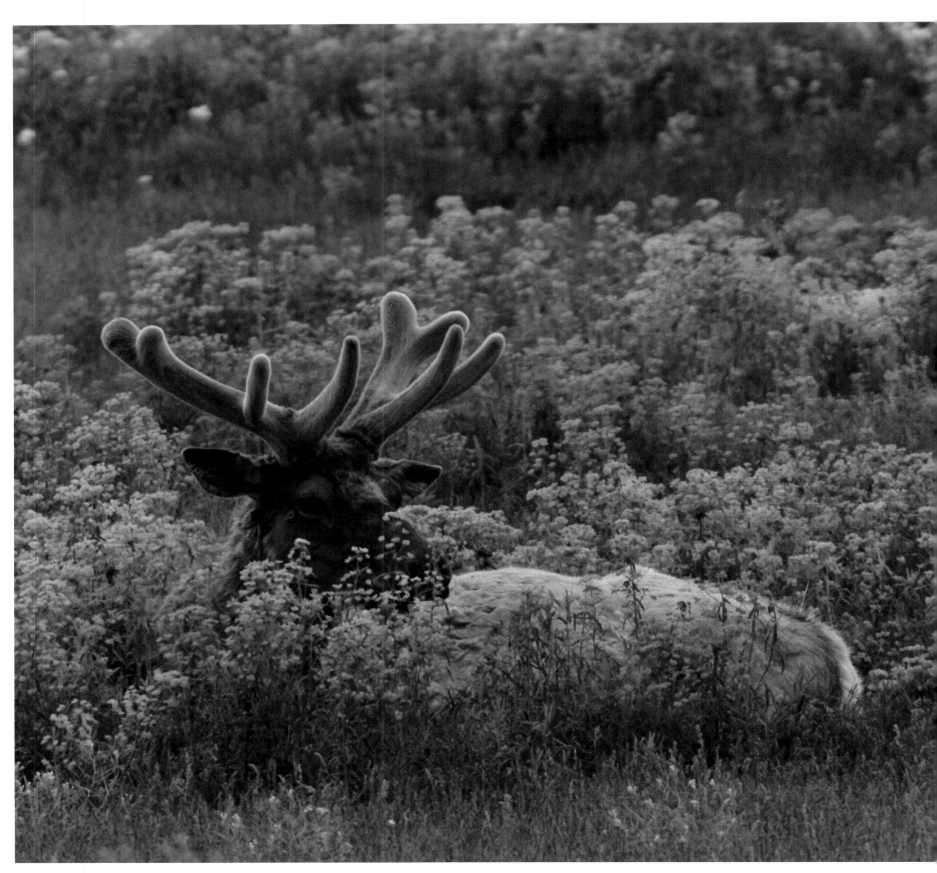

WHITMAN

The grass is greener: Mule and white-tailed deer, pheasant, and grouse are plentiful in the lands drained by the North and Middle Loup rivers of central Nebraska.
Photo by Matt Miller

NORDEN

Ah, spring! A quarter horse colt bounds across fresh grass in the Sandhills of Nebraska. Grass-covered dunes dotted with lakes stretching for hundreds of miles across the northern tier of the state, the Sandhills support a half-million head of cattle.
Photo by Darin Epperly

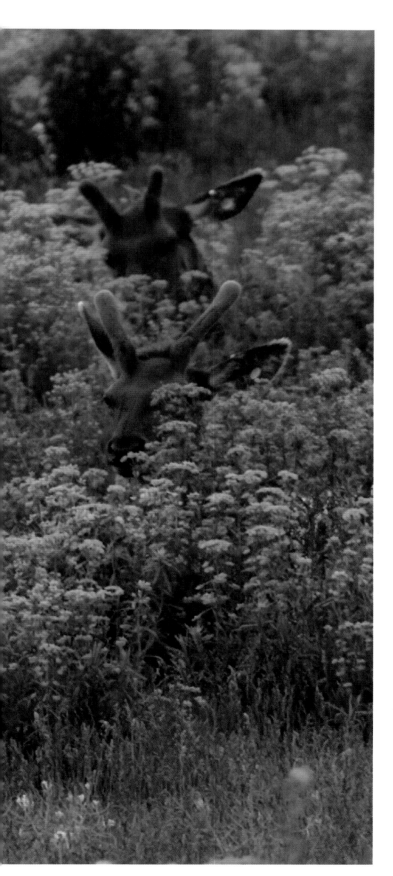

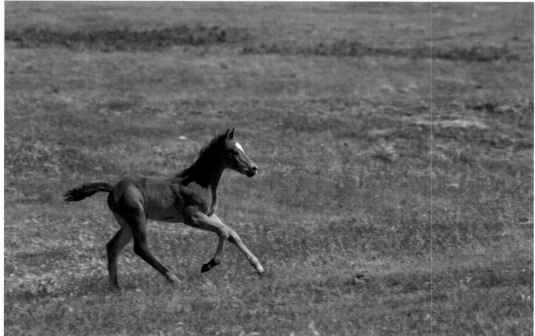

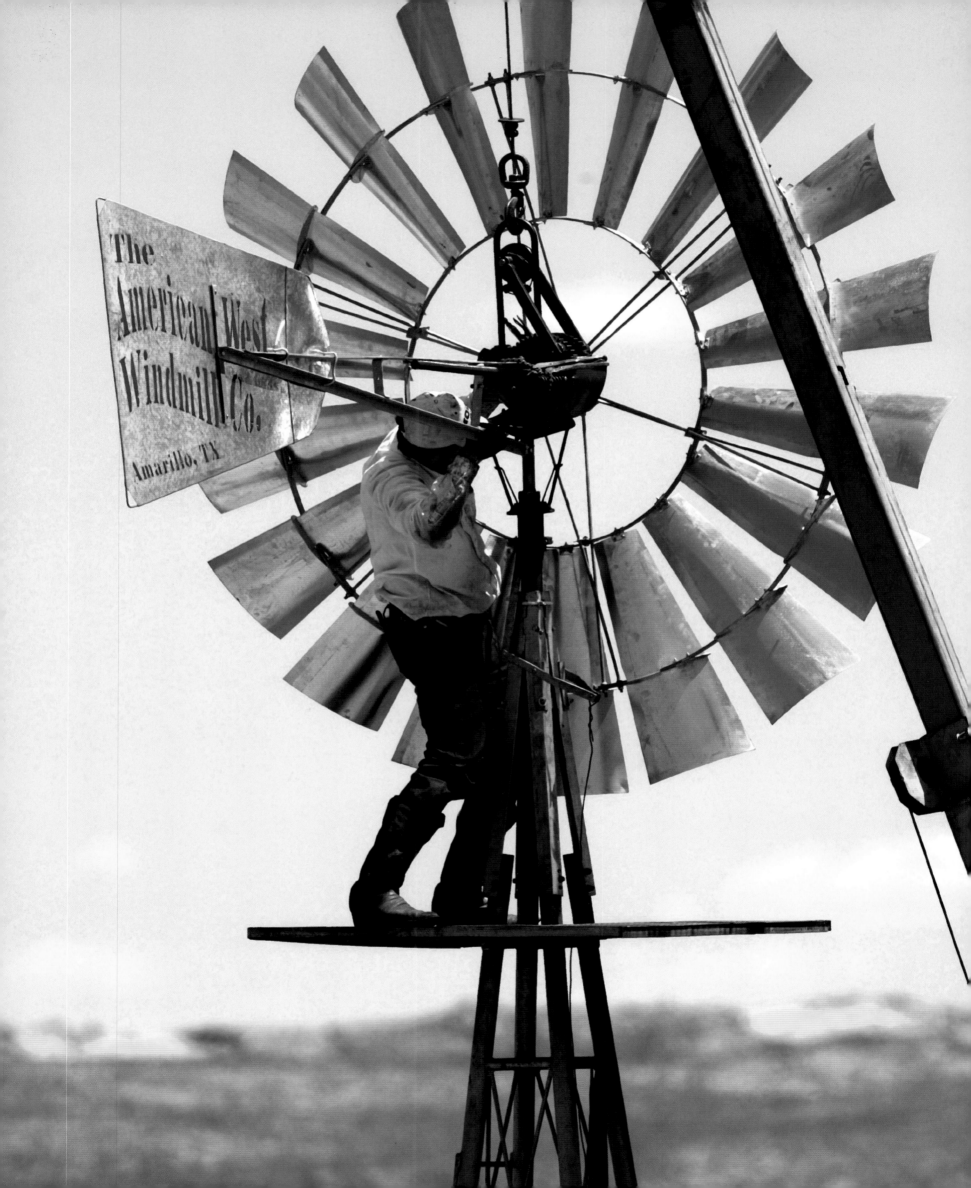

ALLIANCE

After high winds damaged windmills across a 70-mile swath of western Nebraska, James Girard set out on a repair-and-replace mission. A student at Chadron State College, James helps his dad with his well and windmill business during school breaks.
Photo by Matt Miller

BROKEN BOW

Nebraska's water-pumping windmills tap into the giant Ogallala Aquifer, lying just 50 feet below the surface. Roughly the size of California, the underground lake runs from South Dakota to the Texas panhandle.
Photo by George Burba

BASSETT

The windmill is known as the machine that settled Nebraska. Without its ability to harness the wind and pump out groundwater, homesteading and ranching would have been impossible. At one time, 700 companies sold windmills in America. Today only two remain, including Dempster Industries, Inc. in Beatrice, Nebraska.
Photo by George Burba

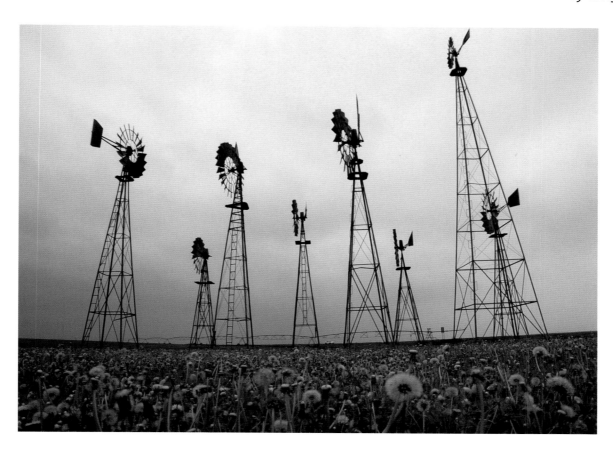

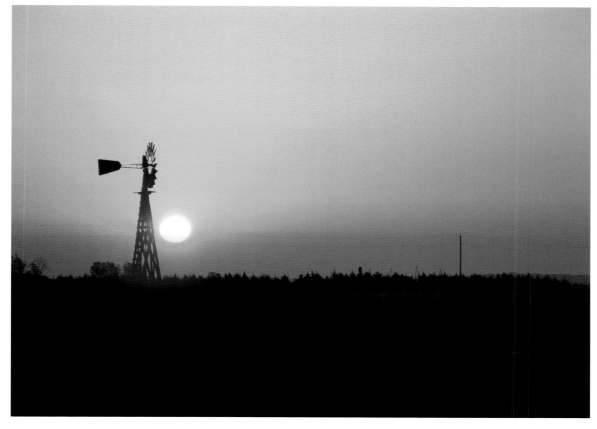

LINCOLN
On the Holmes Lake dam in southeast
Lincoln, kite flyers make the most of an

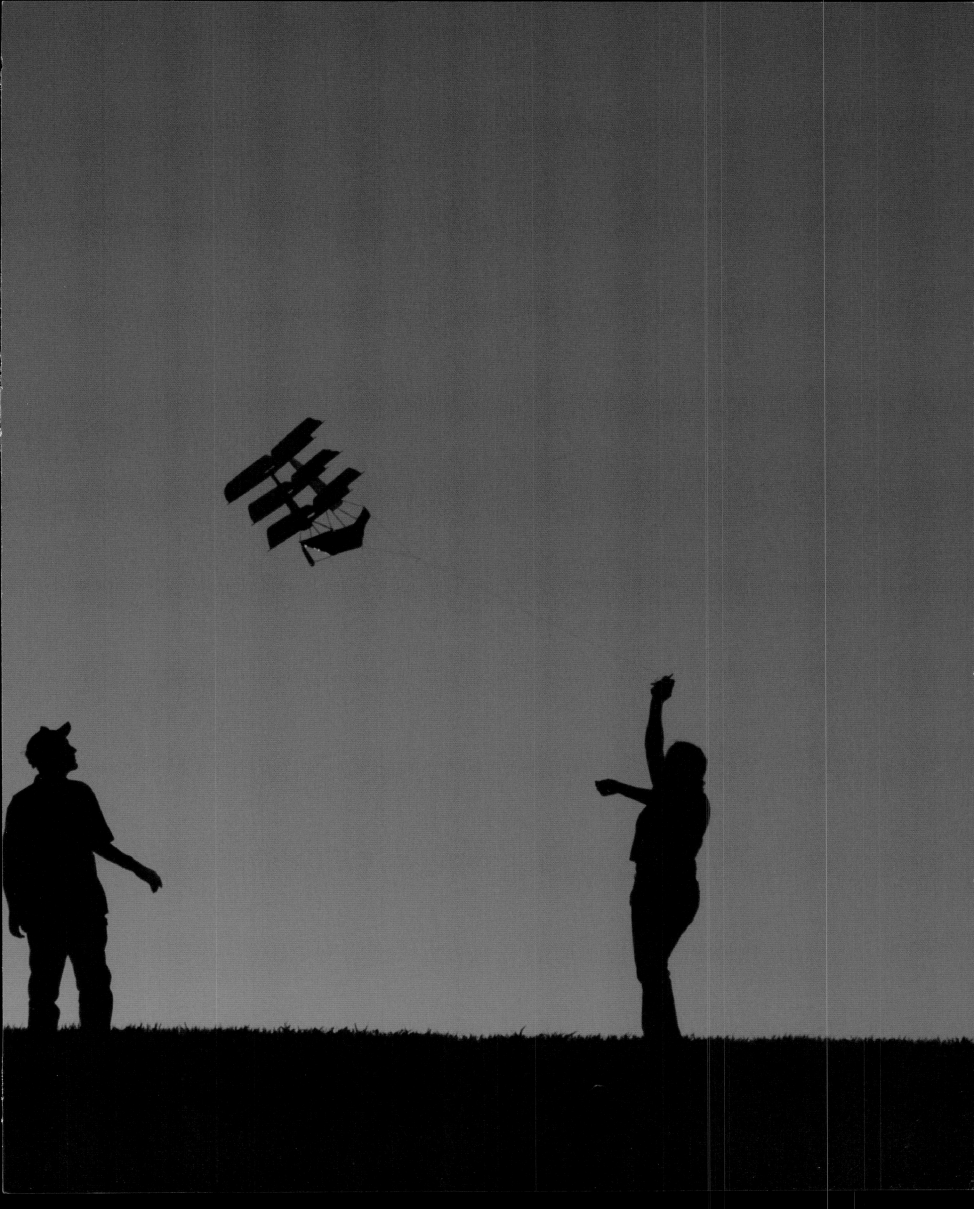

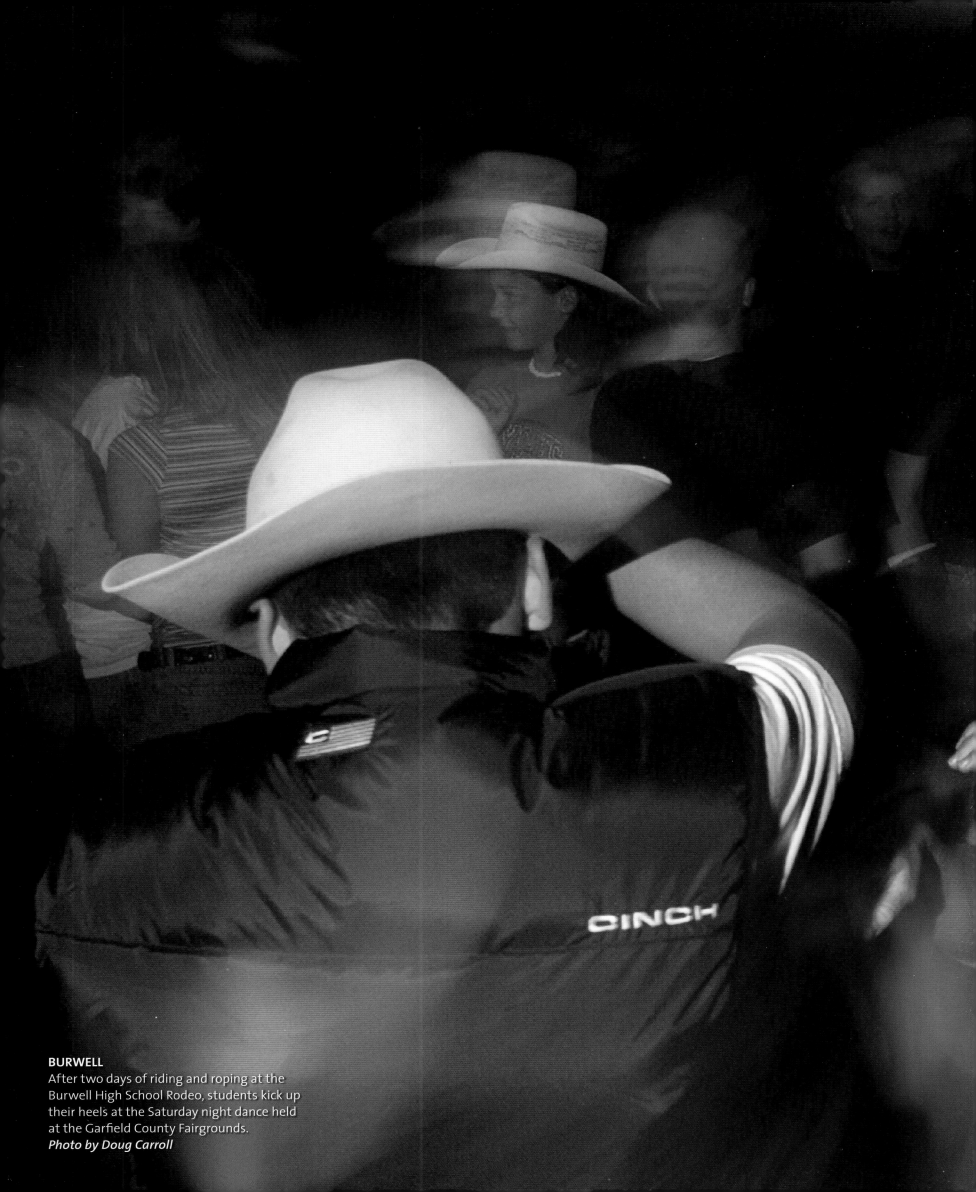

BURWELL
After two days of riding and roping at the
Burwell High School Rodeo, students kick up
their heels at the Saturday night dance held
at the Garfield County Fairgrounds.
Photo by Doug Carroll

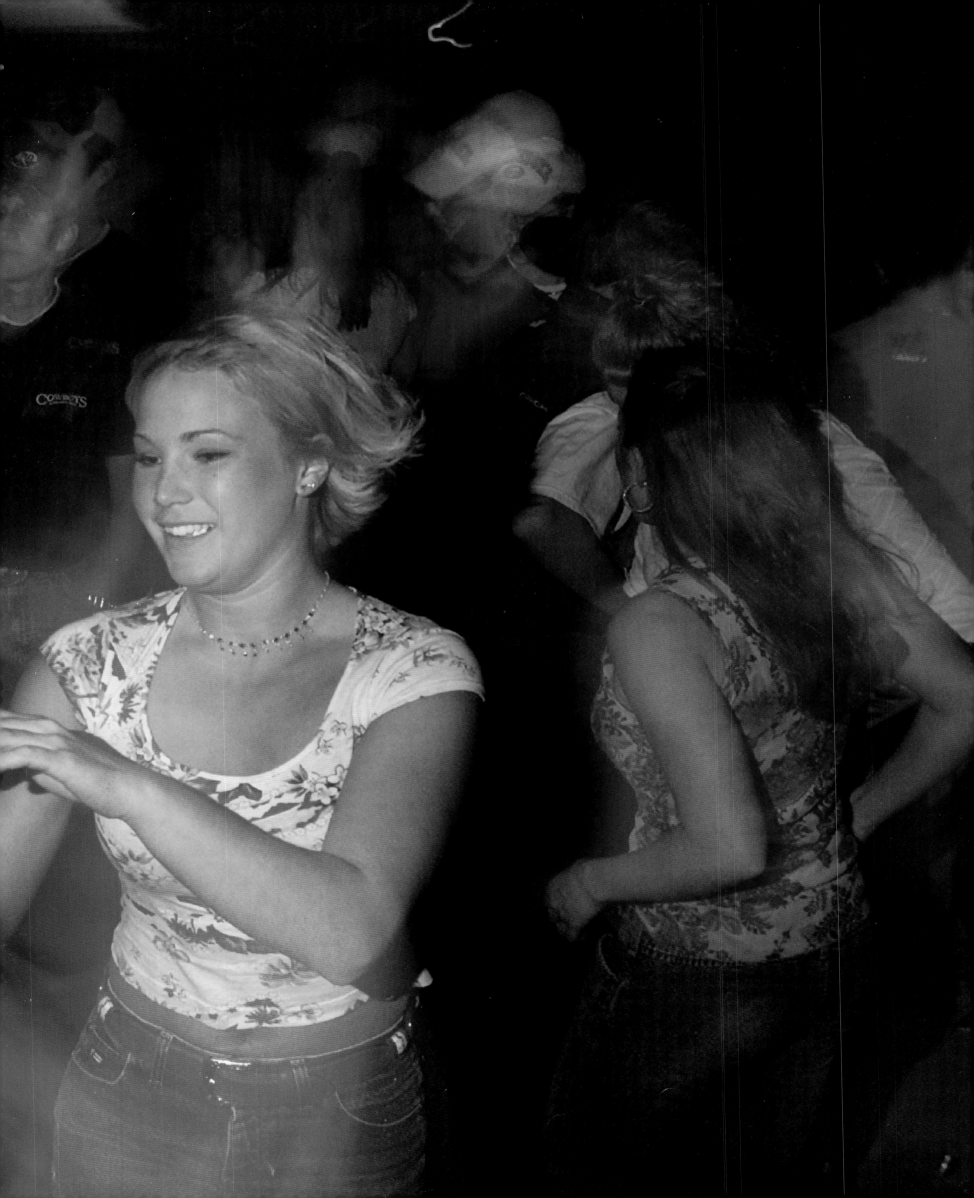

The week of May 12-18, 2003, more than 25,000 professional and amateur photographers spread out across the nation to shoot over a million digital photographs with the goal of capturing the essence of daily life in America.

The professional photographers were equipped with Adobe Photoshop and Adobe Album software, Olympus C-5050 digital cameras, and Lexar Media's high-speed compact flash cards.

The 1,000 professional contract photographers plus another 5,000 stringers and students sent their images via FTP (file transfer protocol) directly to the *America 24/7* website. Meanwhile, thousands of amateur photographers uploaded their images to Snapfish's servers.

At *America 24/7*'s Mission Control headquarters, located at CNET in San Francisco, dozens of picture editors from the nation's most prestigious publications culled the images down to 25,000 of the very best, using Photo Mechanic by Camera Bits. These photos were transferred into Webware's ActiveMedia Digital Asset Management (DAM) system, which served as a central image library and enabled the designers to track, search, distribute, and reformat the images for the creation of the 51 books, foreign language editions, web and magazine syndication, posters, and exhibitions.

Once in the DAM, images were optimized (and in some cases resampled to increase image resolution) using Adobe Photoshop. Adobe InDesign and Adobe InCopy were used to design and produce the 51 books, which were edited and reviewed in multiple locations around the world in the form of Adobe Acrobat PDFs. Epson Stylus printers were used for photo proofing and to produce large-format images for exhibitions. The companies providing support for the *America 24/7* project offer many of the essential components for anyone building a digital darkroom. We encourage you to read more on the following pages about their respective roles in making *America 24/7* possible.

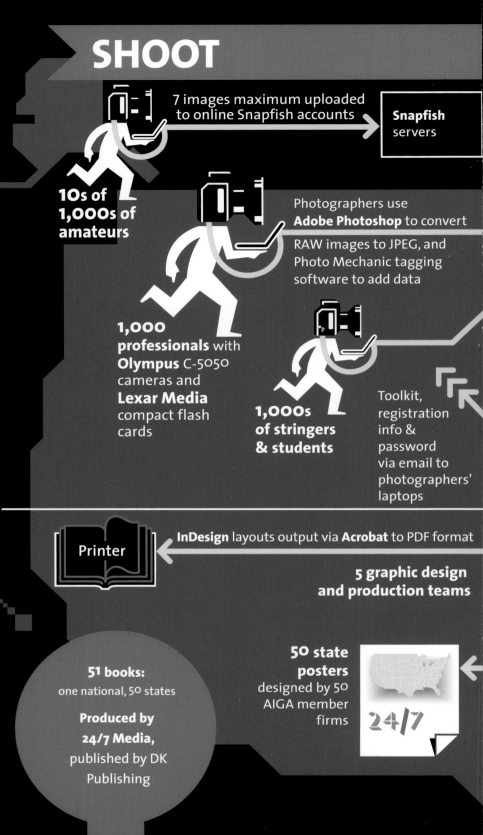

SHOOT

7 images maximum uploaded to online Snapfish accounts

Snapfish servers

10s of 1,000s of amateurs

Photographers use **Adobe Photoshop** to convert RAW images to JPEG, and Photo Mechanic tagging software to add data

1,000 professionals with **Olympus** C-5050 cameras and **Lexar Media** compact flash cards

1,000s of stringers & students

Toolkit, registration info & password via email to photographers' laptops

InDesign layouts output via **Acrobat** to PDF format

Printer

5 graphic design and production teams

51 books: one national, 50 states

Produced by 24/7 Media, published by DK Publishing

50 state posters designed by 50 AIGA member firms

24/7

DESIGN & PUBLISH

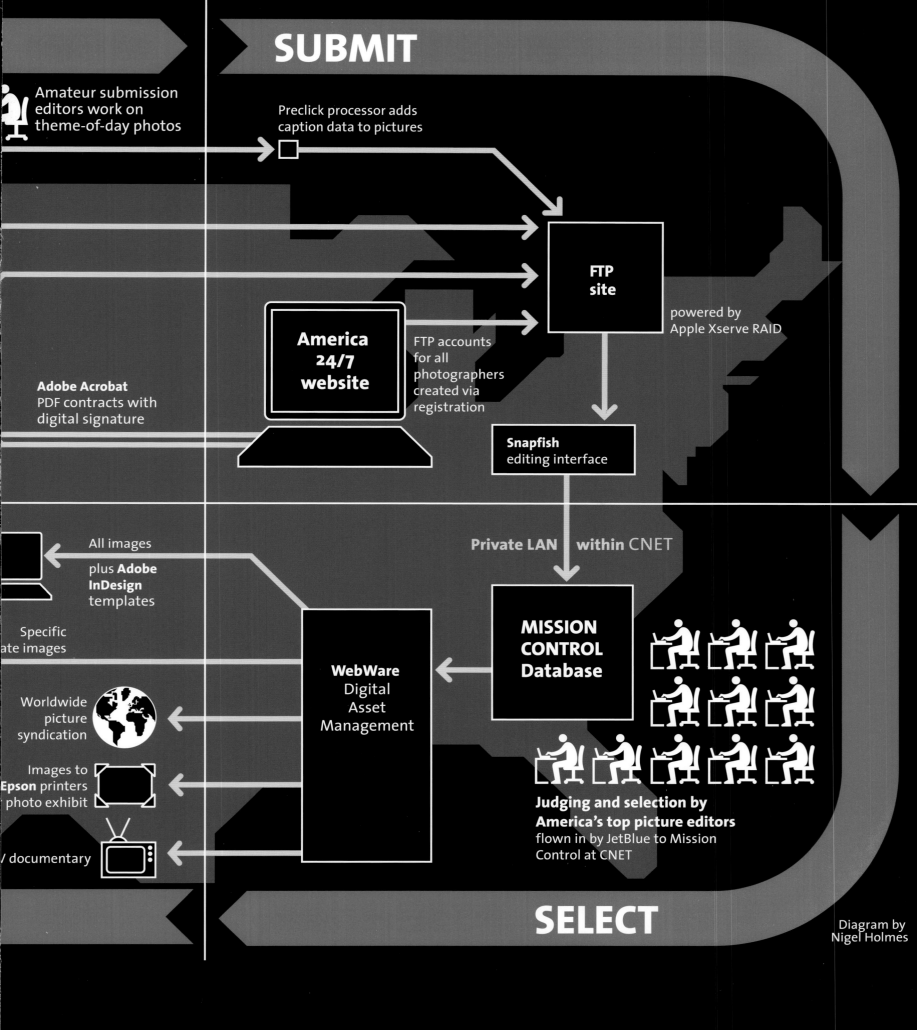

SUBMIT

Amateur submission editors work on theme-of-day photos

Preclick processor adds caption data to pictures

Adobe Acrobat PDF contracts with digital signature

America 24/7 website

FTP accounts for all photographers created via registration

FTP site

powered by Apple Xserve RAID

Snapfish editing interface

All images

plus **Adobe InDesign** templates

Specific ate images

Worldwide picture syndication

Images to **Epson** printers photo exhibit

/ documentary

WebWare Digital Asset Management

Private LAN within CNET

MISSION CONTROL Database

Judging and selection by America's top picture editors flown in by JetBlue to Mission Control at CNET

SELECT

Diagram by Nigel Holmes

Nebraska 24/7

About Our Sponsors

America 24/7 gave digital photographers of all levels the opportunity to share their visions of what it means to live in the United States. This project was made possible by a digital photography revolution that is dramatically changing and improving picture-taking for professionals and amateurs alike. And an Adobe product, Photoshop®, has been at the center of this sea change.

Adobe's products reflect our customers' passion for the creative process, be it the photographer, graphic designer, layout artist, or printer. Adobe is the Publishing and Imaging Software Partner for *America 24/7* and products such as Adobe InDesign®, Photoshop, Acrobat®, and Illustrator® were used to produce this stunning book in a matter of weeks. We hope that our software has helped do justice to the mythic images, contributed by well-known photographers and the inspired hobbyist.

Adobe is proud to be a lead sponsor of *America 24/7*, a project that celebrates the vibrancy of the American spirit: the same spirit that helped found Adobe and inspires our employees and customers to deliver the very best.

Bruce Chizen
President and CEO
Adobe Systems Incorporated

Olympus, a global technology leader in designing precision healthcare solutions and innovative consumer electronics, is proud to be the official digital camera sponsor of *America 24/7*. The opportunity to introduce Americans from coast to coast to the thrill, excitement, and possibility of digital photography makes the vision behind this book a perfect fit for Olympus, a leader in digital cameras since 1996.

For most people, the essence of digital photography is best grasped through firsthand experience with the technology, which is precisely what *America 24/7* is about. We understand that direct experience is the pathway to inspiration, and welcome opportunities like this sponsorship to bring the power of the digital experience into the lives of people everywhere. To Olympus, *America 24/7* offers a platform to help realize a core mission: to deliver and make accessible the power of the digital experience to millions of American photographers, amateurs, and professionals alike.

The 1,000 professional photographers contracted to shoot on the America 24/7 project were all equipped with Olympus C-5050 digital cameras. Like all Olympus products, the C-5050 is offered by a company well known for designing, manufacturing, and servicing products used by professionals to perform their work, every day. Olympus is a customer-centric company committed to working one-to-one with a diverse group of professionals. From biomedical researchers who use our clinical microscopes, to doctors who perform life-saving procedures with our endoscopes, to professional photographers who use cameras in their daily work, Olympus is a trusted brand.

The digital imaging technology involved with *America 24/7* has enabled the soul of America to be visually conveyed, not just by professional observers, but by the American public who participated in this project—the very people who collectively breath life into this country's existence each day.

We are proud to be enabling so many photographers to capture the pictures on these pages that tell the story of who we are as a nation. From sea to shining sea, digital imagery allows us to connect to one another in ways we never dreamed possible.

At Olympus, our ideas have proliferated as rapidly as technology has evolved. We have channeled these visions into breakthrough products and solutions to meet the demands of our changing world-products like microscopes, endoscopes, and digital voice recorders, supported by the highly regarded training, educational, and consulting services we offer our customers.

Today, 83 years after we introduced our first microscope, we remain as young, as curious, and as committed as ever.

Lexar Media has grown from the digital photography revolution, which is why we are proud to have supplied the digital memory cards used in the America 24/7 project. Lexar Media's high-performance memory cards utilize our unique and patented controller coupled with high-speed flash memory from Samsung, the world's largest flash memory supplier. This powerful combination brings out the ultimate performance of any digital camera.

Photographers who demand the most from their equipment choose our products for their advanced features like write speeds up to 40X, Write Acceleration technology for enabled cameras, and Image Rescue, which recovers previously deleted or lost images. Leading camera manufacturers bundle Lexar Media digital memory cards with their cameras because they value its performance and reliability.

Lexar Media is at the forefront of digital photography as it transforms picture-taking worldwide, and we will continue to be a leader with new and innovative solutions for professionals and amateurs alike.

Snapfish, which developed the technology behind the *America 24/7* amateur photo event, is a leading online photo service, with more than 5 million members and 100 million photos posted online. Snapfish enables both film and digital camera owners to share, print, and store their most important photo memories, at prices that cannot be equaled. Digital camera users upload photos into a password-protected online album for free. Users can also order film-quality prints on professional photographic paper for as low as 25¢. Film camera users get a full set of prints, plus online sharing and storage, for just $2.99 per roll.

Founded in 1995, eBay created a powerful platform for the sale of goods and services by a passionate community of individuals and businesses. On any given day, there are millions of items across thousands of categories for sale on eBay. eBay enables trade on a local, national and international basis with customized sites in markets around the world.

Through an array of services, such as its payment solution provider PayPal, eBay is enabling global e-commerce for an ever-growing online community.

JetBlue Airways is proud to be *America 24/7's* preferred carrier, flying photographers, photo editors, and organizers across the United States.

Winner of Condé Nast Traveler's Readers' Choice Awards for Best Domestic Airline 2002, JetBlue provides friendly service and low fares for travelers in 22 cities in nine states across America.

On behalf of JetBlue's 5,000 crew members, we're excited to be involved in this remarkable project, and for the opportunity to serve American travelers each and every day, coast to coast, 24/7.

DIGITAL POND

Digital Pond has been a leading creator of large graphic displays for museums, corporations, trade shows, retail environments and fine art since 1992.

We were proud to bring together our creative, print and display capabilities to produce signage and displays for mission control, critical retouching for numerous key images for the book, and art galleries for the New York Public Library and Bryant Park.

The Pond's team and SplashPic® Online service enabled us to nimbly design, produce and install over 200 large graphic panels in two NYC locations within the truly "24/7" production schedule of less than ten days.

WebWare Corporation is pleased to be a major sponsor of the America 24/7 project. We take pride in being part of a groundbreaking adventure that is stretching the boundaries—and the imagination—in digital photography, digital asset management, publishing, news, and global events.

Our ActiveMedia Enterprise™ digital asset management software is the "nerve center" of *America 24/7*, the central repository for managing, sharing, and collaborating on the project's photographs. From photo editors and book publishers to 24/7's media relations and marketing personnel, ActiveMedia provides the application support that links all facets of the project team to the content worldwide.

WebWare helps Global 2000 firms securely manage, reuse, and distribute media assets locally or globally. Its suite of ActiveMedia software products provide powerful media services platforms for integrating rich media into content management systems marketing and communication portals; web publishing systems; and e-commerce portals.

Google's mission is to organize the world's information and make it universally accessible and useful.

With our focus on plucking just the right answer from an ocean of data, we were naturally drawn to the America 24/7 project. The book you hold is a compendium of images of American life distilled from thousands of photographs and infinite possibilities. Are you looking for emotion? Narrative? Shadows? Light? It's all here, thanks to a multitude of photographers and writers creating links between you, the reader, and a sea of wonderful stories. We celebrate the connections that constitute the human experience and are pleased to help engender them. And we're pleased to have been a small part of this project, which captures the results of that interaction so vividly, so dynamically, and so dramatically.

Special thanks to additional contributors: FileMaker, Apple, Camera Bits, LaCie, Now Software, Preclick, Outpost Digital, Xerox, Microsoft, WoodWing Software, net-linx Publishing Solutions, and Radical Media. The Savoy Hotel, San Francisco; The Pan Pacific, San Francisco; Four Seasons Hotel, San Francisco; and The Queen Anne Hotel. Photography editing facilities were generously hosted by CNET Networks, Inc.

Participating Photographers

Nebraska Coordinator: George Tuck, College of Journalism and Mass Communications, University of Nebraska–Lincoln

Jeff Beiermann, *Omaha World-Herald*
Bob Berry
Ken Blackbird
Lane Bleess
Jeff Bundy, *Omaha World-Herald*
George Burba
Doug Carroll
Crystal Corman
Kiley Cruse
Allan E. Detrich
Don Doll, S.J., Creighton University
Tawnya Douglas
Darin Epperly
Bill Ganzel
Lane Hickenbottom
Charlie Hicks

Allen Hudson
Laura Inns
Mikael Karlsson, arrestingimages.com
Scott Kingsley
Khara Marae Lintel
Matt Long
Matt Miller
Gerik Parmele
Kent Sievers
George Tuck,
University of Nebraska–Lincoln
Lisa Van Stratten
Josh Wolfe
Richard Wright
Randy Zuke

Thumbnail Picture Credits

Credits for thumbnail photographs are listed by the page number and are in order from left to right.

16 George Burba
George Burba
George Burba
George Burba
George Burba
George Burba
George Burba

17 Khara Marae Lintel
Scott Kingsley
Khara Marae Lintel
Bob Berry
Khara Marae Lintel
Scott Kingsley
Khara Marae Lintel

18 Bill Ganzel
Crystal Corman
Richard Wright
Darin Epperly
Don Doll, S.J., Creighton University
Crystal Corman
Kent Sievers

19 Don Doll, S.J., Creighton University
Darin Epperly
George Burba
Lane Hickenbottom
George Tuck, University of Nebraska–Lincoln
Matt Miller
Khara Marae Lintel

20 Gerik Parmele
Gerik Parmele
Doug Carroll
Gerik Parmele
Gerik Parmele
Gerik Parmele
Gerik Parmele

21 Gerik Parmele
Gerik Parmele
Gerik Parmele
Gerik Parmele
Gerik Parmele
Gerik Parmele
Gerik Parmele

24 Crystal Corman
Crystal Corman
Crystal Corman
Gerik Parmele
Crystal Corman
S.A. Kauble
Crystal Corman

25 Gerik Parmele
Gerik Parmele
Crystal Corman
Matt Miller
Gerik Parmele
Josh Wolfe
Khara Marae Lintel

26 Josh Wolfe
Josh Wolfe
Crystal Corman
Crystal Corman
Josh Wolfe

Crystal Corman
Doug Carroll

27 Josh Wolfe
Crystal Corman
Josh Wolfe
Crystal Corman
Josh Wolfe
Josh Wolfe
Crystal Corman

28 Bill Ganzel
Janez A. Sever
Josh Wolfe
Cyan R. James, Iowa State University
Janez A. Sever
Kent Sievers
Crystal Corman

29 George Tuck, University of Nebraska–Lincoln
Kent Sievers
Josh Wolfe
Doug Carroll
Khara Marae Lintel
Don Doll, S.J., Creighton University
Ken Blackbird

30 Don Doll, S.J., Creighton University
Laura Inns
George Burba
Laura Inns
Laura Inns
Laura Inns
Laura Inns

31 Laura Inns
Laura Inns
Laura Inns
Laura Inns
Laura Inns
Laura Inns
Laura Inns

33 Crystal Corman
Kiley Cruse
George Burba
Bob Berry
Richard Wright
S.A. Kauble
Steen Nichols

34 George Tuck, University of Nebraska–Lincoln
Scott Kingsley
Scott Kingsley
George Tuck, University of Nebraska–Lincoln
Scott Kingsley
Kent Sievers
Scott Kingsley

36 Laura Inns
Laura Inns
Doug Carroll
Laura Inns
Matt Miller
Khara Marae Lintel
Laura Inns

37 Laura Inns
Laura Inns
Gerik Parmele
Laura Inns
Laura Inns
Laura Inns
Laura Inns

44 Don Doll, S.J., Creighton University
Don Doll, S.J., Creighton University
Don Doll, S.J., Creighton University
Matt Miller
Don Doll, S.J., Creighton University
Matt Miller

45 Matt Miller
Don Doll, S.J., Creighton University
Don Doll, S.J., Creighton University
Matt Miller
Matt Miller
Lane Hickenbottom
Don Doll, S.J., Creighton University

46 Matt Miller
Matt Miller
Matt Miller
Don Doll, S.J., Creighton University
Matt Miller
Don Doll, S.J., Creighton University
Matt Miller

47 Don Doll, S.J., Creighton University
Don Doll, S.J., Creighton University
Don Doll, S.J., Creighton University
Matt Miller
Don Doll, S.J., Creighton University
Matt Miller
Matt Miller

49 George Burba
Matt Miller
George Burba
George Burba
George Burba
Matt Miller
Janez A. Sever

50 Kent Sievers
George Burba
George Burba
George Burba
George Burba
Scott Kingsley
Kent Sievers

51 George Burba
Kent Sievers
Crystal Corman
Khara Marae Lintel
Mikael Karlsson, arrestingimages.com
Kent Sievers
Bob Berry

52 Don Doll, S.J., Creighton University
Darin Epperly
Kiley Cruse
Janez A. Sever
George Burba
Kiley Cruse
Darin Epperly

53 Kiley Cruse
Kiley Cruse
Darin Epperly
Kiley Cruse
Bob Berry
Bob Berry
Mikael Karlsson, arrestingimages.com

56 Darin Epperly
Ken Blackbird
Crystal Corman
Ken Blackbird
Ken Blackbird
Darin Epperly
Crystal Corman

57 Darin Epperly
Don Doll, S.J., Creighton University
Darin Epperly
Ken Blackbird
Ken Blackbird
Ken Blackbird
Lane Hickenbottom

58 Bob Berry
Bob Berry
Bob Berry
Bob Berry
Bob Berry
Bob Berry
Bob Berry

59 Bob Berry
Bob Berry
Bob Berry
Bob Berry
Bob Berry
Bob Berry
Bob Berry

61 Bob Berry
Kent Sievers
Bob Berry
Kent Sievers

Kent Sievers
Kent Sievers
Bob Berry

62 Darin Epperly
Darin Epperly
Darin Epperly
Darin Epperly
Darin Epperly
Darin Epperly
Darin Epperly

63 Darin Epperly
Darin Epperly
Darin Epperly
Darin Epperly
Darin Epperly
Darin Epperly
Darin Epperly

64 Darin Epperly
Bill Ganzel
Bill Ganzel
Darin Epperly
Bill Ganzel
Darin Epperly
Lane Hickenbottom

65 Don Doll, S.J., Creighton University
Darin Epperly
Bill Ganzel
Mikael Karlsson, arrestingimages.com
Darin Epperly
Bill Ganzel
Crystal Corman

66 Bill Ganzel
Bill Ganzel
Bill Ganzel
Jeff Bundy, *Omaha World-Herald*
Bill Ganzel
Bill Ganzel
Bill Ganzel

67 Bill Ganzel
Bill Ganzel
Bill Ganzel
Bill Ganzel
Jeff Bundy, *Omaha World-Herald*
Jeff Bundy, *Omaha World-Herald*
Bill Ganzel

68 Darin Epperly
Darin Epperly
Darin Epperly
Richard Wright
Darin Epperly
Darin Epperly
George Tuck, University of Nebraska–Lincoln

69 Darin Epperly
Darin Epperly
Darin Epperly
Darin Epperly
Darin Epperly
Darin Epperly
George Tuck, University of Nebraska–Lincoln

70 Josh Wolfe
Scott Kingsley
Josh Wolfe
Crystal Corman
Crystal Corman
Crystal Corman
Bob Berry

71 Bob Berry
Josh Wolfe
Bob Berry
Bob Berry
Bob Berry
Bob Berry
Scott Kingsley

72 Josh Wolfe
Josh Wolfe
Richard Wright
Josh Wolfe
Josh Wolfe
Josh Wolfe
Richard Wright

73 Josh Wolfe
Richard Wright
Josh Wolfe
Josh Wolfe
Josh Wolfe
Richard Wright
Josh Wolfe

76 Don Doll, S.J., Creighton University
Lane Hickenbottom
Mikael Karlsson, arrestingimages.com
Josh Wolfe
George Tuck, University of Nebraska–Lincoln
Lane Hickenbottom
Mikael Karlsson, arrestingimages.com

77 Lane Hickenbottom
George Tuck, University of Nebraska–Lincoln
Mikael Karlsson, arrestingimages.com
Lane Hickenbottom
Mikael Karlsson, arrestingimages.com
Bob Berry
Lane Hickenbottom

78 George Tuck, University of Nebraska–Lincoln
Mikael Karlsson, arrestingimages.com
Mikael Karlsson, arrestingimages.com
Mikael Karlsson, arrestingimages.com
Mikael Karlsson, arrestingimages.com
Mikael Karlsson, arrestingimages.com

79 George Tuck, University of Nebraska–Lincoln
Mikael Karlsson, arrestingimages.com
Mikael Karlsson, arrestingimages.com
Ken Blackbird
George Tuck, University of Nebraska–Lincoln
Mikael Karlsson, arrestingimages.com
Bob Berry

80 Bill Ganzel
Kiley Cruse
Bill Ganzel
Bill Ganzel
Bill Ganzel
Bill Ganzel

81 Kiley Cruse
Bob Berry
Gerik Parmele
Bill Ganzel
Gerik Parmele
Bill Ganzel
Kiley Cruse

84 Khara Marae Lintel
Ken Blackbird
Josh Wolfe
Doug Carroll
Ken Blackbird
Kent Sievers
Doug Carroll

85 Ken Blackbird
Kent Sievers
Khara Marae Lintel
Ken Blackbird
Steen Nichols
Scott Kingsley
Ken Blackbird

86 Doug Carroll
Richard Wright
Richard Wright
George Burba
Doug Carroll
Richard Wright
Lane Hickenbottom

87 Carina McCormick, University of Nebraska–Lincoln
Doug Carroll
Richard Wright
Lane Hickenbottom
Don Doll, S.J., Creighton University
George Burba
George Burba

88 Kent Sievers
Kent Sievers
Kent Sievers
Kent Sievers
Kent Sievers
Kent Sievers

90 Kiley Cruse
Darin Epperly
Kiley Cruse
Darin Epperly
Darin Epperly
Kiley Cruse

91 Kiley Cruse
Darin Epperly
Kiley Cruse
Darin Epperly
Kiley Cruse
Kiley Cruse
Kiley Cruse

92 Allan E. Detrich
Don Doll, S.J., Creighton University
Jeff Beiermann, *Omaha World-Herald*
Jeff Beiermann, *Omaha World-Herald*
Khara Marae Lintel
Jeff Beiermann, *Omaha World-Herald*
Jeff Beiermann, *Omaha World-Herald*

93 Khara Marae Lintel
Jeff Beiermann, *Omaha World-Herald*
Richard Wright
Jeff Beiermann, *Omaha World-Herald*
Khara Marae Lintel
Jeff Beiermann, *Omaha World-Herald*
Richard Wright

94 Richard Wright
Richard Wright
Richard Wright
Richard Wright
Richard Wright
Richard Wright
Richard Wright

95 Richard Wright
Richard Wright
Richard Wright
Richard Wright

Richard Wright
Richard Wright
Richard Wright

97 Jeff Bundy, *Omaha World-Herald*
Kent Sievers
S.A. Kauble
Khara Marae Lintel
Kent Sievers
S.A. Kauble
Kent Sievers

98 Bill Ganzel
George Tuck, University of Nebraska-Lincoln
Josh Wolfe
Scott Kingsley
Khara Marae Lintel
Scott Kingsley
Khara Marae Lintel

99 Bob Berry
Scott Kingsley
Scott Kingsley
Scott Kingsley
Scott Kingsley
Scott Kingsley
Scott Kingsley

100 Allan E. Detrich
Bill Ganzel
Doug Carroll
George Burba
Doug Carroll
George Burba
Khara Marae Lintel

101 George Burba
Ken Blackbird
Kent Sievers
S.A. Kauble
Khara Marae Lintel
Richard Wright
Khara Marae Lintel

102 Don Doll, S.J., Creighton University
Doug Carroll
Doug Carroll
Doug Carroll
Doug Carroll
Doug Carroll
Doug Carroll

103 Doug Carroll
Doug Carroll
Doug Carroll
Don Doll, S.J., Creighton University
Doug Carroll
Doug Carroll
Doug Carroll

104 Don Doll, S.J., Creighton University
Don Doll, S.J., Creighton University
Don Doll, S.J., Creighton University
Doug Carroll
Doug Carroll
Doug Carroll
Doug Carroll

105 Doug Carroll
Doug Carroll
Doug Carroll
Doug Carroll
Janez A. Sever
Doug Carroll

106 Allan E. Detrich
Don Doll, S.J., Creighton University
Doug Carroll
Bill Ganzel
Don Doll, S.J., Creighton University
Don Doll, S.J., Creighton University
Doug Carroll

107 Doug Carroll
Doug Carroll
Doug Carroll
Doug Carroll
Doug Carroll
Jeff Beiermann, *Omaha World-Herald*
Doug Carroll

108 Richard Wright
Kiley Cruse
Lane Hickenbottom
Richard Wright
Don Doll, S.J., Creighton University
Richard Wright
Crystal Corman

109 Richard Wright
Lane Hickenbottom
Richard Wright
Richard Wright
Richard Wright
Lane Hickenbottom
Richard Wright

112 Darin Epperly
Don Doll, S.J., Creighton University
Darin Epperly
Ken Blackbird
Darin Epperly
George Burba
Darin Epperly

113 George Tuck, University of Nebraska–Lincoln
Darin Epperly
George Burba
Ken Blackbird
Darin Epperly
Laura Inns
Darin Epperly

114 George Burba
George Burba
George Burba
Bob Berry
George Burba
Jeff Beiermann, *Omaha World-Herald*
George Burba

115 Lane Hickenbottom
Josh Wolfe
George Burba
Bob Berry
George Burba
S.A. Kauble
George Burba

116 Kiley Cruse
Jeff Beiermann, *Omaha World-Herald*
Kiley Cruse
Kiley Cruse
Laura Inns
Laura Inns
Kiley Cruse

117 Laura Inns
Kiley Cruse
Laura Inns
Laura Inns
Laura Inns
Laura Inns
Laura Inns

120 Laura Inns
Laura Inns
Laura Inns
Laura Inns
Laura Inns
Laura Inns
Laura Inns

121 Laura Inns
Laura Inns
Laura Inns
Laura Inns
Laura Inns
Laura Inns
Laura Inns

124 Kent Sievers
Kent Sievers
Kent Sievers
Kent Sievers
Kent Sievers
Khara Marae Lintel
Kent Sievers

125 Kent Sievers
Kent Sievers
Kent Sievers
Kent Sievers
Kent Sievers
George Burba
Richard Wright

126 Laura Inns
Doug Carroll
Darin Epperly
Laura Inns
Darin Epperly
George Tuck, University of Nebraska–Lincoln
Darin Epperly

127 George Tuck, University of Nebraska–Lincoln
Jeff Bundy, *Omaha World-Herald*
Laura Inns
Mikael Karlsson, arrestingimages.com
Laura Inns
Mikael Karlsson, arrestingimages.com
Lane Hickenbottom

130 Don Doll, S.J., Creighton University
Don Doll, S.J., Creighton University
Crystal Corman
Laura Inns
Doug Carroll
George Burba
Darin Epperly

131 Matt Miller
Matt Miller
George Burba
Lane Hickenbottom
Bob Berry
Matt Miller
Bill Ganzel

132 Allan E. Detrich
Crystal Corman
Don Doll, S.J., Creighton University
Scott Kingsley
Don Doll, S.J., Creighton University
Scott Kingsley
George Tuck, University of Nebraska–Lincoln

133 Scott Kingsley
Scott Kingsley
Scott Kingsley
Scott Kingsley

Scott Kingsley
Scott Kingsley
Scott Kingsley

134 Don Doll, S.J., Creighton University
Don Doll, S.J., Creighton University
Doug Carroll
George Burba
Doug Carroll
Janez A. Sever

135 George Burba
Doug Carroll
Janez A. Sever
Doug Carroll
Allan E. Detrich
Matt Miller
Mikael Karlsson, arrestingimages.com

137 Scott Kingsley
Scott Kingsley
Lane Hickenbottom
Scott Kingsley
Scott Kingsley
Scott Kingsley
Scott Kingsley

138 Darin Epperly
Doug Carroll
Darin Epperly
Doug Carroll
Lane Hickenbottom
George Burba
Mikael Karlsson, arrestingimages.com

139 Josh Wolfe
Khara Marae Lintel
Lane Hickenbottom
Bill Ganzel
Allan E. Detrich
Josh Wolfe
Doug Carroll

140 Allan E. Detrich
Lane Bleess
George Burba
Allan E. Detrich
Bill Ganzel
Lane Bleess
Bill Ganzel

141 Allan E. Detrich
Scott Kingsley
Mikael Karlsson, arrestingimages.com
Lane Bleess
Lane Bleess
George Tuck, University of Nebraska–Lincoln
Scott Kingsley

142 Ken Blackbird
Ken Blackbird
Ken Blackbird
Ken Blackbird
Ken Blackbird
Ken Blackbird

143 Ken Blackbird
Ken Blackbird
Ken Blackbird
Ken Blackbird
Ken Blackbird
Ken Blackbird
Ken Blackbird

144 Don Doll, S.J., Creighton University
George Burba
Don Doll, S.J., Creighton University
Don Doll, S.J., Creighton University
Lane Hickenbottom
George Burba
Don Doll, S.J., Creighton University

145 Don Doll, S.J., Creighton University
Jeff Bundy, *Omaha World-Herald*
George Burba
Don Doll, S.J., Creighton University
Don Doll, S.J., Creighton University
George Burba
Don Doll, S.J., Creighton University

146 Darin Epperly
Darin Epperly
Doug Carroll
Don Doll, S.J., Creighton University
George Tuck, University of Nebraska–Lincoln
Darin Epperly
George Tuck, University of Nebraska–Lincoln

147 Janez A. Sever
Matt Miller
George Tuck, University of Nebraska–Lincoln
George Tuck, University of Nebraska–Lincoln
Darin Epperly
George Tuck, University of Nebraska–Lincoln
Matt Miller

149 Matt Miller
Matt Miller
George Burba
George Burba
Matt Miller
George Burba
Matt Miller

Staff

The *America 24/7* series was imagined years ago by our friend Oscar Dystel, a publishing legend whose vision and enthusiasm have been a source of great inspiration.

We also wish to express our gratitude to our truly visionary publisher, DK.

Rick Smolan, Project Director
David Elliot Cohen, Project Director

Administrative
Katya Able, Operations Director
Gina Privitere, Communications Director
Chuck Gathard, Technology Director
Kim Shannon, Photographer Relations Director
Erin O'Connor, Photographer Relations Intern
Leslie Hunter, Partnership Director
Annie Polk, Publicity Manager
John McAlester, Website Manager
Alex Notides, Office Manager
C. Thomas Hardin, State Photography Coordinator

Design
Brad Zucroff, Creative Director
Karen Mullarkey, Photography Director
Judy Zimola, Production Manager
David Simoni, Production Designer
Mary Dias, Production Designer
Heidi Madison, Associate Picture Editor
Don McCartney, Production Designer
Diane Dempsey Murray, Production Designer
Jan Rogers, Associate Picture Editor
Bill Shore, Production Designer and Image Artist
Larry Nighswander, Senior Picture Editor
Bill Marr, Sarah Leen, Senior Picture Editors
Peter Truskier, Workflow Consultant
Jim Birkenseer, Workflow Consultant

Editorial
Maggie Canon, Managing Editor
Curt Sanburn, Senior Editor
Teresa L. Trego, Production Editor
Lea Aschkenas, Writer
Olivia Boler, Writer
Korey Capozza, Writer
Beverly Hanly, Writer
Bridgett Novak, Writer
Alison Owings, Writer
Fred Raker, Writer
Joe Wolff, Writer
Elise O'Keefe, Copy Chief
Daisy Hernández, Copy Editor
Jennifer Wolfe, Copy Editor

Infographic Design
Nigel Holmes

Literary Agent
Carol Mann, The Carol Mann Agency

Legal Counsel
Barry Reder, Coblentz, Patch, Duffy & Bass, LLP
Phil Feldman, Coblentz, Patch, Duffy & Bass, LLP
Gabe Perle, Ohlandt, Greeley, Ruggiero & Perle, LLP
Jon Hart, Dow, Lohnes & Albertson, PLLC
Mike Hays, Dow, Lohnes & Albertson, PLLC
Stephen Pollen, Warshaw Burstein, Cohen,
Schlesinger & Kuh, LLP
Rick Pappas

Accounting and Finance
Rita Dulebohn, Accountant
Robert Powers, Calegari, Morris & Co. Accountants
Eugene Blumberg, Blumberg & Associates
Arthur Langhaus, KLS Professional Advisors Group, Inc.

Picture Editors
J. David Ake, Associated Press
Caren Alpert, formerly *Health* magazine
Simon Barnett, *Newsweek*
Caroline Couig, *San Jose Mercury News*
Mike Davis, formerly *National Geographic*
Michel duCille, *Washington Post*
Deborah Dragon, *Rolling Stone*
Victor Fisher, formerly Associated Press
Frank Folwell, *USA Today*
MaryAnne Golon, *Time*
Liz Grady, formerly *National Geographic*
Randall Greenwell, *San Francisco Chronicle*
C. Thomas Hardin, formerly *Louisville Courier-Journal*
Kathleen Hennessy, *San Francisco Chronicle*
Scot Jahn, *U.S. News & World Report*
Steve Jessmore, *Flint Journal*
John Kaplan, University of Florida
Kim Komenich, *San Francisco Chronicle*
Eliane Laffont, *Hachette Filipacchi Media*
Jean-Pierre Laffont, *Hachette Filipacchi Media*
Andrew Locke, MSNBC
Jose Lopez, *The New York Times*
Maria Mann, formerly AFP
Bill Marr, formerly *National Geographic*
Michele McNally, *Fortune*
James Merithew, *San Francisco Chronicle*
Eric Meskauskas, *New York Daily News*
Maddy Miller, *People* magazine
Michelle Molloy, *Newsweek*
Dolores Morrison, *New York Daily News*
Karen Mullarkey, formerly *Newsweek, Rolling Stone, Sports Illustrated*
Larry Nighswander, Ohio University School of Visual Communication
Jim Preston, *Baltimore Sun*
Sarah Rozen, formerly *Entertainment Weekly*
Mike Smith, *The New York Times*
Neal Ulevich, formerly Associated Press

Website and Digital Systems
Jeff Burchell, Applications Engineer

Television Documentary
Sandy Smolan, Producer/Director
Rick King, Producer/Director
Bill Medsker, Producer

Video News Release
Mike Cerre, Producer/Director

Digital Pond
Peter Hogg
Kris Knight
Roger Graham
Philip Bond
Frank De Pace
Lisa Li

Senior Advisors
Jennifer Erwitt, Strategic Advisor
Tom Walker, Creative Advisor
Megan Smith, Technology Advisor
Jon Kamen, Media and Partnership Advisor
Mark Greenberg, Partnership Advisor
Patti Richards, Publicity Advisor
Cotton Coulson, Mission Control Advisor

Executive Advisors
Sonia Land
George Craig
Carole Bidnick

Advisors
Chris Anderson
Samir Arora
Russell Brown
Craig Cline
Gayle Cline
Harlan Felt
George Fisher
Phillip Moffitt
Clement Mok
Laureen Seeger
Richard Saul Wurman

DK Publishing
Bill Barry
Joanna Bull
Therese Burke
Sarah Coltman
Christopher Davis
Todd Fries
Dick Heffernan
Jay Henry
Stuart Jackman
Stephanie Jackson
Chuck Lang
Sharon Lucas
Cathy Melnicki
Nicola Munro
Eunice Paterson
Andrew Welham

Colourscan
Jimmy Tsao
Eddie Chia
Richard Law
Josephine Yam
Paul Koh
Chee Cheng Yeong
Dan Kang

Chief Morale Officer
Goose, the dog

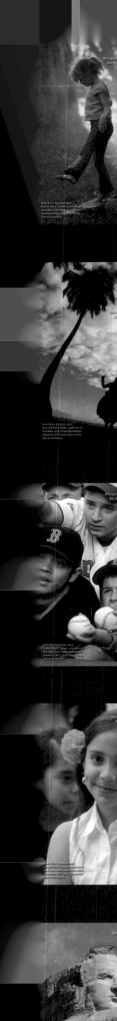

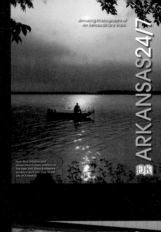
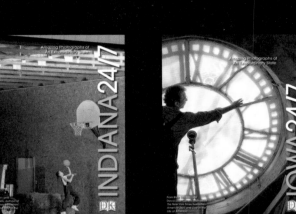

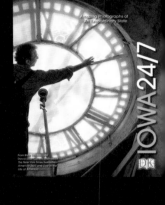
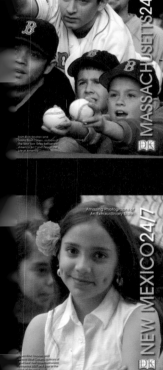

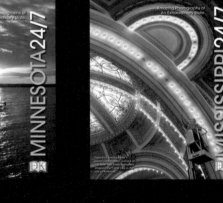